New Hampshire
Then and Now

New Hampshire
Then and Now

Contemporary Photographs and Essay

by

Peter E. Randall

Published in cooperation with the
New Hampshire Historical Society
by
Peter E. Randall Publisher
Portsmouth, New Hampshire
2006

Peter E. Randall Publisher
Box 4726, Portsmouth, NH 03802
www.perpublisher.com

Design concept: Grace Peirce

New Hampshire Historical Society
The Tuck Library
30 Park Street
Concord, NH 03301-6394
Telephone: 603/228-6688
www.nhhistory.org

ISBN 1-931807-47-7
Library of Congress Control Number: 2005911057

Map on page xiii courtesy of New Hampshire Housing Finance Authority

*To Ethan Gaffner Randall Carr,
and to the memory of
Joseph G. Sawtelle*

About the New Hampshire Historical Society

Founded in 1823, the society is a private nonprofit organization dedicated to saving and sharing New Hampshire's history. The society's mission is to educate a diverse public about the significance of New Hampshire's past and its relationship to our lives today. Each year, through the research library, Museum of New Hampshire History, and award-winning education and publication programs, the society provides people with information critical to strengthening their sense of place and identity. Public programs include exhibitions (long-term, changing, and off-site), school lessons (in-museum and outreach), and technical workshops for local historical societies, lectures, concerts, and publications. The society is an independent, nonprofit organization and receives no operating support from the State of New Hampshire. The Society's annual budget of $2.3 million is met through a combination of endowment earnings, membership dues and donations, earned income, and gifts and grants from approximately 4,000 individuals, businesses, and foundations.

This book serves as the catalogue for the exhibition "New Hampshire Then and Now," that will be on view in Concord at the New Hampshire Historical Society's Park Street library from March 3 through December 31, 2006. Developed in consultation with the author, the eighty photographs featured in the exhibition provide an important historical record contrasted with a contemporary artistic vision of the changing face of New Hampshire and its people. After its introduction at the New Hampshire Historical Society, the exhibition will travel to museums and galleries around New Hampshire including the Historical Society of Cheshire County, Keene; Plymouth State University, Plymouth; the Portsmouth Athenaeum, Portsmouth; and the Mount Washington Hotel during 2007 and 2008.

Preface

When I began to think about a third New Hampshire book of photographs, I considered a number of concepts, but I had been intrigued with "then-and-now" books. Most of them are devoted to a single community and many of the "now" views lack interest because most photographers usually adhere to a strict attempt to duplicate the exact location of the "then" image. The result is often an old image of a picturesque street with horse and buggy matched with a new view of a busy road with wires, streetlights, and vehicles. The latter is not usually an attractive image.

There are other statewide "then-and-now" books. *Utah, Then and Now* was made easier because that mostly dry state has few trees compared to New Hampshire. When I began to photograph, I rejected dozens of images because trees had grown up to hide the landscape shown in the old images and I couldn't make a new image to match the old one. I found *Wisconsin Then and Now* in which several photographers used "then-and-now" as an approach rather than a strict photographic protocol. This made more sense to me and for the most part I have used that approach. A book of this type also involves my two lifelong interests: history and photography.

To begin I had to gather old, or "then," images. These photographs had to be interesting or have some historic value. If I had needed to contact every historical society in the state to view their photographs, this project would have taken a decade. Instead, I sought the cooperation of the New Hampshire Historical Society as my sponsor and spent several days looking at thousands of society photographs. I selected some 160 potential pictures, made photocopies of each one, and organized them by town. With copies in hand, I drove around the state attempting to find the locations of the photographs. As interesting as the old photographs had to be, so too the "now" images had to be compelling. Some of the old images were rejected because I could not find the current locations. In other cases, I discovered that the "now" scenes were not interesting or the old subject matter could not be duplicated.

An example of the later is the photograph of the Derry shoe factory workers. For about a century, the manufacture of shoes was perhaps the most common industry in New Hampshire. Every large community had at least one shoe factory and many small towns had them as well. By the beginning of the twenty-first century, however, New Hampshire shoe factories were gone, victims of foreign competition. I liked the Derry photograph, but what could I use to match it with? I thought of two options. The first possibility was to find another industry as common as shoemaking. I considered something in the high-tech area, but there were too many choices. The second approach was to stay with shoemaking, and I soon learned about Paul Mathews, of Deerfield, who has been making shoes by hand for more than half a century.

I used a similar approach when I found an old photo of a Concord coach being assembled. Does New Hampshire make vehicles today? The Segway, a high-tech scooter, was an obvious choice. Although the long piazza of the Senter House in Center Harbor is long gone, the nineteenth-century porch of the current Oceanic Hotel on Star Island is equally impressive.

There were, of course, many old images that could be duplicated almost exactly today. I have written elsewhere in the book about the Acworth church, a scene little changed in decades. In Hancock, Harrisville, Hampton Falls, Kingston,

Jaffrey, Nelson, and New Boston, among others, are townscapes that look today about the same as they did fifty to one hundred years ago.

Since I have been photographing New Hampshire for more than forty years, I could use some of my own "then" photographs to match with my own "now" images. Examples are the two images of the Old Man of the Mountain site and two of the Rye Harbor fishing shacks, now summer cottages.

Almost all of the "then" images were captured with view cameras, those wooden boxes that used sheet film and required the photographer to focus on an upside-down image under a black cloth. One image, which I could not duplicate because no one knows the exact location, was one of the first photographs made in America. But that was then and this is now. With a few exceptions, the new images were made with various Canon digital cameras. I also used transparency film in a Noblex swing lens panoramic camera and a panoramic Hasselblad Xpan camera.

Some final thoughts. Another photographer would undoubtedly choose different photographs. To a certain extent, I was limited by the "then" images I could find, and as a result some sections of the state are not well covered. But I selected photographs that appealed to me and that I thought would provide a good cross-section of New Hampshire then and now. I went back to places that I had visited while making images for my other two books on New Hampshire, but I also "discovered" new locations to photograph. Although New Hampshire is a small state, the geographical diversity offers limitless opportunities to make interesting images. It has been my joy to travel throughout the state for more than four decades and I'm looking forward to finding new places and people to photograph.

Except where noted, all of the "then" images are by unknown photographers.

Acknowledgments

When this book was just an idea, the New Hampshire Historical Society quickly supported the concept. Old friend and society editor Donna-Belle Garvin was the first to embrace the project and she worked closely with other members of the publication committee, who agreed to grant me permission to use the society's archives to seek out suitable "then" images. Special Collections Librarian David Smolen treated me as a staff member and provided easy access to thousands of photographs. When the new executive director, Bill Veillette, and the new director of collections and exhibitions, Wesley G. Balla, came on board they quickly added their support. In particular, Wes was intrigued with the potential for an exhibit, an event that became a reality in the late winter of 2005.

The society's photographic archive is extensive, but it was not as comprehensive as I needed to produce the book. Also, I knew of "then" images in other collections that I wanted to use.

Matthew Thomas, of Fremont, has been collecting Rockingham County historical data and images since he was a teenager. He provided several images that I could not find elsewhere. Old friend Gary Samson, of Concord, offered images from his collection of Manchester and Concord photographs. I have worked on several projects with Alan Rumrill, of the Historical Society of Cheshire County, and once again he provided assistance with several photographs. I owe a major thanks to the Hillsboro Historical Society, especially to Tom Talpey, who went out of his way to assist with advice, caption material, and site visits, and to Gil Shattuck.

Many other people supported the project with single

images and/or historical information. With apologies to those whose names I might have missed, I am grateful to the following: Velma Ide, Bath Historical Society; William Chapin, Contoocook; Paul Hayward, The Homestead, Sugar Hill; New Castle Town Archives; Jeremy D'Entremont, New Castle; Andover Historical Society; David Ruell, Ashland Historical Society; Jonathan and Nancy Downing, Bartlett and Alton; Colin Sanborn, Fiske Public Library, Claremont; Eric Small, Seabrook Historical Society; David Fleming, Segway Inc., Bedford; Michael O'Connor, Enfield Shaker Museum; Barbara Rimkunas, Exeter Historical Society; Paul Gagnon, Franklin Historical Society; Ed Butler, Notchland Inn, Harts Location; Peter Crane, Mount Washington Observatory; Daniel Fallon, Colony Mill Marketplace; Karen Bakis, PC Connection; Mr. and Mrs. Robert Southworth, North Hampton; Sally Hinkle, Historical New England, Boston; Beatrice Peirce, New Boston; Sylvia Getchell, Newmarket; Mark Sammons, Wentworth-Coolidge Mansion, Portsmouth; Bruce Montgomery, Sandwich Historical Society; Woodward Openo, Somersworth; Jack Noon, Sutton Historical Society; and Jim Bowditch, Tamworth and New London.

Grace Peirce, developed the book's design and helped with other aspects of the project.

Family members also assisted. Daughter Deidre Randall has used her expertise in the marketing and promotion of the book. Grandson Kael Evans Randall, who appears in one photograph, and brother-in-law Rodger Smith accompanied me on shooting trips. My wife, Judith, as usual, accepted my many absences during parts of four years while this book was in the works.

New Hampshire Then and Now

On a late September afternoon, my brother-in-law Rodger Smith and I headed north from Keene en route to one of my favorite places in New Hampshire. Leaves on the hillsides were just starting to turn into colored woodland sentinels amid forests of pine and hemlock. From Route 12, we turned off to Alstead, following the winding road through the town center, past Vilas pool, now drained for the winter, and on to South Acworth. Here we turned left and drove up steep Hill Road for a few miles to Acworth Village and its spectacular Federal-period church.

Take a drive around this hilltop town and you'll wonder when the last house was built there as nearly every one looks like it's part of a Colonial restoration. Houses painted white with black or green shutters evoke memories of a past New Hampshire that has all but succumbed to shopping malls, convenient-stores and gas stations, fast-food restaurants, multi-lane highways with traffic lights every half mile, and farm fields now growing McMansions.

If you don't live there and visit only every few years, as I have, it would appear that Acworth has not changed at all since the church was built in 1821. That's not the case of course. Acworth was chartered in 1766, but had no settlers until a decade later. In 1790, the town had a population of 704. By 1820, Acworth had 1,479 residents, then the population declined slowly but steadily until 1950, when only 418 people were living there.

In the beginning, cheap land attracted settlers, farmers who could be nearly self-sufficient with thick woods for building homes and barns and cleared fields for crops and livestock. So prosperous was the town that by 1821, it could build one of the state's more elaborate churches. The building replaced the town's first meetinghouse, built in 1784. In that era, the meetinghouse doubled as a town hall and as a church and local taxes also supported the "settled" minister. In 1819, New Hampshire's legislature voted to separate church and state, and to end the practice of using town money to pay a minister. The old meetinghouse was then torn down and its parts were used to build a new town house. A new building, now the United Church of Christ, replaced the old meetinghouse.

What led to Acworth's decline in population? There are many causes. After a few years in Acworth, some people moved to other New Hampshire towns or Vermont. With cheap land available in what was then called the West, but today is the Midwest, people began to migrate, especially when the Erie Canal opened in 1825. Later, Civil War soldiers were offered land in the Midwest where the soil, free from New Hampshire's glacier-carried rocks, was fertile and easy to farm. Many soldiers never returned to their New Hampshire towns and others came back only to get their families, pack a few belongings, and head west. Also during the mid-nineteenth century, New Hampshire and Massachusetts developed textile mills, which attracted not only immigrants but also local men and women tired of farming as well as their children who saw no future in a small hill town. The noisy, dust-filled textile mills were, at best, unpleasant places to work, but a worker was paid every week and cities

such as Claremont, Keene, Manchester, and Nashua offered many social diversions not found in the countryside. Life in the city probably seemed better than milking cows in a frigid barn on a windy hilltop.

For Acworth and many other small towns, time seemed to stop. As older residents died and their children moved away, the villages changed little for nearly a century. A few farmers held on, but others died or left. A walk in woods divided by stonewalls tells the story of long-abandoned hay fields and nearby cellar holes.

As I looked at the church and compared my planned photograph with one taken perhaps a hundred years ago, I marveled at how little has changed in the view. There are not many places in New Hampshire where you can see this. There are no ugly power lines or traffic lights, and the town house still needs to be painted: no vinyl siding here. Even today, there is only one paved road into town; if you want to go north to Unity, take the dirt road next to the school.

Acworth will be like this forever. Or will it? From 1950 until 2000, the population doubled to just fewer than nine hundred people. The next twenty years will see a couple of hundred more residents. Will the old school be large enough? Already 80 percent of the working residents commute an average of a half hour to Keene, Claremont, and Walpole. Who is left in town to staff the volunteer fire department when a home or woodlot catches fire?

Acworth then and now offers nearly the same view. But what about the rest of New Hampshire? What was then and what is now? We know what now is, and for some of us, it is not a pleasant picture. What Acworth has managed to avoid by the very nature of its isolation, many parts of this state have accepted as progress. New Hampshire, the fastest growing New England state, doubled in population from 1960 to 2000, so clearly many people from outside New Hampshire are attracted by employment opportunities and our amenities, be they shopping malls and multiplex movie theaters or country fairs and broad fields bordered by woodlands.

Those of us who were born here remember the past, but mostly we were not aware of the changes. Change in most towns does not happen quickly. Certainly the shopping center in the hay field is rapid change but the forces that led to the "demand" for the commercial development were in place long before many of us noticed. The reasons for New Hampshire's growth are not mysterious. Modern north–south highways, a lack of a sales or income tax, a favorable development climate, the ocean and lakes for water recreation, and the mountains for hiking and skiing have all contributed to the state's popularity. By the middle of the twentieth century, New Hampshire also had many abandoned textile mills, large, inexpensive spaces perfect for industrial startups or expansion. Despite its residential, industrial, and commercial growth, New Hampshire is also known for quiet villages like Acworth, New Castle, and Harrisville. The quality of visual arts and crafts also enhances life in New Hampshire. We knew about and appreciated these things, but somehow we forgot that others would be attracted by the very elements of life here that we love.

I lived most of my life in Hampton, a seaside town situated astride the main route between Boston and Portland. Before what is now Interstate 95 was built in 1950, Lamies Tavern in Hampton Center stayed open 24 hours on major summer weekends to serve travelers driving to or returning from the White Mountains or Maine's seacoast. Local owners of shops, gas stations, motels, and restaurants were opposed to the new

highway, fearing a loss of business as travelers sped past the town center on the four-lane highway. Those business owners were correct in their fears. Hampton's business district has struggled even as local traffic on Route 1 has increased to far more than it was before the interstate was built.

Despite its location and first settlement in 1638, Hampton was slow to grow. Founded as a farming community, by 1820, when Acworth had nearly 1,500 residents, Hampton had only 1,100. Unlike Acworth, however, Hampton's population has never declined, but rather has grown steadily. In 1920, Hampton had 1,250 residents and twenty years later the population was 2,137. During the next two decades Hampton boomed as a residential community. By 1960 the population was 5,380, an increase pushed partially by returning World War II servicemen and -women who wanted homes in which to start families and, by the opening of the new super highway that made feasible commuting to Boston area jobs. Hampton's farmlands became developments of small houses, affordable answers to the desires of middle-income folks who wanted their own homes. Acworth's population in 1960 was still declining with 371 residents. In 2005, Acworth still has fewer than 1,000 residents while Hampton has more than 15,000.

I began driving daily to Portsmouth from Hampton in 1968. During the ten-mile commute, I passed through five traffic lights and three of those were in downtown Portsmouth. In those days, Route 1 was still lined with homes, woods, and fields. The same drive in 2005 passes through thirteen traffic lights providing access to five large shopping centers, several fast-food restaurants, two major automobile dealerships, and a number of buildings replacing homes that were torn down for development.

It is tempting to believe that New Hampshire has been a rural state until very recently. Indeed, New Hampshire was best known for farming through the years of the Civil War. As much as 60 percent of the land by 1860 was open fields on which farmers grew corn and hay and raised sheep and cattle. The departure of Civil War soldiers and the development of textile mills began to change New Hampshire in a process that continues today. Textile mills in small towns and large communities were built on many rivers, transforming New Hampshire into one of the most heavily industrialized states in the country. When textiles failed, the old mills became shoe factories, and when shoemaking declined, the mills were converted into residential and office condos or computer and high-tech companies.

Southern New Hampshire, especially the Merrimack Valley, has grown rapidly in the last 50 years. When the old mills were no longer adequate to support business, industrial parks sprouted in fields and woodlands, and to support workers, residential developments and shopping centers were built apace.

With all of this development, how it is that New Hampshire approaches 90 percent woodlands? Faster than developers can pave southern New Hampshire, the trees are growing back on abandoned fields in the central and northern sections of New Hampshire. Since the early twentieth century, the White Mountain National Forest and the Society for the Protection of New Hampshire Forests have protected woodlands, stopping the clear-cutting that once marked nineteenth-century forestry. As farms have closed, pastures and croplands have become overgrown with trees. Drive nearly anywhere outside a city proper and view woods where farms once thrived.

Other than the rapid residential, commercial, and industrial development of the late twentieth and early twenty-first centuries, the most obvious change in New Hampshire has been its reforestation. As an admitted "tree hugger" and with a deep

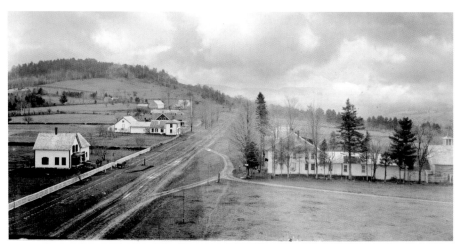

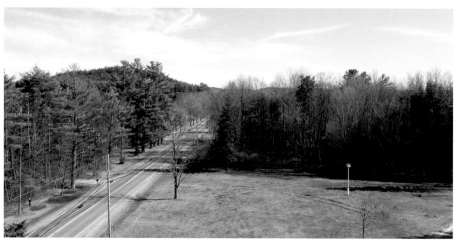

Canaan Street, Canaan, c. 1900 and 2005. One of New Hampshire's more picturesque roads, Canaan Street is lined with old houses. It was once the home of Canaan College, and nearby is Cardigan Mt. School. The open fields that were once common in New Hampshire have grown up with shrubs and trees, in many cases obscuring views. New Hampshire Historical Society collection.

interest in conservation, I have been amazed at the growth of trees. As I set out on this project, I reviewed thousands of old photographs and selected a large number as potential "then" images. My interest in panoramic photography led to my selection of several sweeping vintage views of Bartlett, Barnstead, East Haverhill, Hinsdale, and Lincoln. Not one of these views can be duplicated today even though many of the same buildings seen in the images still exist. Those early photographers stood on cleared hillsides to record late nineteenth-century landscapes. Now the fields are grown with trees and half-mile views are limited to a few feet into the woods.

This 1888 view of East Haverhill differs somewhat from the contemporary scene, but the photograph cannot be duplicated because the hillside from which it was taken is now covered with trees. New Hampshire Historical Society collection.

When this project began, my sponsor, the New Hampshire Historical Society, asked me to show the effects of reforestation. It was a daunting task because once the trees are grown, how does one show the loss of the view other than making an image of a few feet of forest? The above then and now views from the steeple of the old meetinghouse on Canaan Street in Canaan offer a dramatic example of reforestation and the difficulty in explaining the concept. Only by climbing a rickety set of stairs and a ladder to the top of the steeple could I make a "now" image to compare with a "then" view. And Canaan Street is not really forest, just a few fields abandoned

and grown back with hardwoods. Those hardwoods, of course, give this state such brilliant colors during the foliage season. Have we exchanged bucolic views across fields and valleys for a few weeks of autumn color?

It is not just the growth of trees in the countryside that has changed our landscape. New Hampshire cities and larger towns once had streets lined with elm, but disease has killed most American elm. Although utility wires and poles have now replaced city trees in many communities, I still discovered locations in Berlin, Franklin, and Tilton where new trees have eliminated urban views of "then" scenes. Even roadside rest areas, many situated because of the views they offer, are now overgrown with small trees and the vistas are gone. It is clear that trees grow back in time and there are places where a little judicious trimming could again open up broad landscapes.

The other major element of change in New Hampshire, as it has been for every other state, is the automobile. The ability to get into your vehicle and to be many miles away in even a half hour has forever altered the way we live and work. Its location at the end of a paved road has limited growth in Acworth, and I suspect the residents there are happy to live in a rural community, even though a quart of milk, a tank of gas, or going out for dinner requires a drive of a few or perhaps many miles. The automobile has made living in Acworth possible.

The automobile also has made living in Hampton possible. For decades several times daily train service connected Hampton with Boston and Portland. When that service ended, buses plied the same route. Today, with only limited public transportation available, a vehicle is a necessity. Hampton residents can purchase nearly anything within a few minutes' drive. Strip development and major commercial centers make shopping easy, except for the traffic congestion. It is not 1940s Hampton any more.

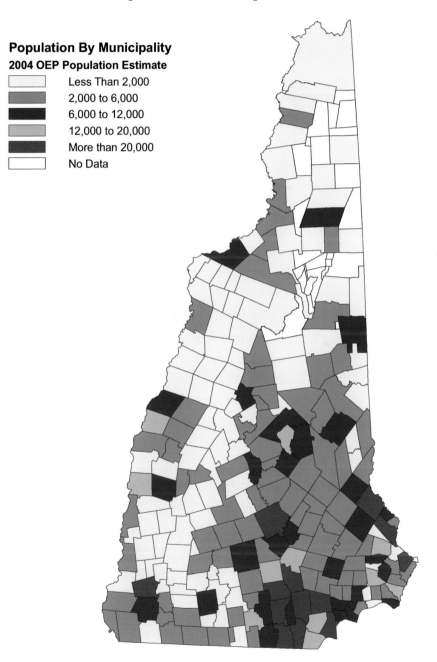

New Hampshire Population

Population By Municipality
2004 OEP Population Estimate

- Less Than 2,000
- 2,000 to 6,000
- 6,000 to 12,000
- 12,000 to 20,000
- More than 20,000
- No Data

The woods behind my 1850s Hampton home were converted into a residential development of Cape Cod–style houses on small lots. A new neighbor expressed concern about his move to Hampton. "I've always lived in the city." he said, "I don't know if I can live in a rural area." *Rural*? Most of Hampton east of Route 1, where I lived, was already developed with houses on small lots, sewer and water lines, and cable television. This man's children could walk to school, the town library, or McDonalds in a few minutes.

Hampton residents must like or at least be able to adapt to the growth because the town's population is increasing. Would any of them move to Acworth? Probably not many from Hampton or anywhere else would choose to move there. Only relatively few people find the quiet beauty of Acworth worth the inconvenience of living so far from the "conveniences" of the twenty-first century.

In the decade of the 1990s, Acworth grew by only thirteen people while Hampton increased nearly a hundred times. All of Sullivan Country, including Acworth, grew by just 4.3 percent as Rockingham County and Hampton jumped nearly 10 percent. Clearly there are two different New Hampshires. Hillsborough, Rockingham, and Merrimack Counties are growing rapidly. They are New Hampshire Now. Coos and Sullivan have much slower growth, and if you drive around there, you'll see New Hampshire Then. Look at the map on the previous page of New Hampshire's 2004 population. Western and northern parts of the state are the least populated; the southern and eastern sections are where the development action is.

Of course it is not wrong to live in one part of the state instead of another, but ask anyone from a small town such as Acworth and he will tell you he lives there because of the quality of life found in a place that really is rural. Ask a Hampton resident why she lives in that town and chances are she'll talk about the schools, nearby shopping, and a relatively easy commute to a high-paying job.

In late September, when Rodger and I drove through Alstead and up the hill to Acworth, it was one of those perfect New Hampshire days. Had we waited two weeks to visit Acworth, our route would have been less direct. Heavy rains in early October began to fill rivers to flood stage. Late on the night of October 8, Alstead police began warning some residents along Route 123 to evacuate, because Warren Brook was rising and flooding was possible. Most people heeded the police and left their homes. Shortly after seven the next morning, the rising water breached the dam at Lake Warren and roared down the book, washing out a culvert, and leaving several miles of Route 123 in ruins. Thirty-six homes were destroyed, two dozen others were damaged, and four people were lost in the rushing waters. Downstream, even the city of Keene experienced flooding, although no major damage.

Up on the hill, Acworth had some road washouts, but mostly experienced just heavy rain.

In 1978 I drove up to Acworth for the first time. I was gathering images for my first book of New Hampshire photographs. Schoolchildren were playing on the broad lawn in front of church and I made a picture of them for my book *New Hampshire Four Seasons*. Nearly two decades later, a photographer friend went to Acworth and saw the scene of the children playing in front of the church. "Can I take a picture?" he asked the teacher. Well, you can, he was told, "but Peter Randall's already done it"!

In Acworth maybe things don't change.

New Hampshire Then and Now

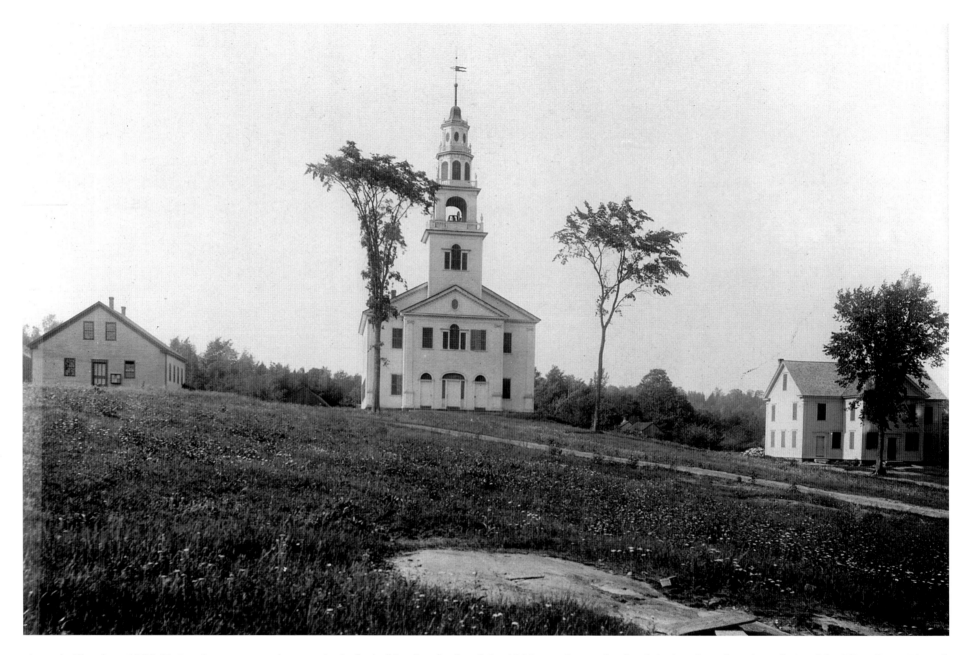

Acworth Church, c. 1900. Facing the common and appropriately flanked by the school and the 1821 town house, the church is thought to have been designed by Elias Carter. Erected in 1821, with such characteristic Federal elements as Palladian windows, fluted Ionic pilasters, oval windows, and decorated cornices, its graceful spire houses an 1828 Revere-firm bell. New Hampshire Historical Society collection.

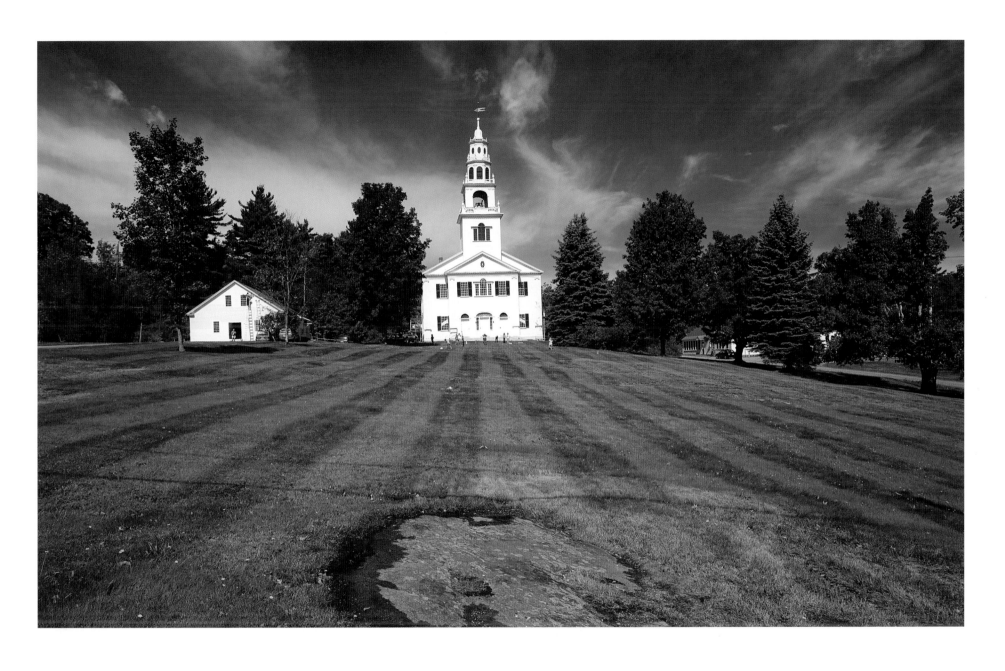

Acworth Church, 2005. Perched high on a hill in the center of this small town of fewer than 900 residents, the building remains one of the most picturesque of its type in New England. As they have for decades, local schoolchildren play on the broad lawn. The town hall is at left, the school is behind the trees at right.

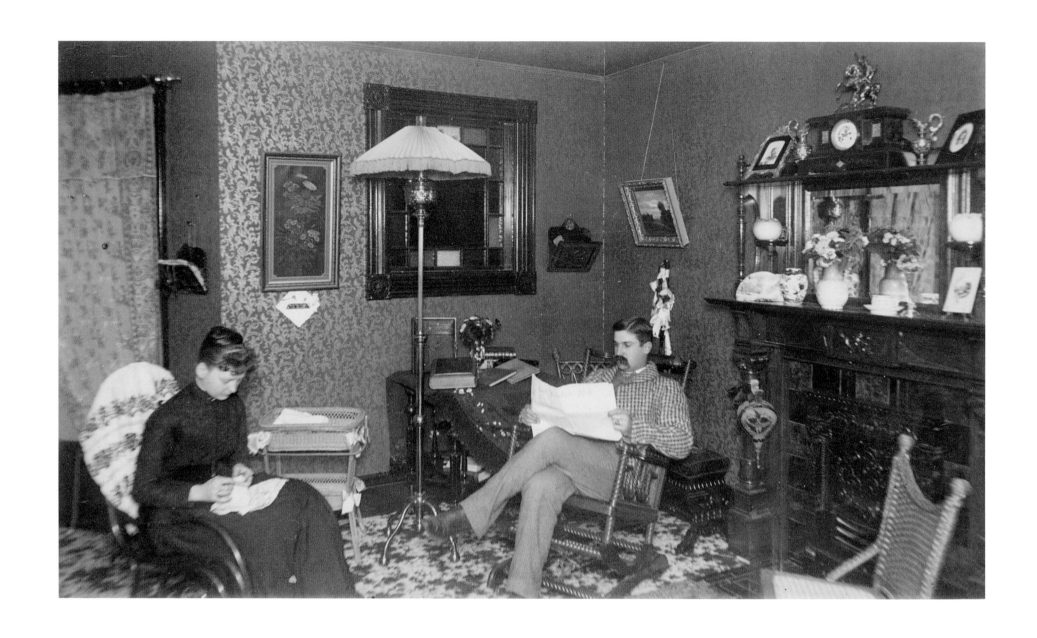

Victorian Parlor, unidentified home, Alton, c. 1890. The parlor was where mother and father spent their evenings, reading, sewing and pursuing other quiet activities. Colorful, multi-patterned rugs, drapes, and wallpaper indicated county affluence. The fireplace may have burned coal. New Hampshire Historical Society collection.

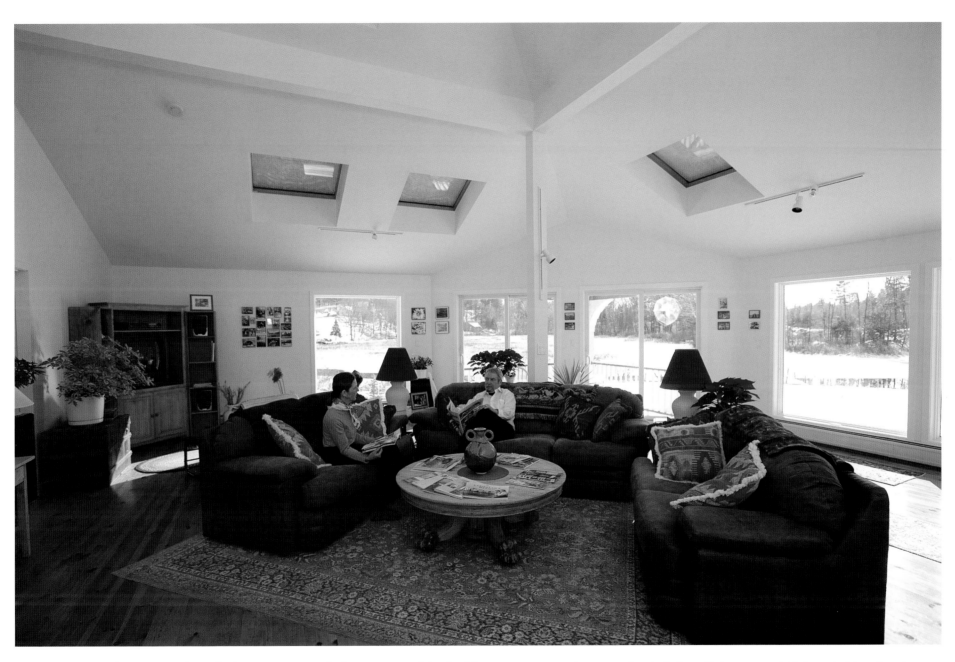

Downing House, Alton, 2005. The parlor has given way to the living room and, in the 21st century, to a spacious room that includes a dining area and kitchen. Architect Jonathan Downing, who designed the house, and his wife Nancy relax in a bright room with skylights, angled walls, and large windows that frame a marsh with a small stream. The pale yellow walls and ceilings allow the Oriental rug and furniture to accent the decor.

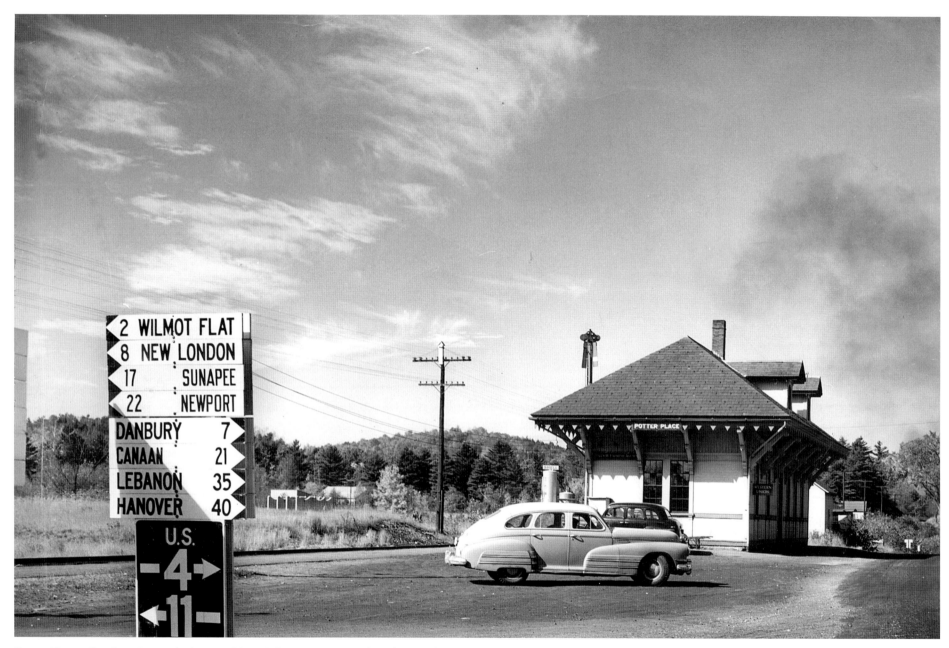

Potter Place railroad station in Andover, c. 1940s. There was a time when this was busy as summer folk arrived from cities to the south to spend carefree days boarding with local farmers, and small inns. When this the photograph was taken in the 1940s, the heyday of the railroad was drawing to a close, but this village was still a major highway intersection. New Hampshire Historical Society.

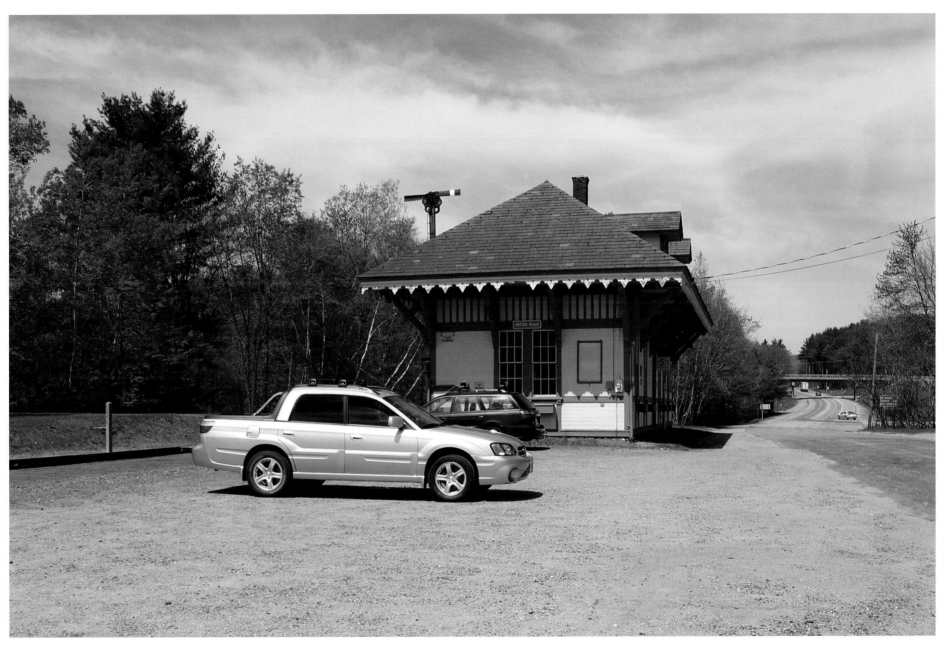

Potter Place railroad station in Andover, 2004. The Potter Place station is now maintained as a railroad museum by the Andover Historical Society, and even the highway, seen in the background, has bypassed this location.

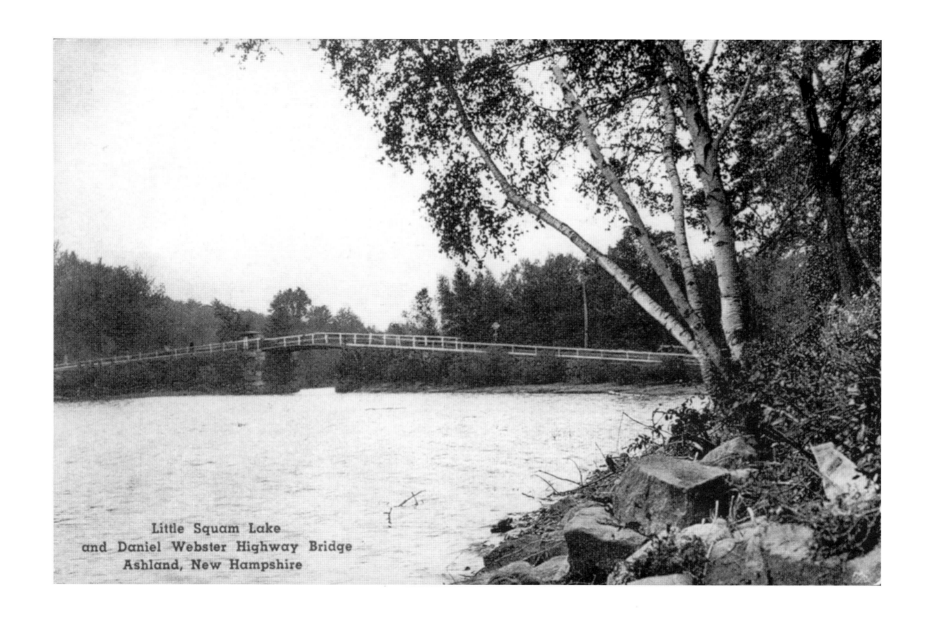

Little Squam Lake
and Daniel Webster Highway Bridge
Ashland, New Hampshire

Daniel Webster Highway Bridge, Ashland, c. 1950. This little bridge over an outlet to Little Squam Lake was once part of Route 3, the Daniel Webster Highway, a major north-south road through town. In the mid-1980s, the highway was rerouted and the bridge then served local traffic to a marina, the town beach, and residences. The bridge was deteriorating, however, and it was closed. Later a Bailey bridge was placed over its deck. In 1985, the town meeting voted to spend $1.1 million to replace the bridge with a modern one. Ashland Historical Society collection.

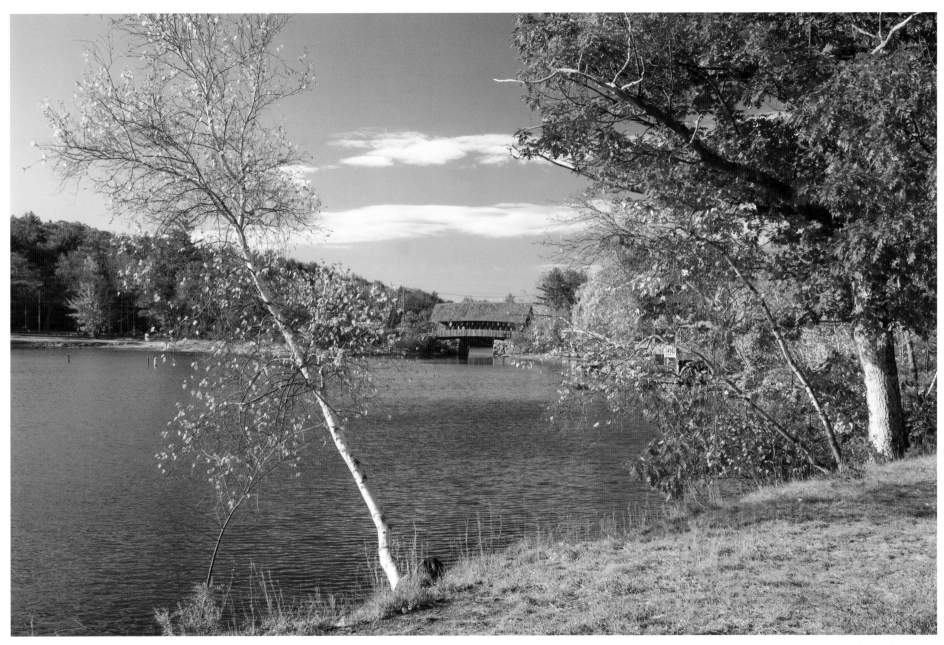

Covered bridge, Ashland, 2003. In 1987, Ashland residents convinced the selectmen to reconsider the decision to construct the modern bridge. Citizens suggested a wooden bridge to be designed and erected by Milton Graton of Ashland, a nationally known covered-bridge builder. After a study, the 1988 town meeting voted to scrap plans for the $1.1 million bridge in favor of a one-lane wooden one at a cost $189,000. The new bridge opened to traffic in May 1990.

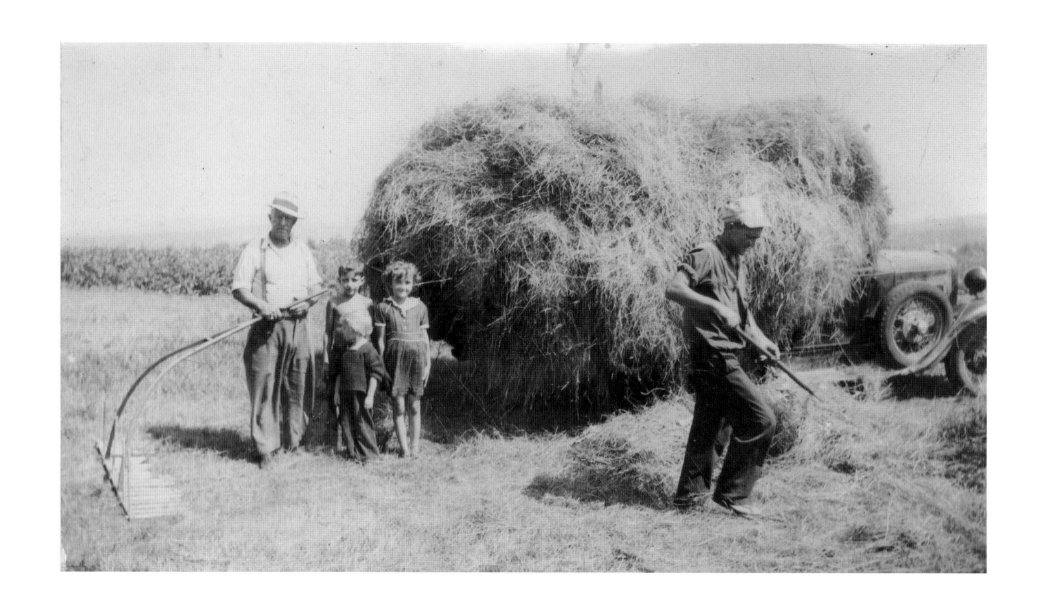

Haying the old fashioned way in Barnstead, c. 1944. Subjects and photographer unknown. New Hampshire Historical Society collection.

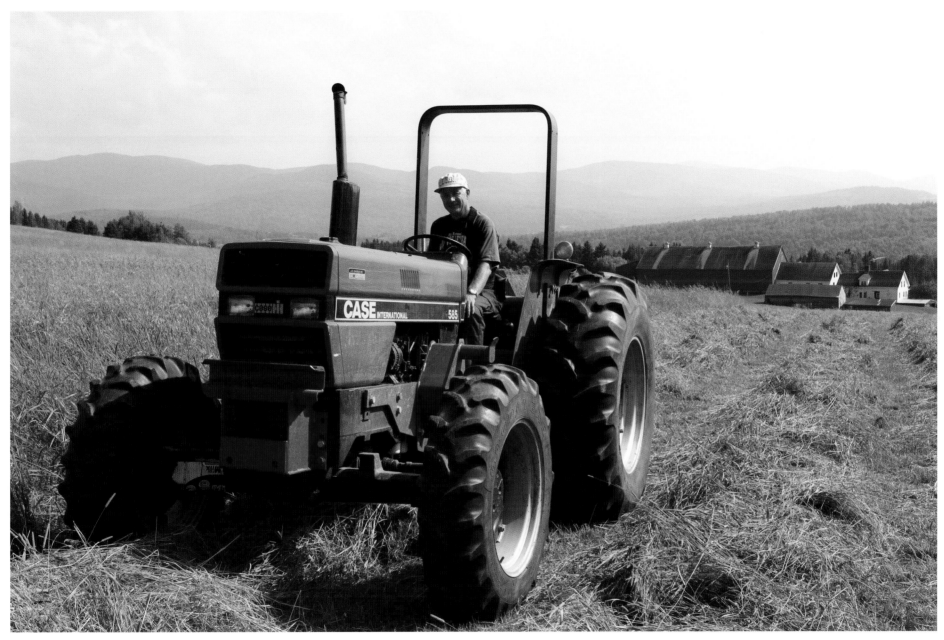

Bill Kezar haying one of his fields above the family homestead in East Colebrook. Mechanized equipment has made haying much easier, but farming remains hard work. East Colebrook's many dairy farms are now closed and fields are growing back to trees.

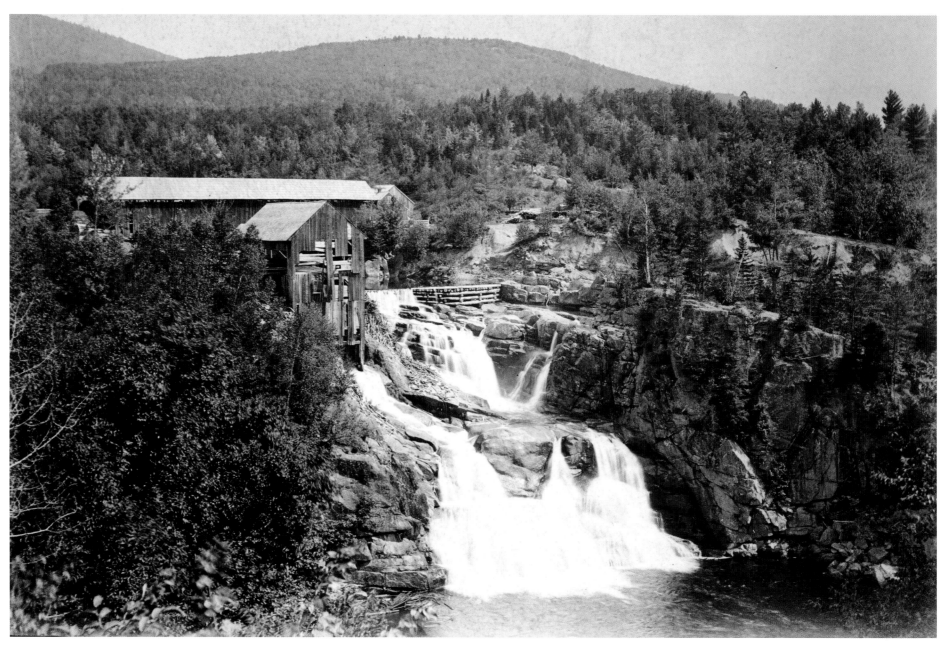

Goodrich Falls, Bartlett, photographed by amateur James Wood Allen (1858-1940), of New Bedford, Massachusetts, September 1887. This 80-foot waterfall on the Ellis River was a popular tourist spot in the 19th century. New Hampshire Historical Society collection.

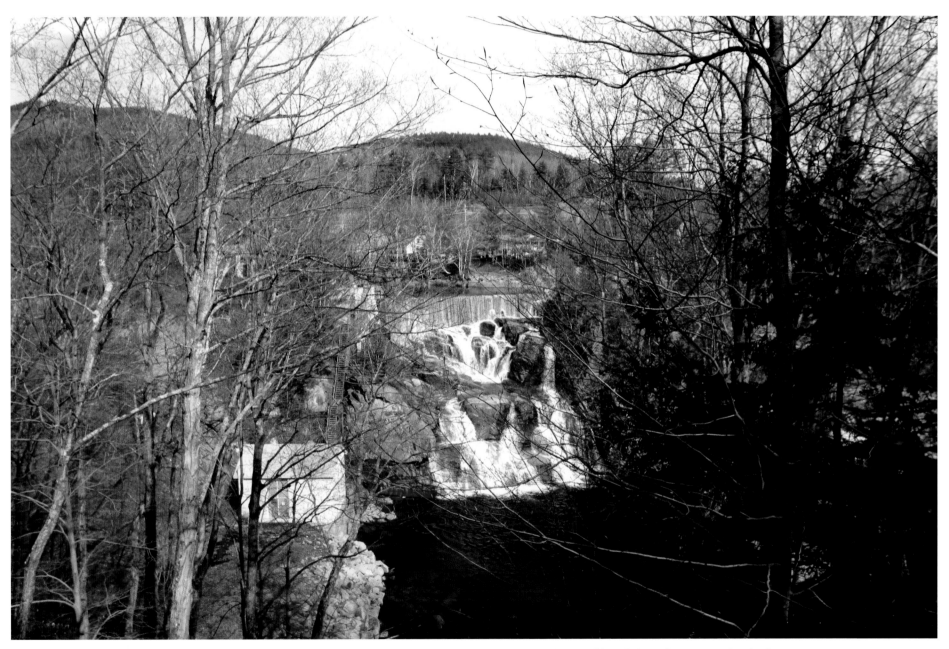

Goodrich Falls, Bartlett, 2004. Because the falls are near Jackson village, many people think they are in Jackson. Although located just west of and adjacent to Route 16, the falls remain hidden from drivers speeding by on the wide highway. A hydro electric plant, established here in 1950s, is owned by Goodrich Falls Hydro Electric Company.

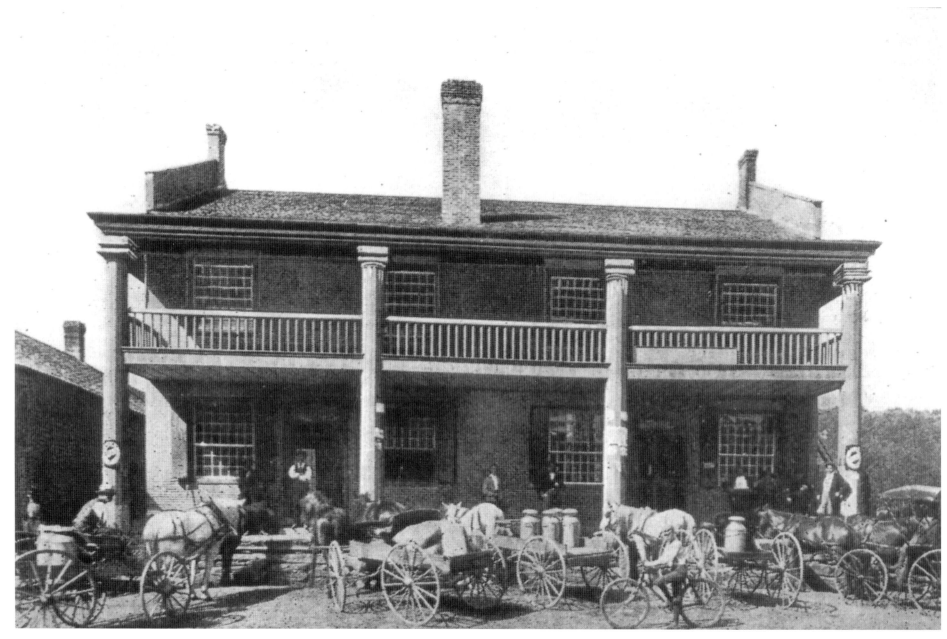

The Old Brick Store in Bath, built c. 1804 and rebuilt in 1824 after a fire, c. 1890. Listed on the National Register of Historic Places, the store has been supplying the small community with general merchandise continuously for 200 years, and it was also the post office until 1943. Bath Historical Society.

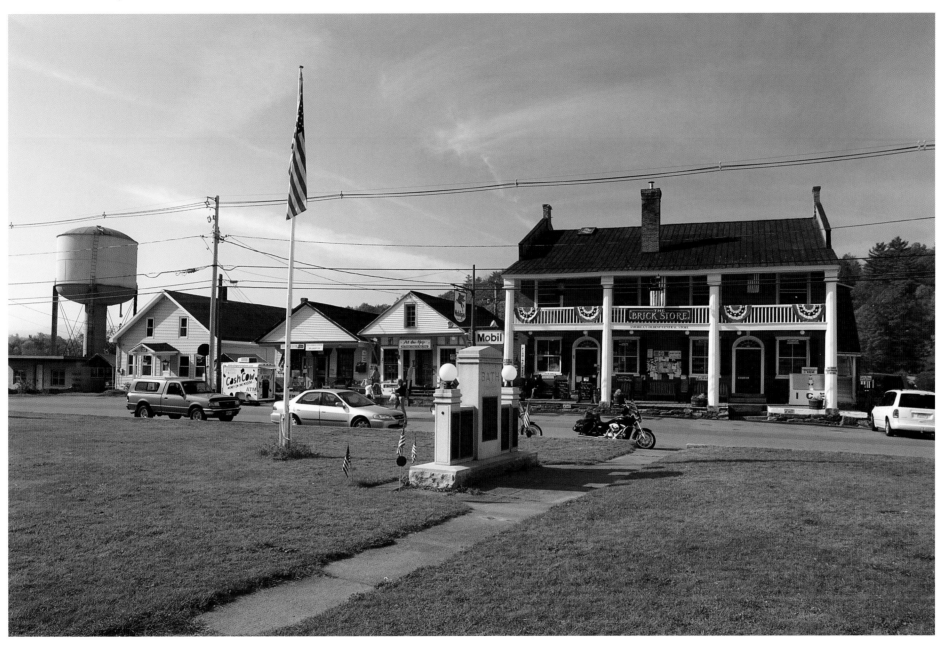

The Old Brick Store, Bath, 2004. While the store still serves the small community as it has for some 200 years, it has also become a tourist attraction, selling gifts and nostalgic items. On the day of this photograph, a tour bus had stopped by on its way from New York state to Bar Harbor and the passengers were enjoying a bit of "old" New England.

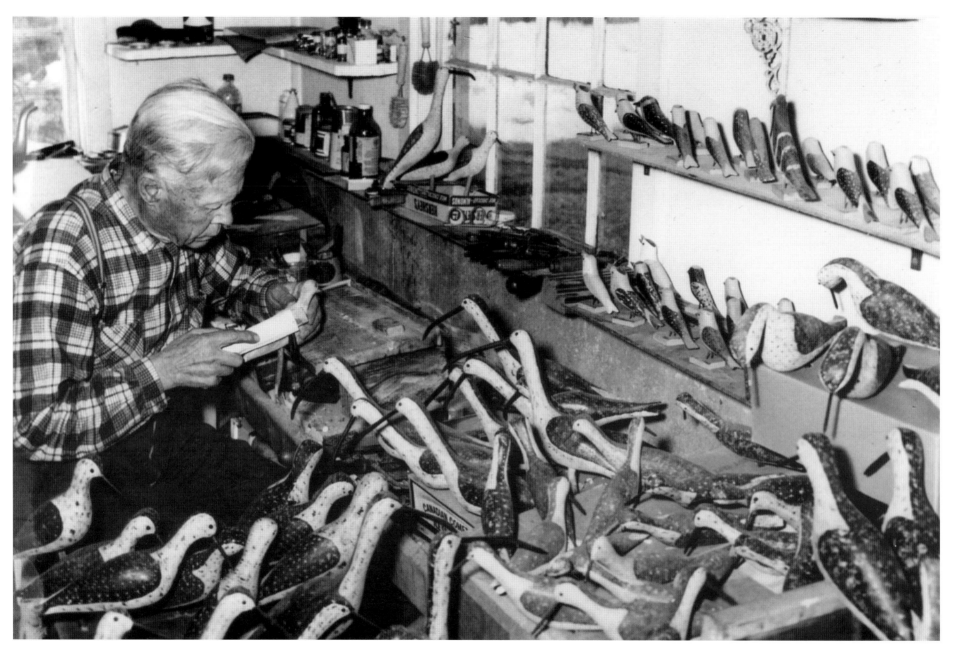

Hervey Beckman of Seabrook (1873-1963) was one of many near legendary decoy carvers who worked in this seacoast community. Beckman's birds are highly collectible now, but were carved and painted in the style of working decoys such as the yellowlegs shown here. Seabrook Historical Society.

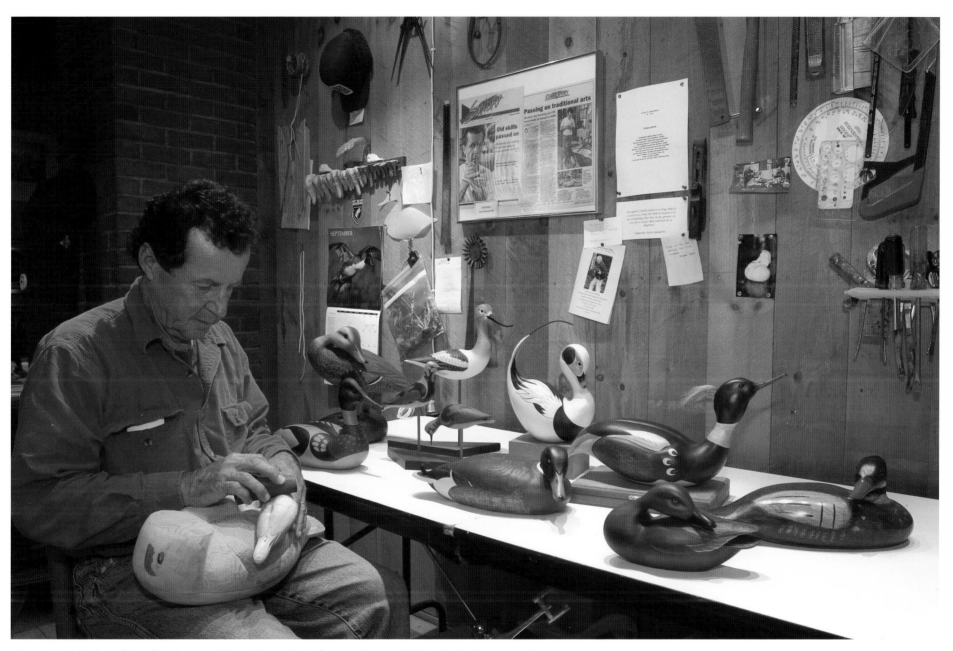

Carver Fred Dolan of Strafford is one of New Hampshire's finest craftsmen, 2005. His birds, more stylistic than would be used for working decoys, have been exhibited and awarded prizes in New Hampshire and national competitions.

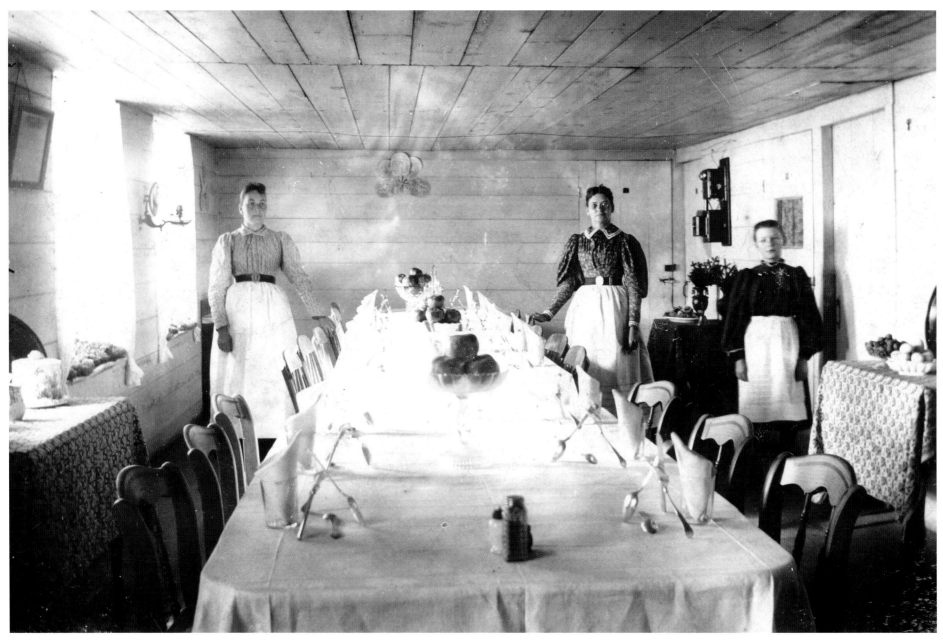

The Prospect House, Benton, 1896. Built in 1860, then called the Tip Top House and later Dartmouth's Summit Camp, the Mt. Moosilauke summit house was ultimately lost in a 1942 storm. Summer tourists once traveled a carriage road to the summit. Left to right are Mrs. John Foss (Louisa Flanders), Mrs. C. O. Whitcher, and Mrs. Whitcher's daughter Kate. New Hampshire Historical Society collection.

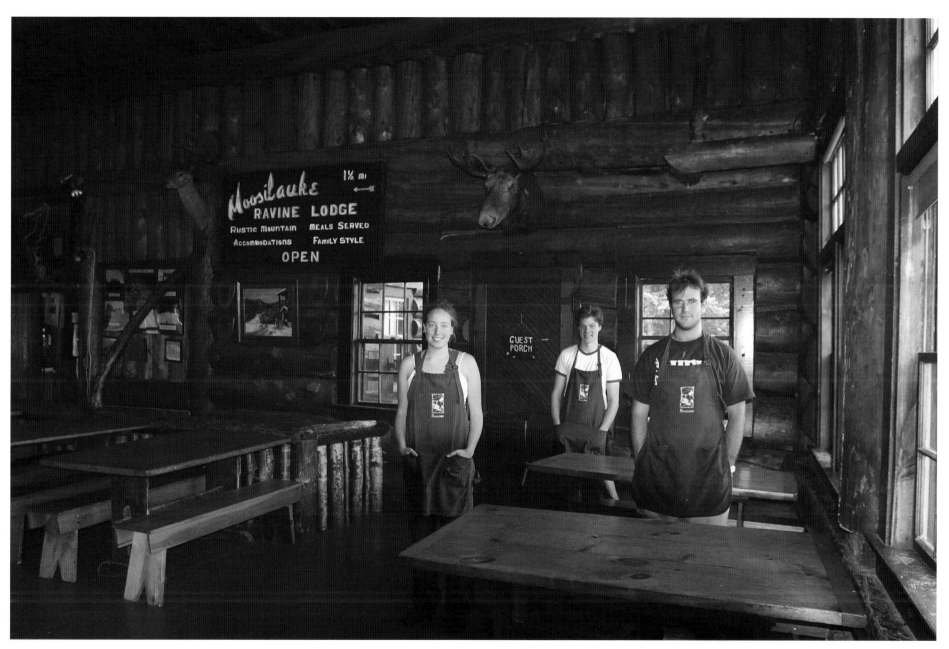

The Moosilauke Ravine House, Benton, 2003. Although not located on the summit of Mt. Moosilauke, the lodge overlooks the mountain that rises just beyond the front door. Built in 1938 at an elevation of 2,450 feet and operated by Dartmouth College, the lodge provides accommodations and is the center for hiking in the region. Left to right are Lydia Smith, Saulius Kliorys, and George Storm.

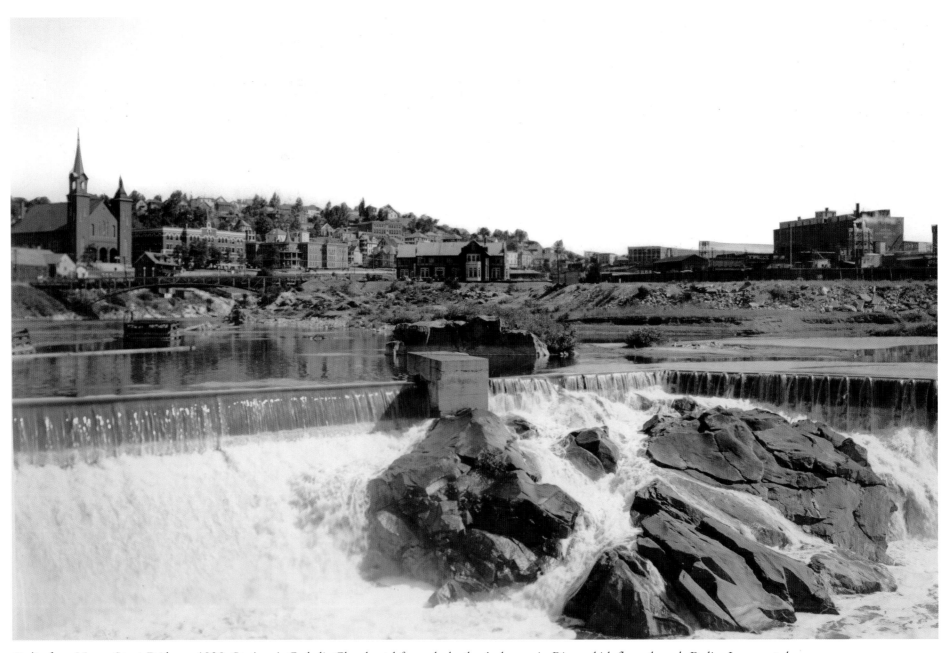

Berlin from Mason Street Bridge, c. 1920. St. Anne's Catholic Church, at left, overlooks the Androscoggin River, which flows through Berlin. Incorporated in 1829 and originally a logging community, Berlin soon became a booming mill town, attracting large numbers of French Canadians, Scandinavians, and other ethnic workers. New Hampshire Historical Society collection.

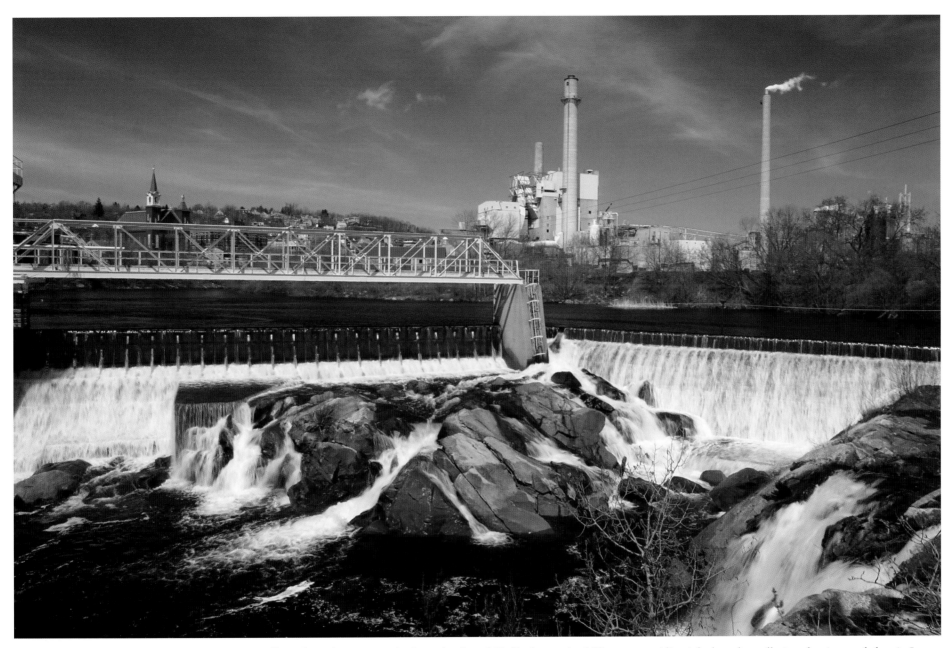

Berlin from Mason Street Bridge, 2003. Paper mills, such as the one at right, have dominated Berlin for nearly 150 years, providing jobs but also polluting the river and the air. In recent years the paper companies have undergone hard times, while other industries have closed or moved away. As a result, Berlin and many other North Country communities have suffered economically, losing population while the rest of the state continues to grow.

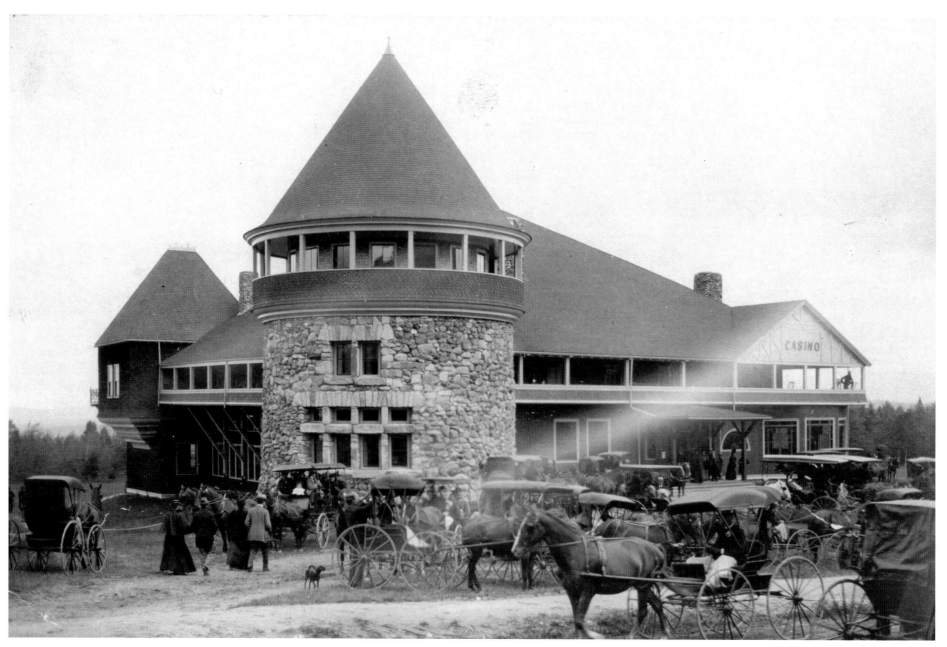

The Maplewood Casino, Bethlehem, c. 1890. When the railroad came to town in 1867, the sleepy village north of the White Mountains became a tourist boomtown. Soon seven trains a day brought guests to the 30 local hotels and inns. One of the largest was the Maplewood, built 1875-78, where families stayed for the whole summer and the fathers came from the city to visit on weekends. The casino was built in 1889, complete with a theater, dance hall, bowling alleys, and golf clubhouse. New Hampshire Historical Society collection.

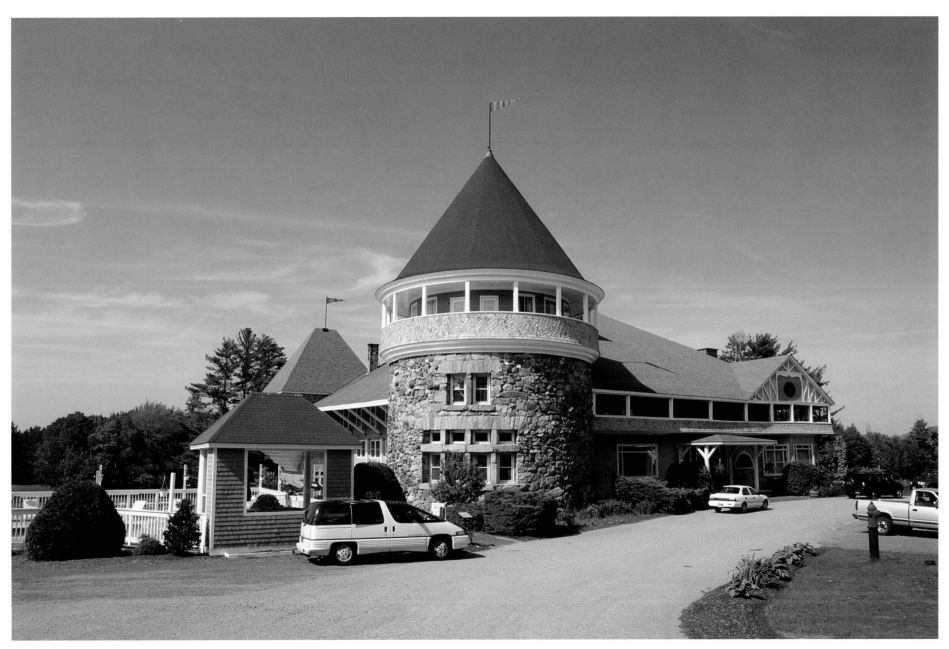

The Maplewood Casino, Bethlehem, 2004. By the 1930s, the golden years of the White Mountains were ending due mostly to the automobile, which made travel more flexible than could trains. Most tourists preferred to stay in cabin colonies and those hotels that didn't close were destroyed by fire, including the Maplewood, burned in 1963. The casino survived the fire as did the 1914 Donald Ross golf course. In 1988 the casino was restored and in 2005 the new owner was planning to improve and lengthen the golf course.

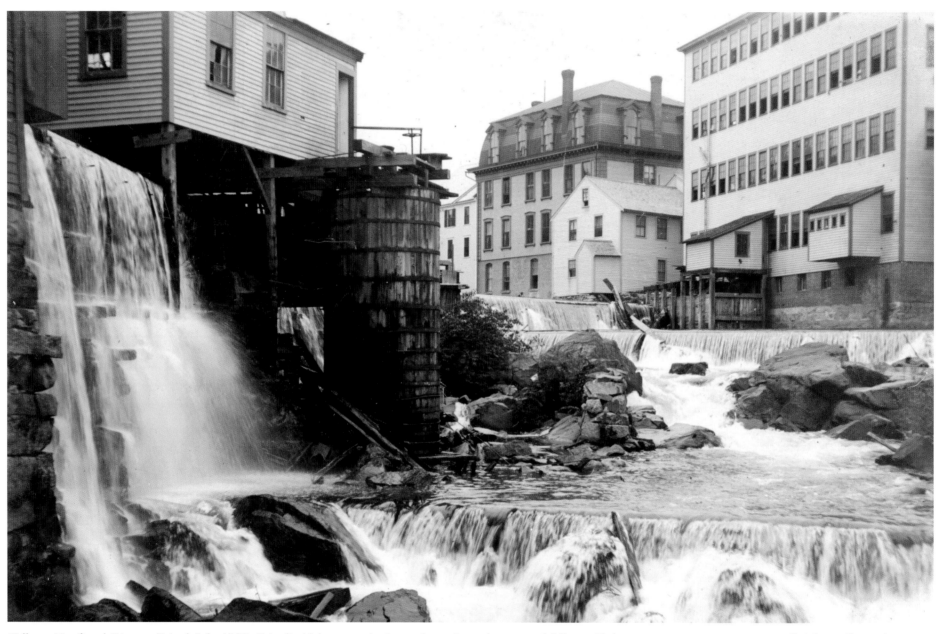

Falls on Newfound River at Bristol, July 1898. Bristol's 18th century businesses began here where natural falls provided water power to operate various mills. The Calley and Currier Company, a crutch manufacturer, at left, began in 1880. The c. 1860 Abel Block, center, housed the post office and other shops. The small building was a grist mill, c. 1794-1804. In 1894, the Bristol Improvement Company built the large structure at right for Nathaniel Bartlett and Son, shoe manufacturers. New Hampshire Historical Society collection.

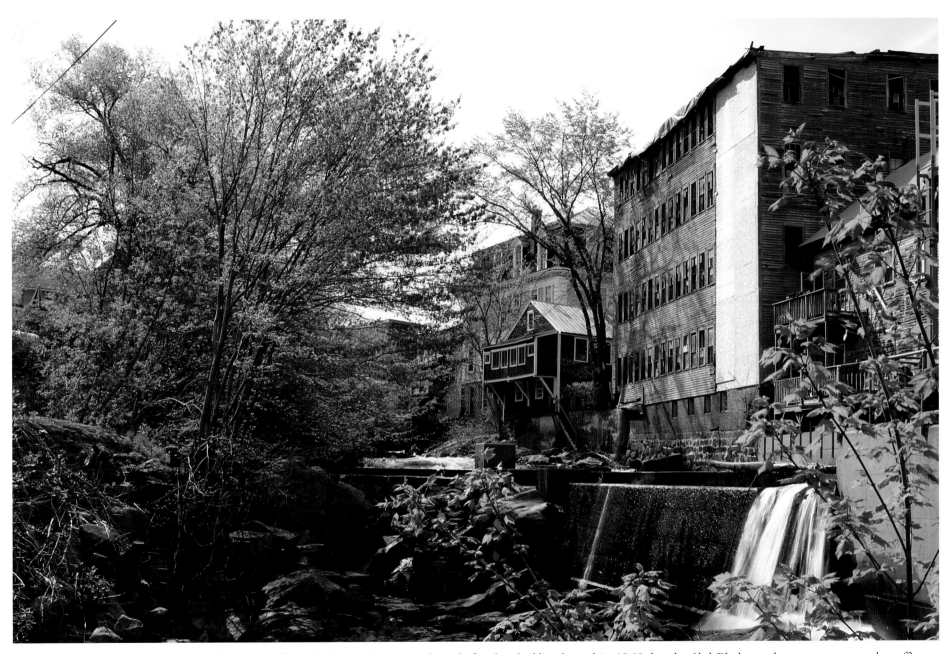

Falls on Newfound River at Bristol, 2004. The Calley and Currier Company relocated after their building burned in 1960, but the Abel Block now houses a restaurant, law offices, and other businesses. The little red building is a residence, but the old shoe factory has long since closed and the building sits unused.

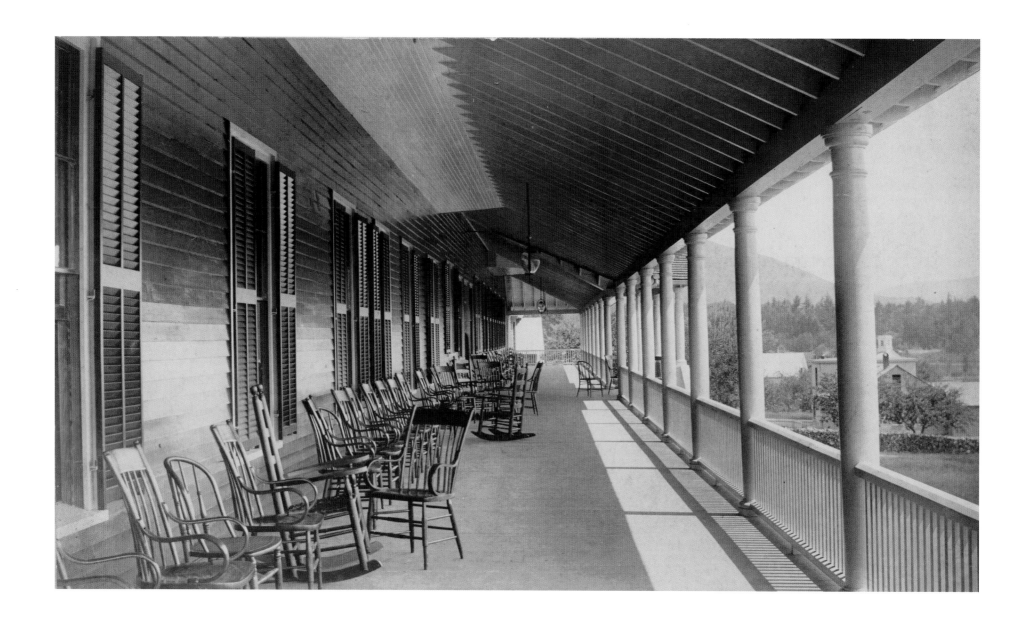

Lakeside piazza of Senter House, Centre Harbor. Photograph by F. W. Fowler, Salisbury, Massachusetts. c. 1890 The large 19th-century hotels in the Lakes Region and White Mountains of New Hampshire usually had long piazzas where guests could read or rock away the hours while enjoying the scenery. From this hotel, summer visitors such as poet John Greenleaf Whittier could view boats on Lake Winnipesaukee. Built in 1887-88, the Senter House burned in 1919. New Hampshire Historical Society collection.

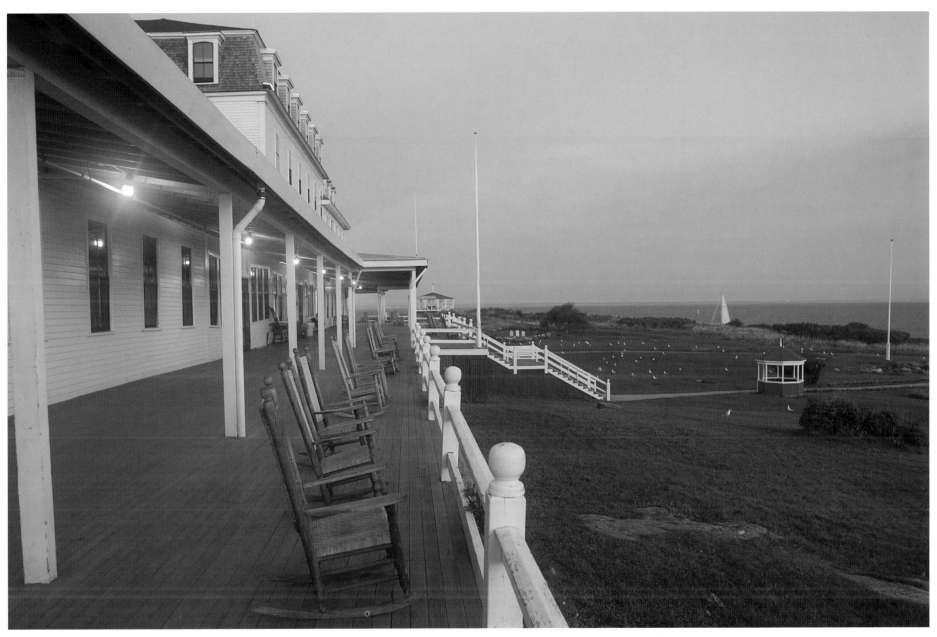

Oceanside piazza, Oceanic Hotel, Star Island, Isles of Shoals, Rye, 2004. Conferees at the Star Island Conference Center fill these rocking chairs most of the day during the summer season. This long porch is one of the few 19th-century piazzas left in New Hampshire. In this early morning photograph, only the herring gulls on the lawn are enjoying the view.

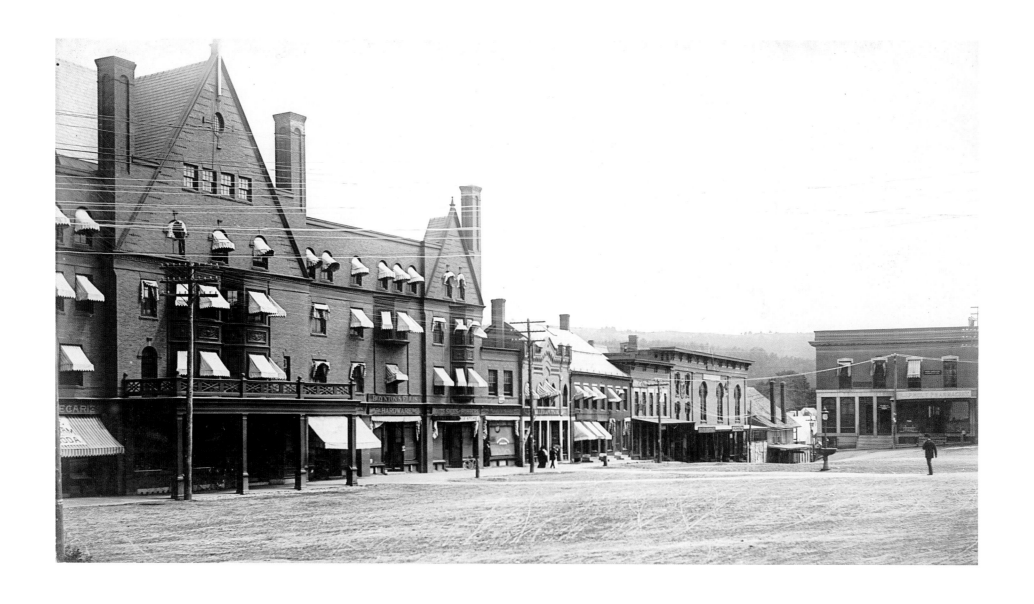

Hotel Claremont, Tremont Square, Claremont, photographed by W. A. Wright, Ayer, Massachusetts, July 1896. The Hotel Claremont was built in 1892 by a group of local men. The building replaced the old Tremont House which had burned in 1879. The Hotel Claremont had a fire in 1898, which was contained on the uppermost floors. Following this fire, the building was purchased by William Henry Harrison Moody of Claremont, who rebuilt the upper story and eventually renamed it Hotel Moody. A Claremont boy, Moody made his fortune in the shoe industry in Nashua and Boston. He retired for health reasons and returned to Claremont, where he purchased a large farm and raised race horses. Upon regaining his health Moody again entered the business community with the purchase of the hotel. New Hampshire Historical Society collection.

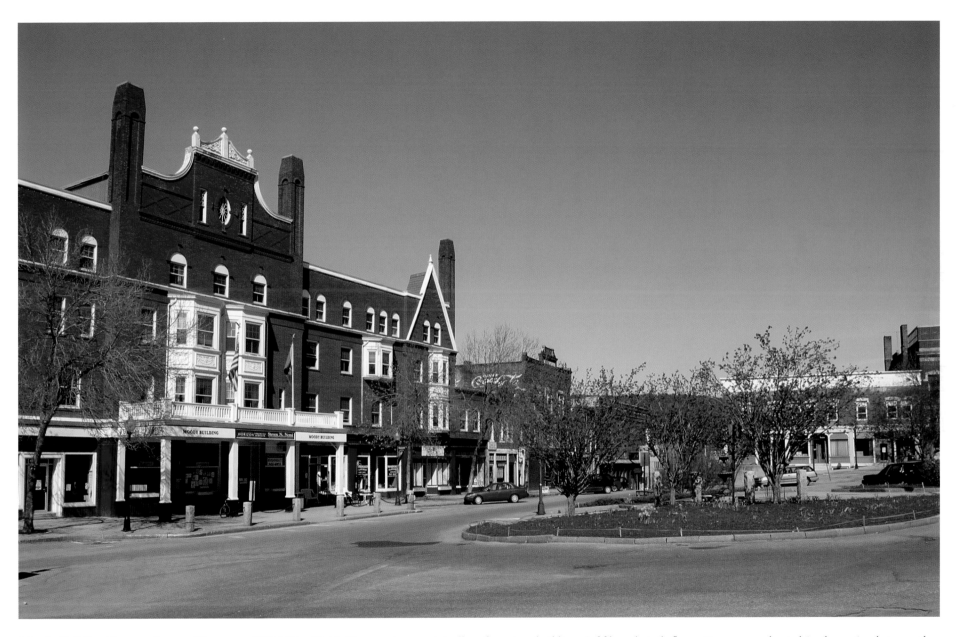

Moody Building, Tremont Square, Claremont, 2004. The Hotel Claremont was originally a four-story building. A fifth and sixth floor attic area was located in the section between the two central chimneys. This area had a cross-gable roof with gables facing each cardinal direction. It was this attic that had the fire in 1898. When Moody rebuilt the hotel, he changed this area to its present configuration with the oval window flanked by two long, narrow windows and capped by the curved Queen Anne pediment. The hotel closed in the 1970s and the building is now used for shops and offices.

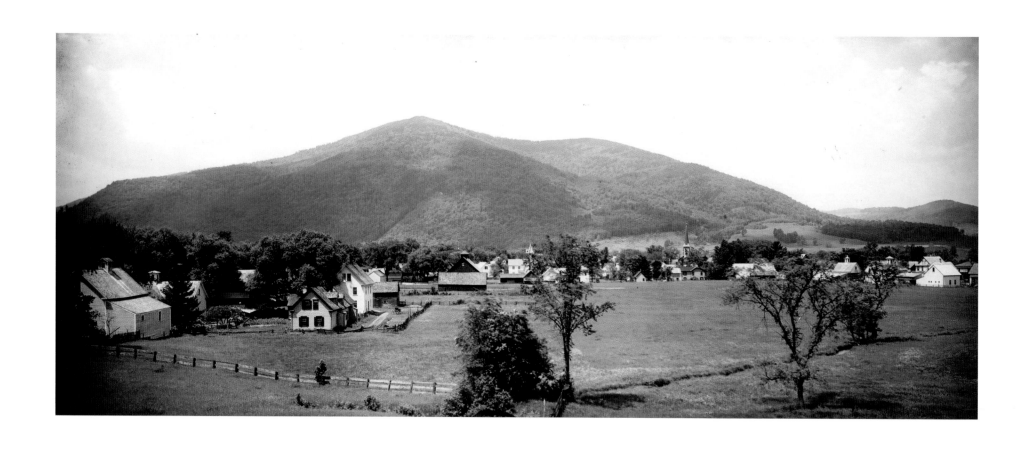

Colebrook c. 1910. The village spreads out behind farmlands in this panoramic view. Colebrook has long been the shopping and commercial center for a large section of northern New Hampshire and Vermont. New Hampshire Historical Society collection.

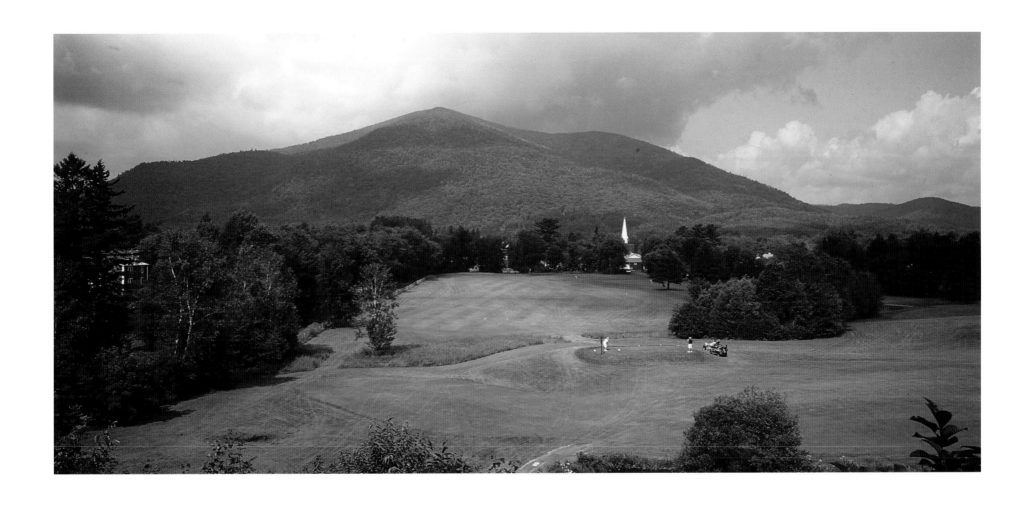

Colebrook, 2004. The Colebrook Country Club now occupies the former farmland. Vermont's Mt. Monadnock rises in the background. Open fields on the mountain, shown in the opposite page photograph, are now covered with trees.

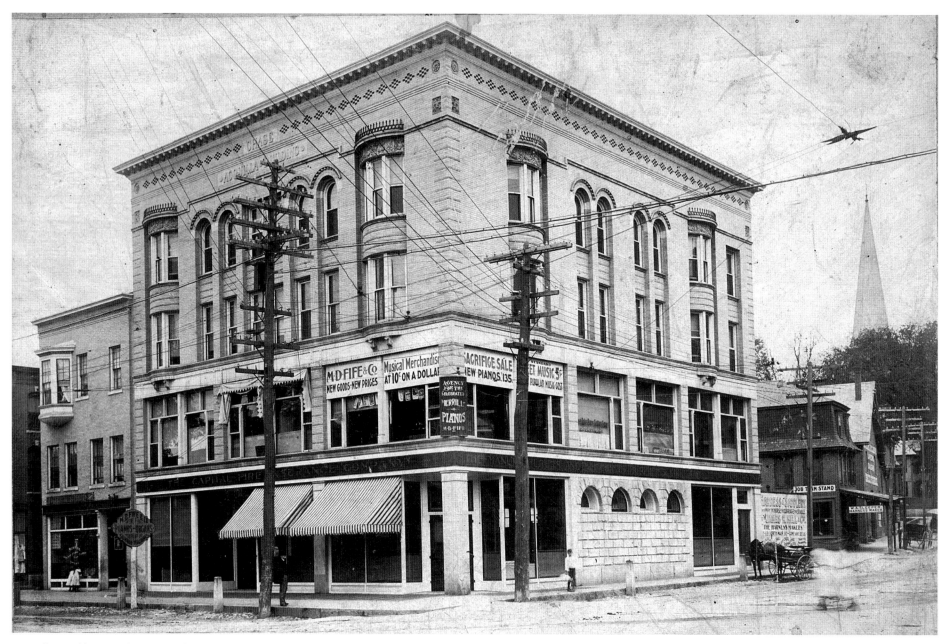

Acquilla Building on the corner of North Main and Pleasant Streets in Concord, c. 1899. Designed by Manchester architect William Butterfield in 1894, this is the first building in Concord to be erected with a new construction method: the use of interior steel framing that made possible the modern 20th-century skyscraper. The yellow sandstone brick and terra-cotta ornaments also contrasted with the traditional red brick and granite trim of the rest of the 19th-century Main Street. New Hampshire Historical Society collection.

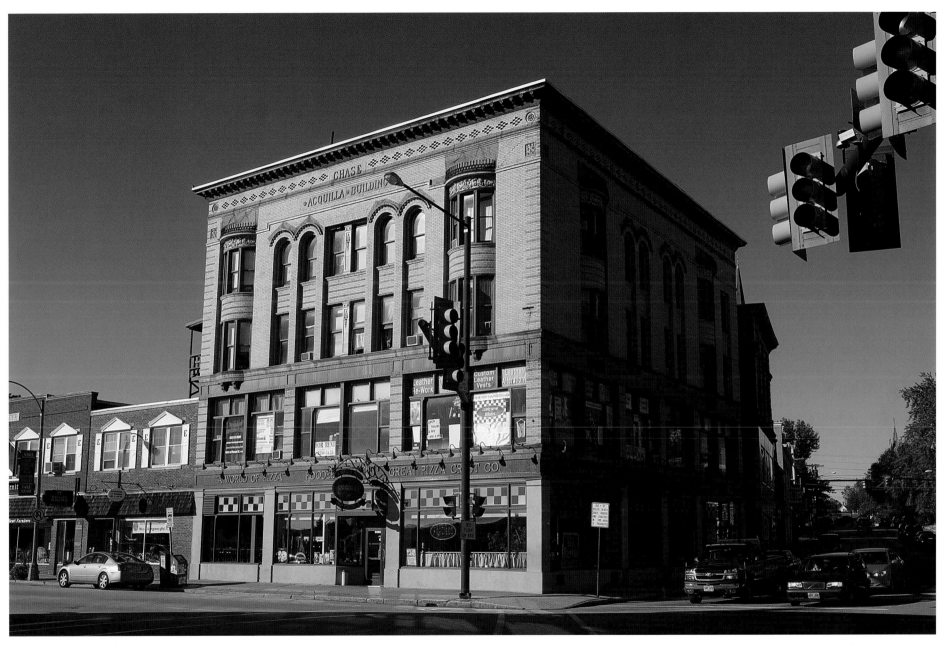

Acquilla Building on the corner of North Main and Pleasant Streets in Concord, 2004. This seemingly unremarkable building is only one of many such New Hampshire structures that could have been selected for this book. The name caught my eye a number of years ago. As suspected, "Acquilla" recalls the first Chase in America, from whom all Chases are descended, including the author. The building was erected by the heirs of James H. Chase, who selected a then modern building technique to remember their 17th-century ancestor.

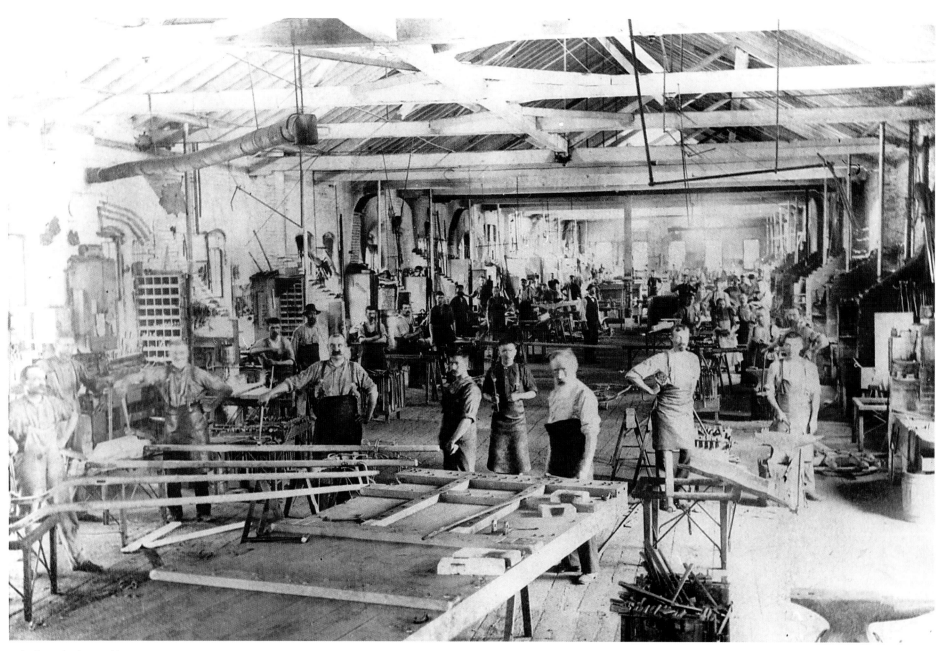

Blacksmith shop, Abbot-Downing Company, Concord, c. 1880. One of the most common objects in a Western movie is the stagecoach, a vehicle built by the Abbot-Downing Company of Concord. This is one of the few views inside the company's large factory. Outfitted and brightly painted, the coaches were loaded onto railroad cars and shipped west. Ironically, the railroad eventually doomed the company and the coaches are now collector's items. New Hampshire Historical Society collection.

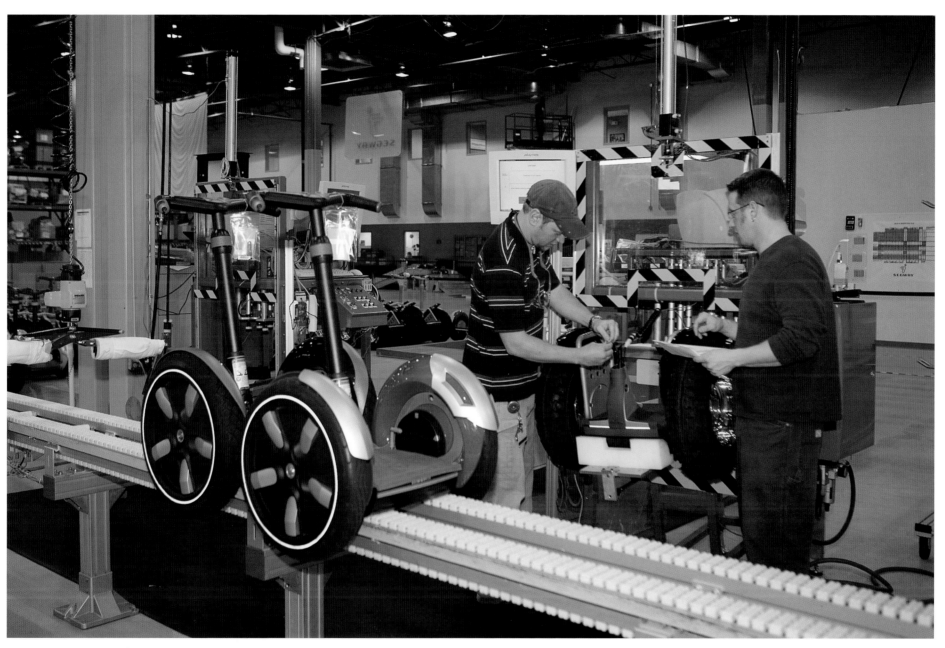

Segway Company, Bedford, 2005. New Hampshire does not have much of a history as a manufacturer of vehicles but today the Granite State makes one of America's most unusual modes of transportation, the Segway. Developed by inventor Dean Kaman, the two-wheeled, self-balancing electric scooter was designed to provide personal transportation in pedestrian areas. It is used by postal and warehouse workers, police, and security officers as well as private individuals. Here Al Glass, left, and Dave French test a new off-road model.

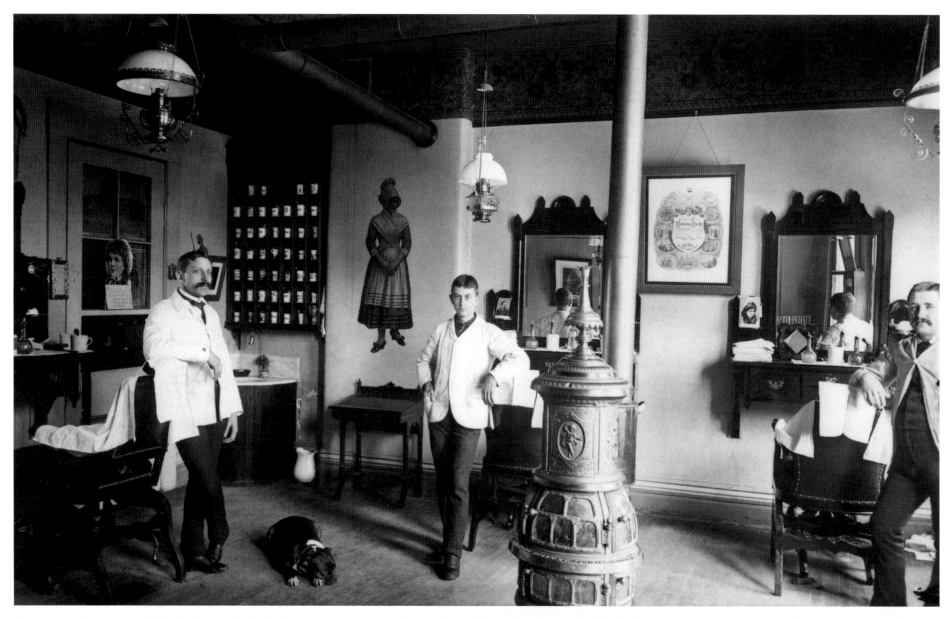

Barber shop, Concord, c. 1898. Until recently, the barbershop was a bastion of masculinity. Men gathered at the local barbershop, whether or not they needed a haircut, to chat, discuss politics and sports, or reminisce about the good old days. The slapping of razor strops, the smell of bay rum, and sometimes the tears of small boys getting their first haircut marked many a Saturday morning. When this photograph was taken, Concord had 21 barbers, or hairdressers, as they were called then, all of them men. The corner cupboard holds the shaving mugs of regular customers. New Hampshire Historical Society collection.

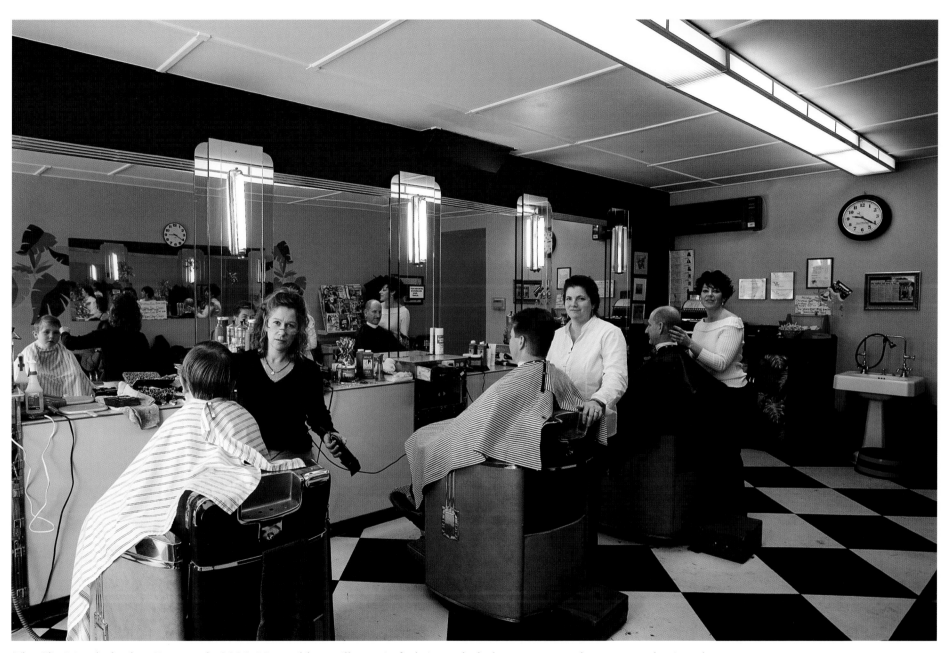

The Clip Joint, barbershop, Portsmouth, 2005. Men and boys still come in for haircuts, the barbers are women, the razors are electric, and customers can make an appointment to eliminate waiting. A traditional barbershop for decades, the Art Deco Clip Joint has had only women barbers for 20 years. Left to right are Colleen Baker, Jannine Moran, and Julie Estes.

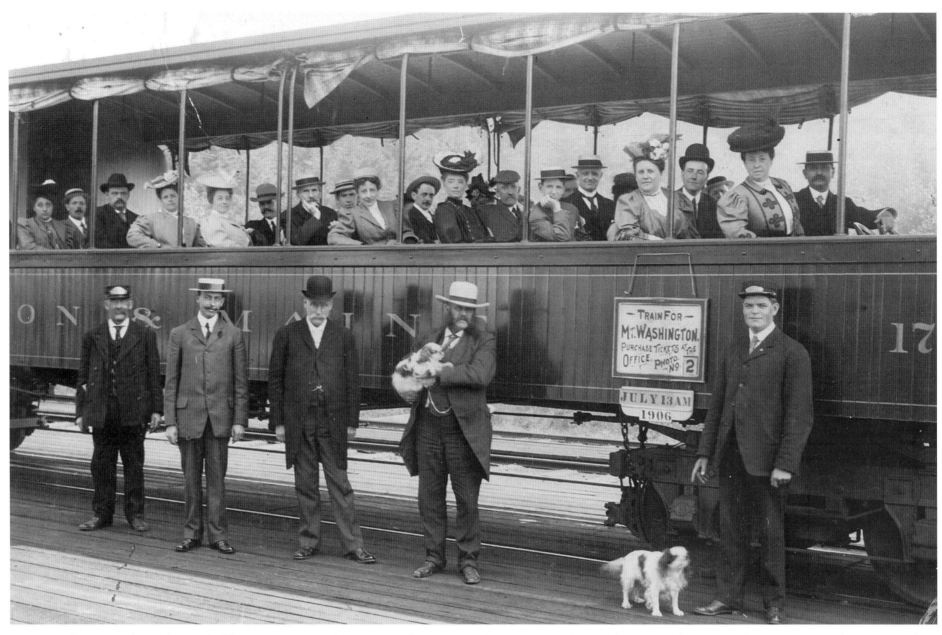

Mount Washington Railway, photographed by C. E. Leavitt, July 13, 1906. The Mount Washington Cog Railway to the summit of Mount Washington was opened in 1869, and in 1876 a spur line from the Boston and Maine tracks at Fabyans, above Crawford Notch, was extended to the cog's base station. Passengers could then ride by train from major cities right to the top of Mount Washington, spend the night at the Summit House, then go back down via the cog railway or by stage down the carriage road to connect with the train at Glen in Bartlett. In 1887, such a round trip from Boston cost $17. New Hampshire Historical Society collection.

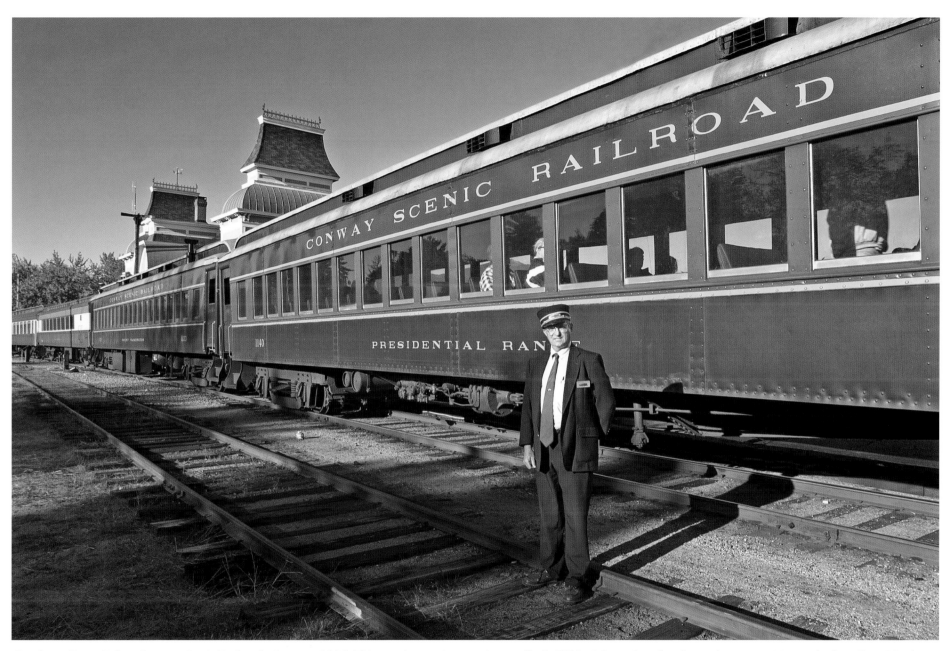

Conductor Dave Baker, Conway Scenic Railroad, Conway, 2004. This popular tourist attraction recalls the White Mountain railroad era when most visitors rode the rails to North Country hotels and inns. The Conway Scenic Railroad runs a passenger train through Crawford Notch to the old Boston and Maine Crawford Station adjacent to the Appalachian Mountain Club's Highland Center (see page 45), and sometimes travels a few miles north to Fabyans Station, where the old spur line extended to the cog railway.

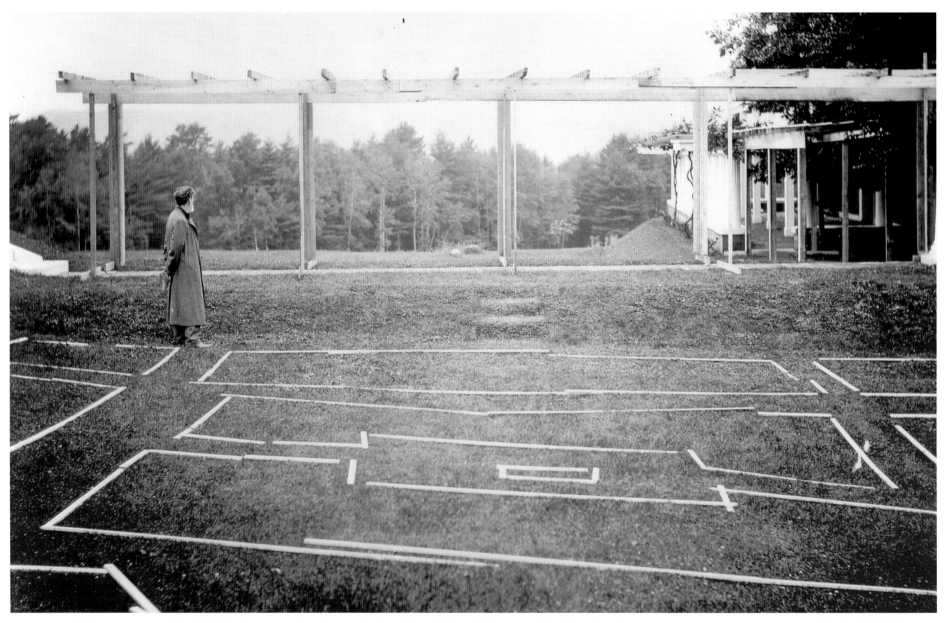

Aspen, Cornish, 1904. Augustus Saint-Gaudens views the plan, marked in laths, of the middle terrace of his formal garden at Aspen. In the background is a mock-up of the arbor. One of America's greatest sculptors, Saint-Gaudens lived here summers from 1885 until 1897 and it was his permanent home from 1900 until his death in 1907. As a member of the Cornish Colony, Saint-Gaudens hosted neighbors such as novelist Winston Churchill and artist Maxfield Parrish, as well as many leading American painters and sculptors. U.S. Department of the Interior, National Park Service, Saint-Gaudens National Historic Site, Cornish.

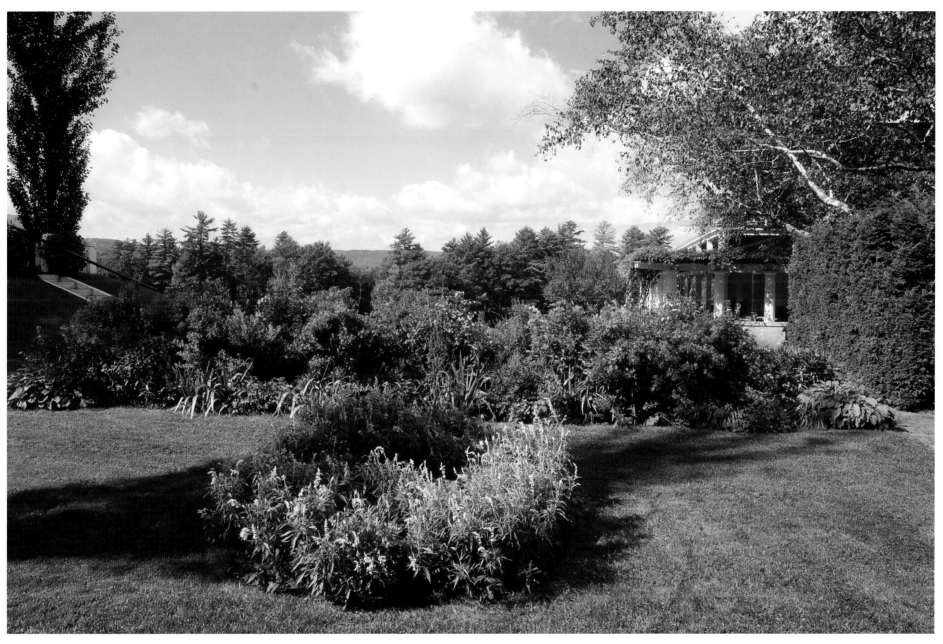

Aspen, Saint-Gaudens National Historic Site, Cornish, 2003. The middle terrace of the formal garden features old-fashioned perennials enclosed by pine and hemlock hedges. Saint-Gaudens was involved in all aspects of planning and developing the landscape at his home. The property was operated by the Saint-Gaudens Memorial as a museum from 1919 until it was donated to the National Park Service in 1964-65.

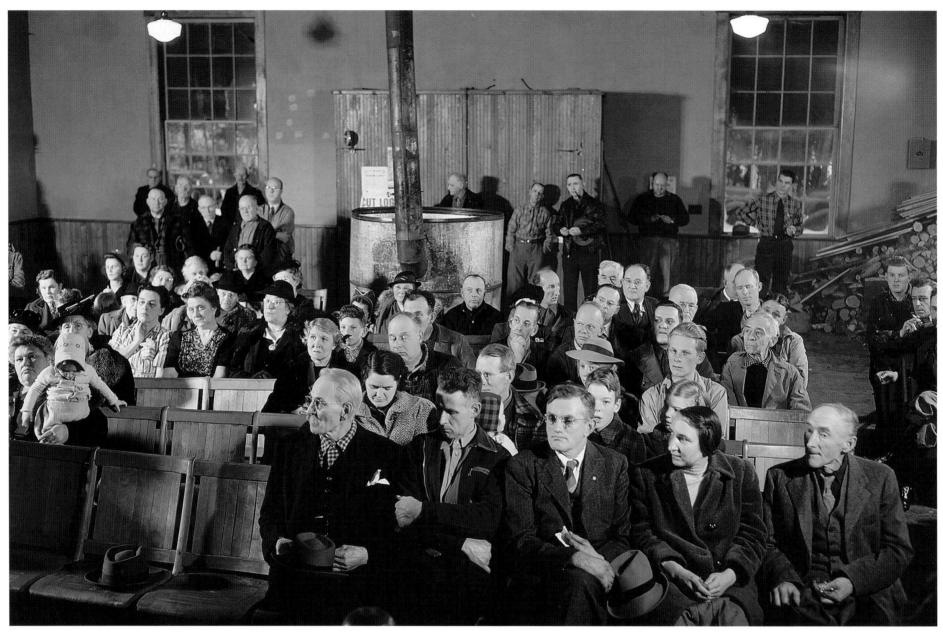

Cornish Town Meeting, photograph by Jerry Cooke, 1947. Ever since there has been a place called New Hampshire, Town Meeting has been an annual rite. With everyone over age 18 eligible to vote, it is pure democracy. Each voter has the opportunity to speak on the floor, defending or opposing the article under discussion. The majority rules and voters determine budgets, zoning, schools, and the election of town officials. Jerry Cooke (1921-2005), a leading photojournalist whose work appeared in Life, Sports Illustrated, *and other leading magazines, photographed the Cornish Town Meeting in the old town hall. Corbis.*

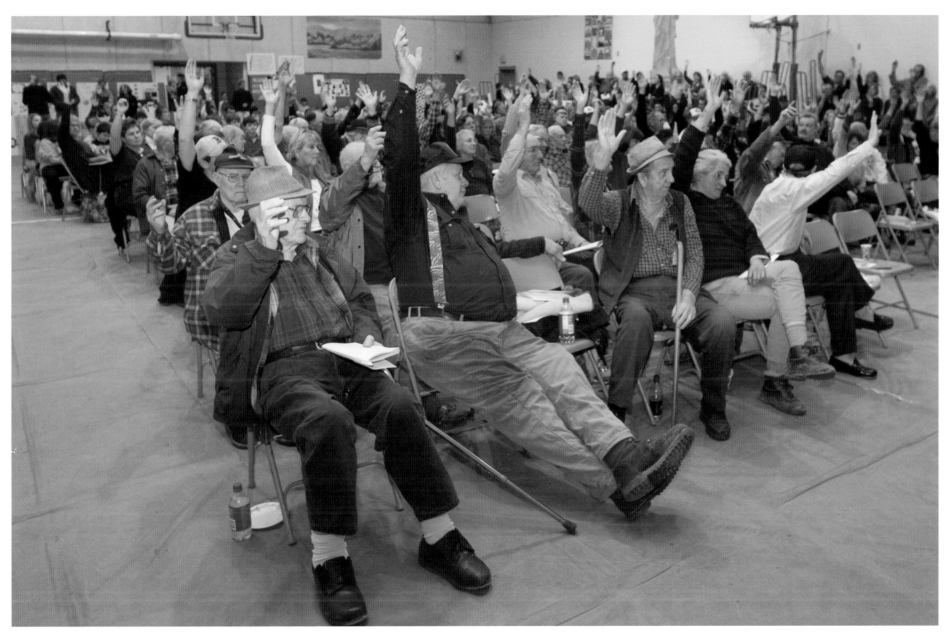

Cornish Town Meeting, 2004. The town now holds its annual Town Meeting in the elementary school gymnasium. Recent New Hampshire law gives towns the option to change the traditional town meeting to an election whereby voters approve or reject articles by ballot. For larger towns, it is impractical to have very many voters at a meeting. A number of communities have decided to accept this option and no longer is there the give-and take on the floor that marked the traditional town meeting. The small town of Cornish is one of the holdouts.

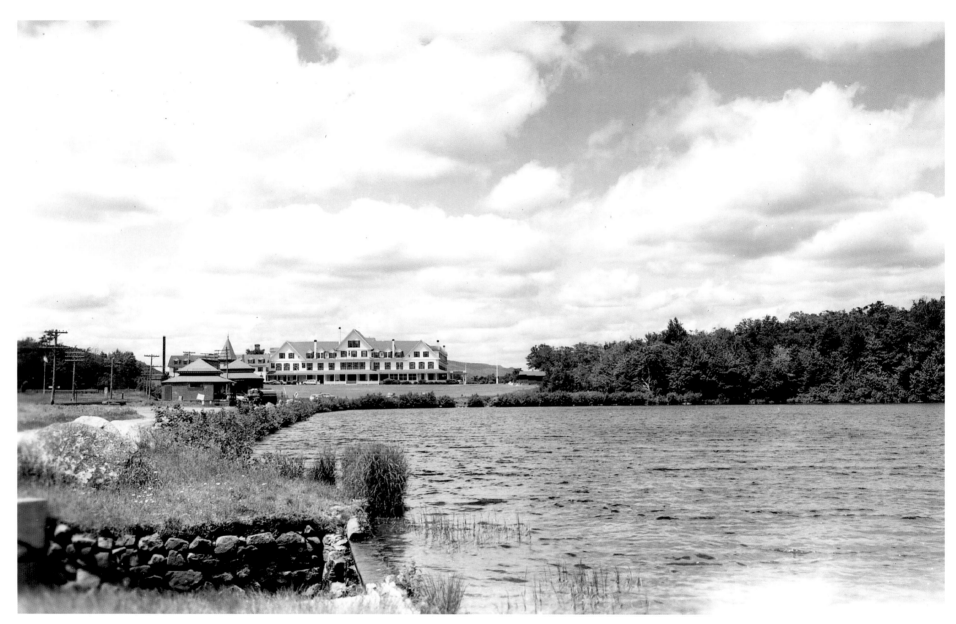

The Crawford House, photograph by Guy L. Shorey, c. 1950. Situated at the top of Crawford Notch, this large hotel greeted White Mountain visitors from 1859 until 1975. Two years later the closed hotel burned. Abel Crawford and his son Ethan Allen Crawford built the first Crawford House in 1828. It was run by Ethan's brother, Thomas, until sold in 1852. An1854 fire destroyed the original inn and its replacement burned on April 30, 1859. Hotel owner Col. Cyrus Eastman, anxious not to miss a summer season, began construction within days of the fire for a new 400-guest hotel. Materials were hauled by oxen from Littleton to the hotel site, adjacent to Saco Lake. In just over sixty days after the fire, the hotel opened on July, 13, 1859. Mount Washington Observatory collection.

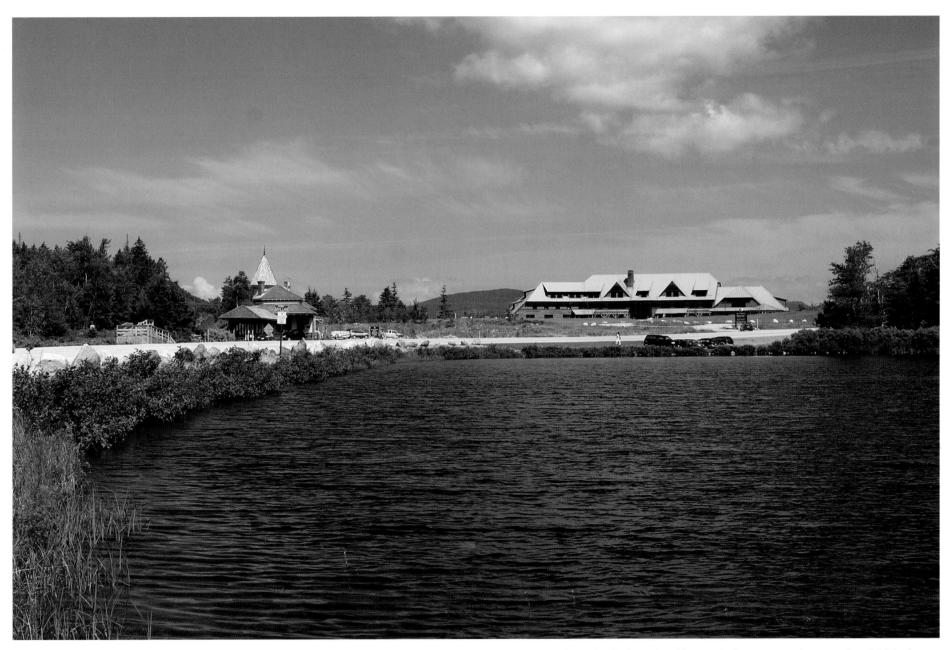

The Appalachian Mountain Club's Highland Center, 2004. This new building occupies a site about 50 yards north of where the old Crawford House stood. Opened in 2003, the lodge provides meals and accommodations for up to 122 guests and caters to hikers and others, who want a relaxed North Country experience. The old Boston and Maine Crawford Station is now a visitor information center and the usual last stop on the Conway Scenic Railroad's mountain trip.

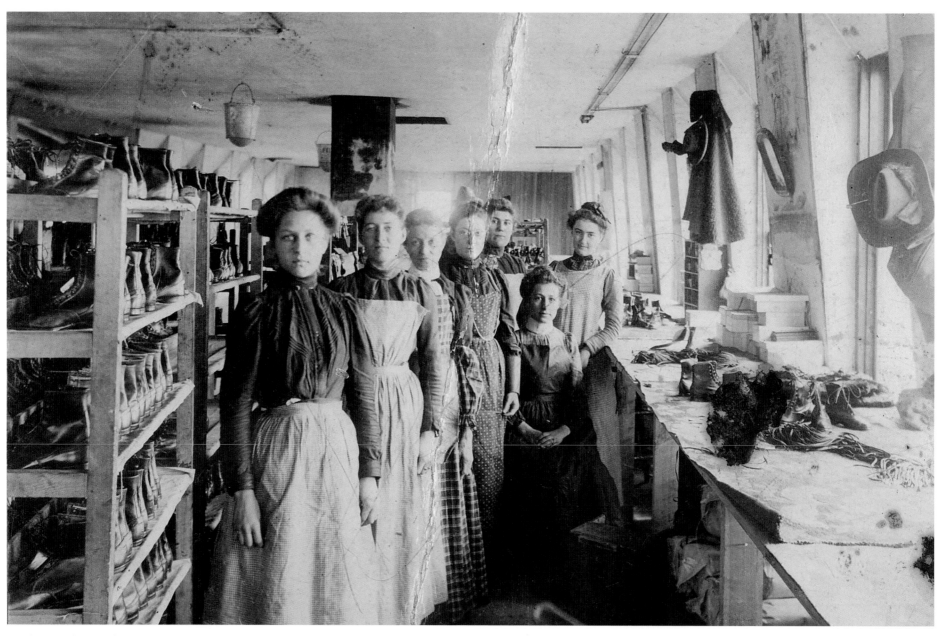

Workers in the Finishing Room, W. S. & R. W. Pillsbury Shoe Shop, West Derry, 1899. Left to right: Katie Lang, Maggie Frazer, Mrs. Duffy, A. Colby, Mary Garrior, Pansy Blodgett, and Mande Bennett. During most of the late 19th- and most of the 20th-century, the most common industry in New Hampshire was shoemaking. Every city and large town and many small towns had shoe shops, often located in former textile mills. Because of foreign competition, all of New Hampshire's shoe manufacturers have closed. New Hampshire Historical Society collection.

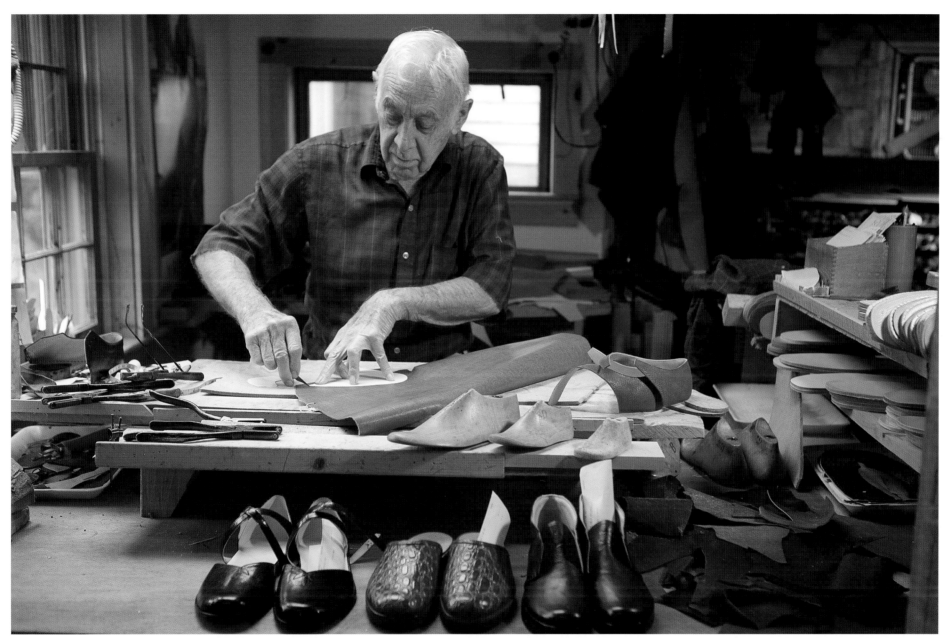

Paul Mathews, the Cordwainer Shop, Deerfield, 2005. By age 17, Paul was designing shoes for his father's custom shoe business. Cordwainer shoes all have round toes and low heels, and the correct fit for health and comfort. Shoe styles that Paul designed in the 1930s are the same popular ones he makes today. At age 87, Paul still travels the country to participate in fine juried craft shows. Paul's wife and daughter make the shoes alongside him in the shop, which is attached to his country farmhouse.

Enfield Shaker Village c. 1890. This view is from Mount Assurance looking down on the Enfield Shaker Village's Church Family. Lake Mascoma is seen beyond the Shaker village and the hillside across the lake is known as Shaker Hill. Founded in 1793, this village was the ninth of 18 Shaker communities to be established in this country. At its peak in the mid-19th century, the community was home to three "Families" of Shakers. Here, Brothers, Sisters, and children lived, worked, and worshiped. They practiced equality of the sexes and races, celibacy, pacifism, and communal ownership of property. Striving to create a heaven on earth, the Enfield Shakers constructed more than 200 buildings, farmed over 3,000 acres of fertile land, educated children in model schools, and followed the "Shaker Way" of worship. The largest and most prominent building in the Shaker village, seen at the center of the photo, is the Great Stone Dwelling. Constructed between 1837 and 1841, it was the architectural centerpiece of this village and one of the most ambitious building projects ever undertaken by the Shakers anywhere. In 1923, after 130 years of farming, manufacturing, and productive existence, the Shakers were forced to close their community due to declining membership and put it up for sale. Enfield Shaker Museum collection.

Enfield Shaker Village, 2004. In a view seemingly little changed from the 19th century, Enfield Shaker Village now is owned mostly by the Enfield Shaker Museum, a nonprofit, membership organization dedicated to preserving and interpreting the complex history of the Shaker village. Since opening in 1986, the museum has purchased from private investors many of the buildings and some of the land. An additional 1,100 acres of Shaker fields, pastures, and forest were purchased by the State of New Hampshire and are now permanently protected from development with guaranteed public access for recreational purposes.

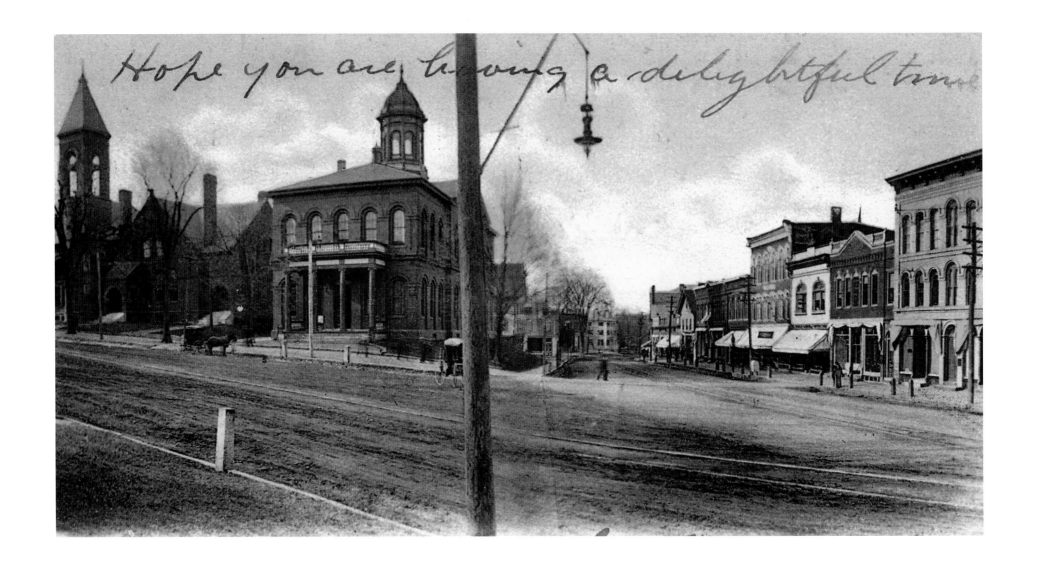

Hope you are having a delightful time

Exeter, c. 1900. As the longtime county seat and the location of textile mills, Exeter became a large town and the shopping center for its much smaller neighboring communities. The town hall at center was designed by Arthur Gilman and built in 1855. At left is the 1896 county courthouse. In the years before the automobile, regular trolley service connected Exeter with Portsmouth, Hampton Beach, and the cities of the Merrimack Valley. Matthew Thomas collection.

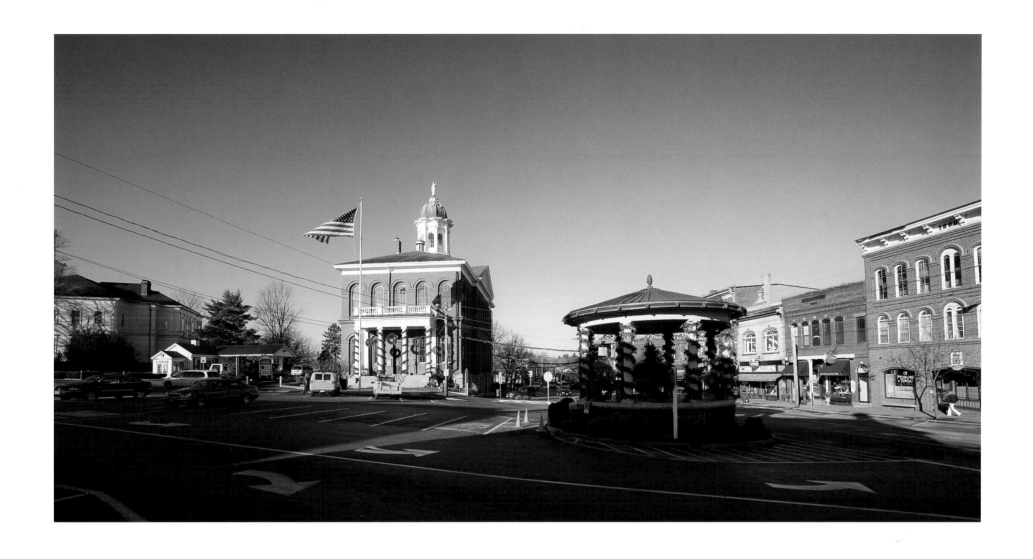

Exeter, 2005. The town hall is now used for community events, and a newly installed elevator provides access to a third-floor gallery with changing art exhibits. In the 1960s, banks in many New Hampshire communities purchased and then razed downtown buildings to make way for additional parking and drive-up facilities. The county courthouse was torn down for this purpose in 1969 after a new courthouse was built outside of the town center. The bandstand, designed by famed architect Henry Bacon, was a gift to the town in 1915 by Exeter-born industrialist Ambrose Swasey. Although the business blocks at right along Water Street have changed storefronts, they still project the 19th-century image of the town center.

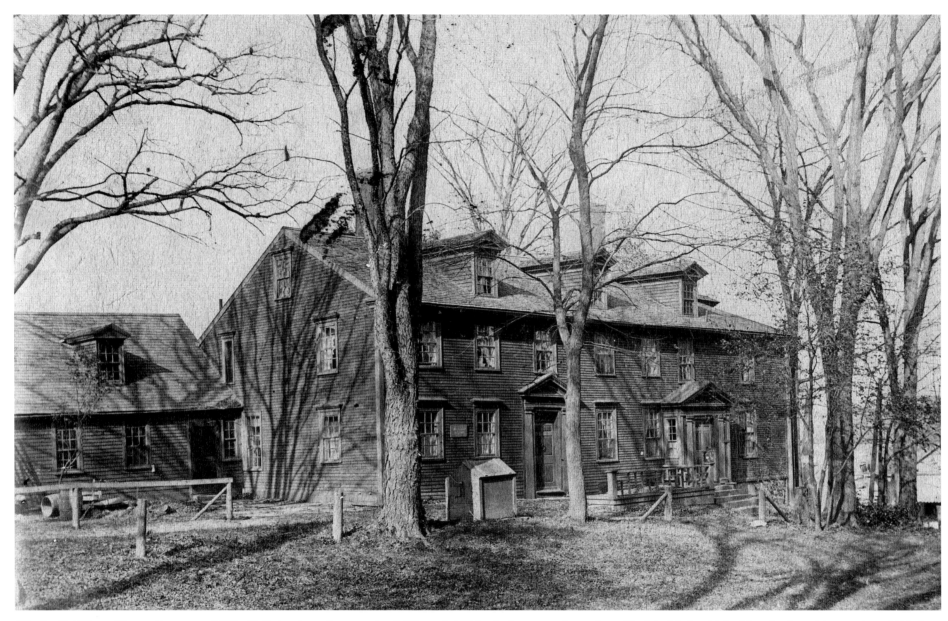

The Ladd-Gilman House, Exeter, ca. 1890s. Built in phases between the 1720s and 1750s, the house was begun by millwright Nathaniel Ladd and enlarged by merchant Nicholas Gilman. During the American Revolution, Exeter became the state capital and the house served as the New Hampshire Treasury. John Taylor Gilman lived here during his 14 terms as Governor and it was also the childhood home of his brother, Nicholas Gilman, Jr., soldier, statesman, and one of the New Hampshire delegates to the Constitutional Convention. The Society of the Cincinnati in the State of New Hampshire purchased the house in 1902 to use as its headquarters and to create a military museum, thus transforming it into one of the first historic homes in the United States to be open to the public. Exeter Historical Society collection.

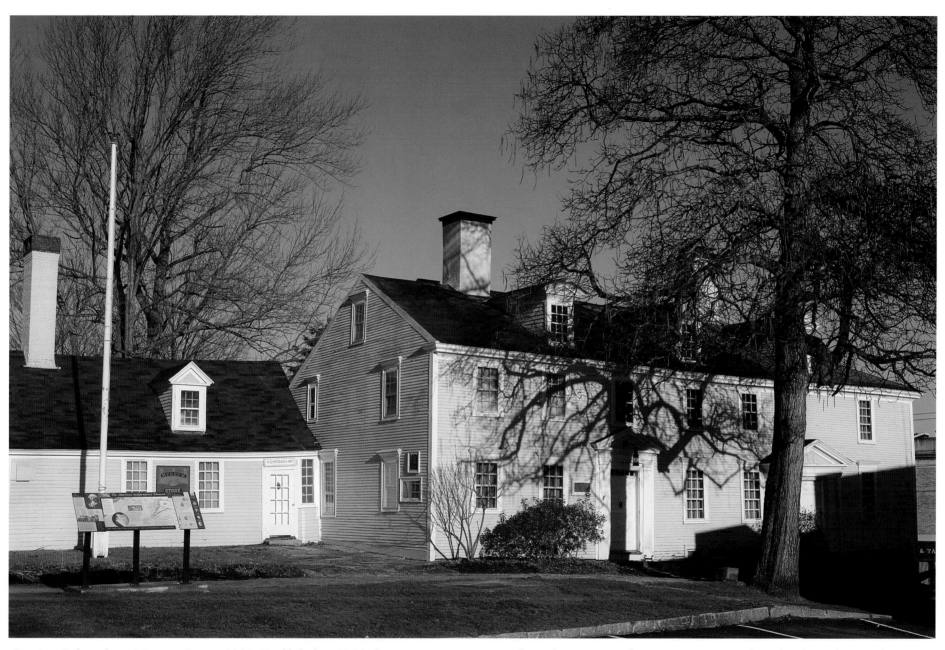

American Independence Museum, Exeter, 2005. Established in 1991, the museum is a private, not-for-profit institution whose mission is to provide a place for study, research, education, and interpretation of the American Revolution and of the role that New Hampshire, Exeter, and the Gilman family played in the founding of the new republic. The museum comprises the 18th-century Ladd-Gilman House, the restored Folsom Tavern, and more than an acre of landscaped property in downtown Exeter.

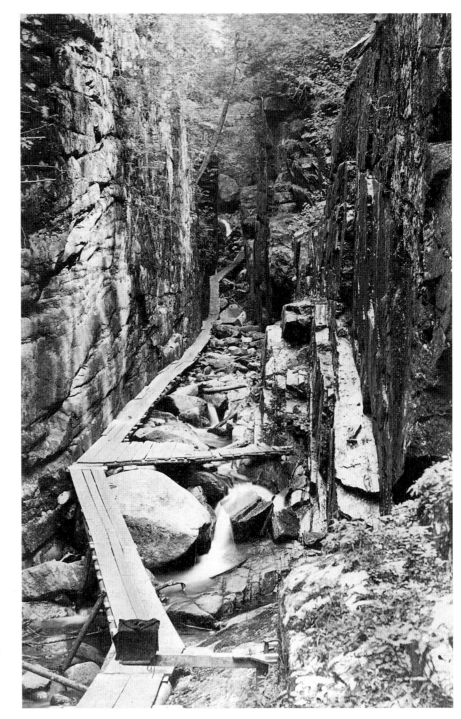

The Flume, Franconia Notch. c. 1880. When first discovered in 1808 by 93-year-old "Aunt Jess" Guernsey, who was out fishing, this 800-foot-long natural gorge had a large boulder lodged between its narrow walls. An inn catering to tourists was built here in 1848. Following a heavy storm on June 20, 1883, the boulder was dislodged and disappeared down the mountain. New Hampshire Historical Society collection.

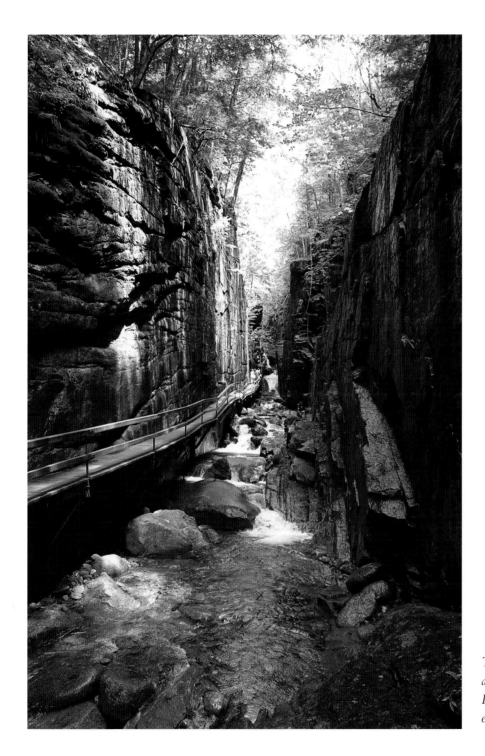

The Flume, Franconia Notch, 2003. The gorge walls are composed of Conway granite, rise to a height of 70 to 90 feet, and are 12 to 20 feet apart. As part of Franconia Notch State Park, the Flume is open for summer visitors, but off-season hikers also pass through the area en route to the peaks of the Franconia Ridge, which rise behind the gorge.

Vadney's General Store, Francestown, photograph by Cyrus Phelps, 1963. When known as Vadney's, the store was selling gasoline for automobiles instead of feed for horses. The store had lost its shutters and sprouted awnings above the first-floor windows and a TV antenna on the roof.

Village Store, Francestown. The view at right shows passengers inside and on top of the stagecoach, which is preparing to depart for the railroad station in Greenfield. Known at the time as the Long Store, built in 1814 and presumably called that to distinguish it from two other stores on the same street, it was owned by P. L. Clark at the time the photograph was taken. The building also served as the post office, with the Francestown Savings Bank on the second floor. After Mr. Clark sold it in 1844, the store had a series of proprietors and owners until Israel H. Vadney bought it about 100 years later. Both photographs from the Manahan-Phelps-McCullough Collection of the Hillsborough Historical Society.

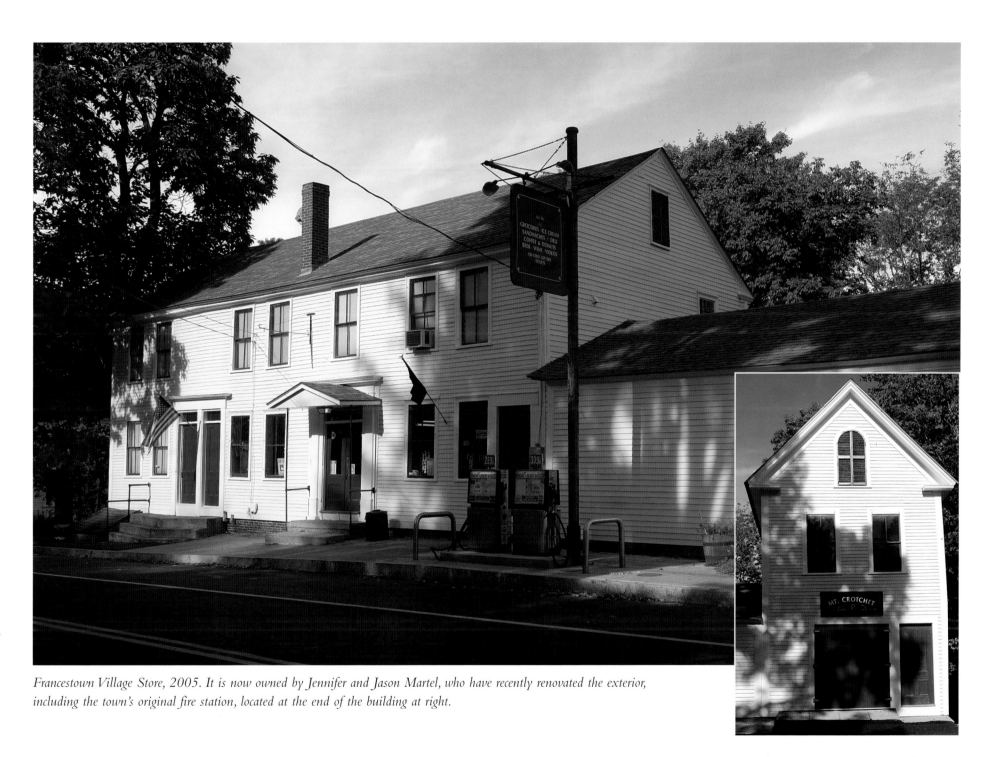

Francestown Village Store, 2005. It is now owned by Jennifer and Jason Martel, who have recently renovated the exterior, including the town's original fire station, located at the end of the building at right.

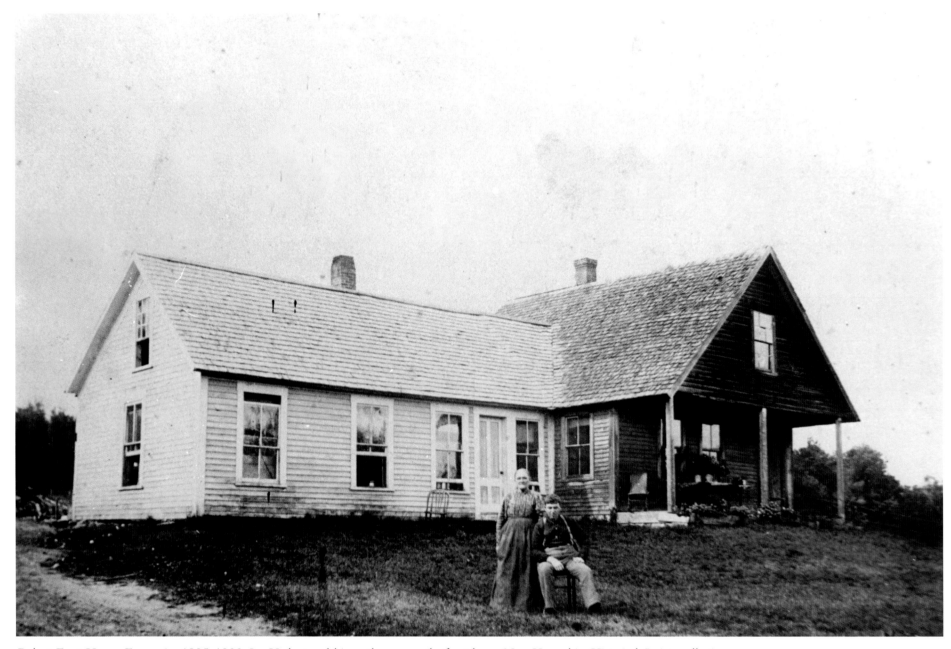

Robert Frost House, Franconia, 1895-1900. Joe Herbert and his mother are on the front lawn. New Hampshire Historical Society collection.

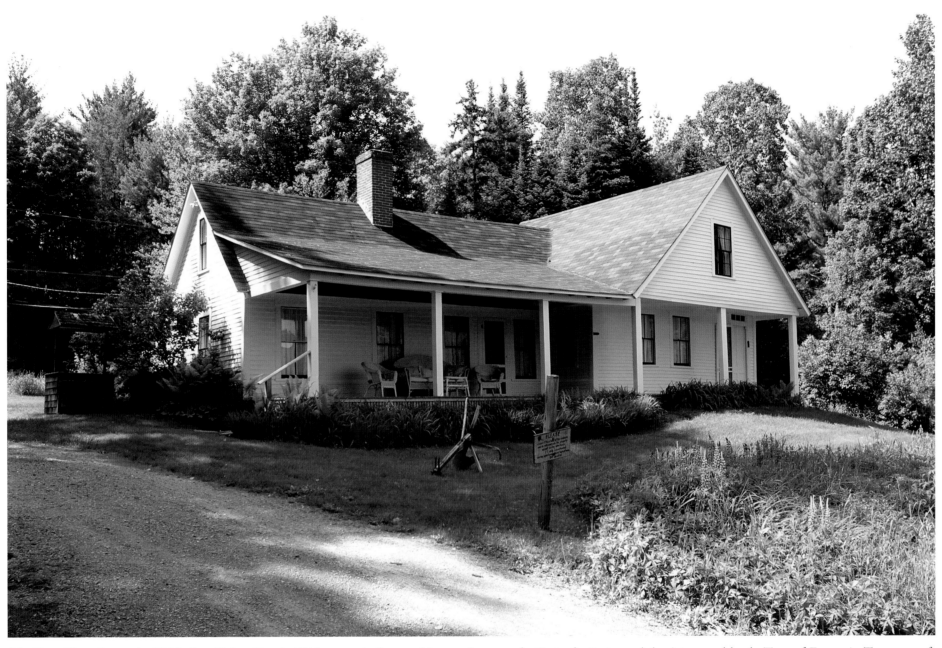

The Frost Place, Franconia, 2003. Poet Robert Frost's 1915 mountain farmstead is now the nonprofit Center for Poetry and the Arts, owned by the Town of Franconia. Two rooms of this 19th-century farmhouse are devoted to a museum of Frost's life and work, with letters and signed first editions of his books. The Frost Place honors Frost's great art by hosting a summer poet-in-residence as well as a series of programs in poetry that rank among the first in the nation.

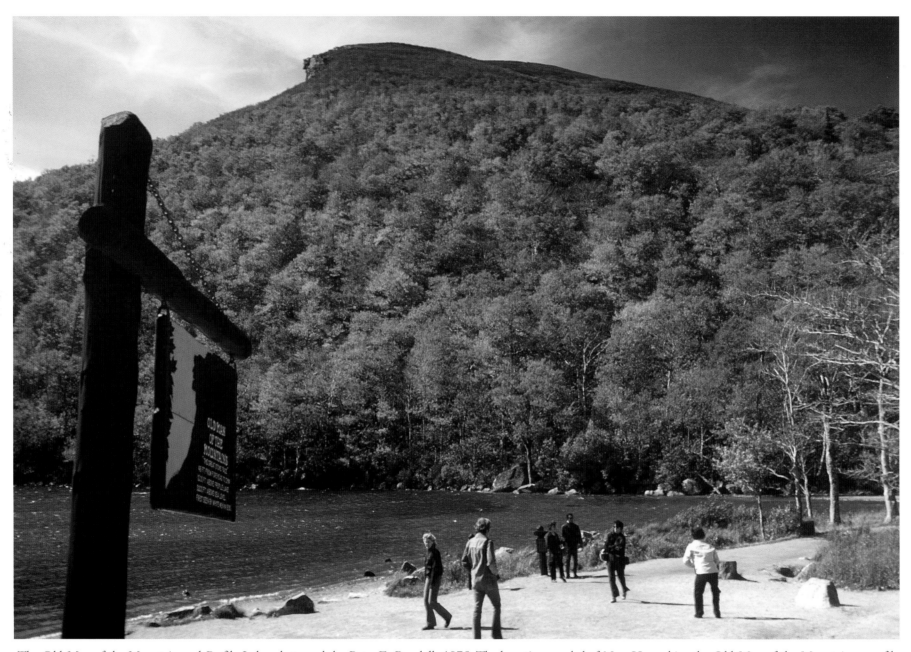

The Old Man of the Mountain and Profile Lake, photograph by Peter E. Randall, 1978. The long time symbol of New Hampshire, the Old Man of the Mountain, a profile composed of Conway red granite ledges, was "discovered" in 1805. It formed the centerpiece of Franconia Notch State Park.

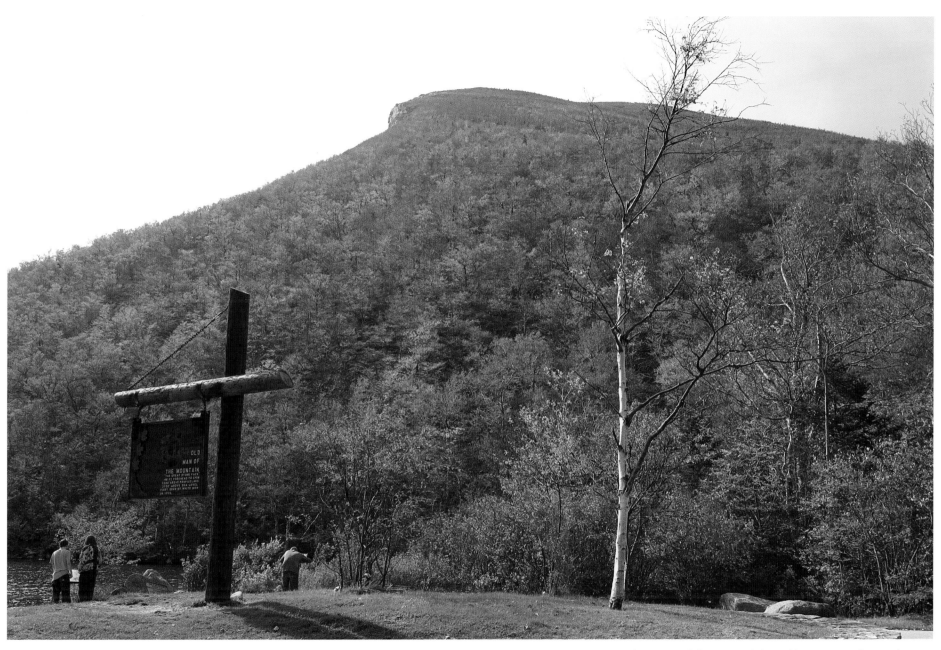

Old Man of the Mountain site, 2003. Almost everything in this view is different from the one on the page opposite. Even the sign is different. And the Old Man is no longer there. On the night of May 3, 2003, the ledges that made up the profile slipped down the mountain, bringing tears to the eyes of residents and tourists alike.

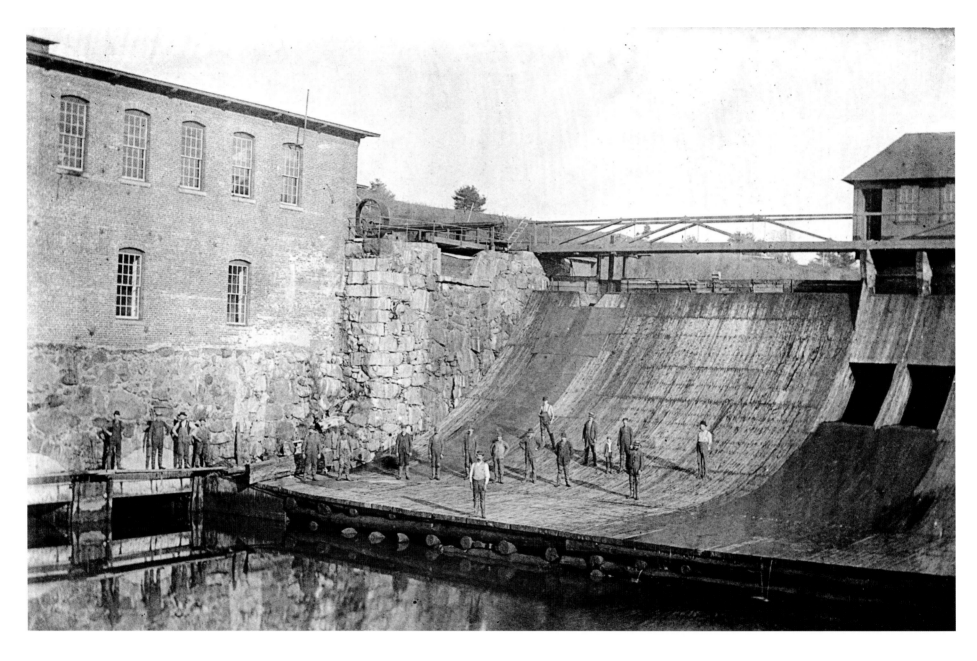

Mill dam, Franklin, c. 1890. Following an 1888 fire that destroyed the Cross Mill and perhaps its dam, the mill was replaced with brick buildings and this new dam, which provided power for a paper mill. Only the dam's abutments remain now, visible just below the Cross Mill Road bridge, which crosses the Winnipesaukee River. New Hampshire Historical Society collection.

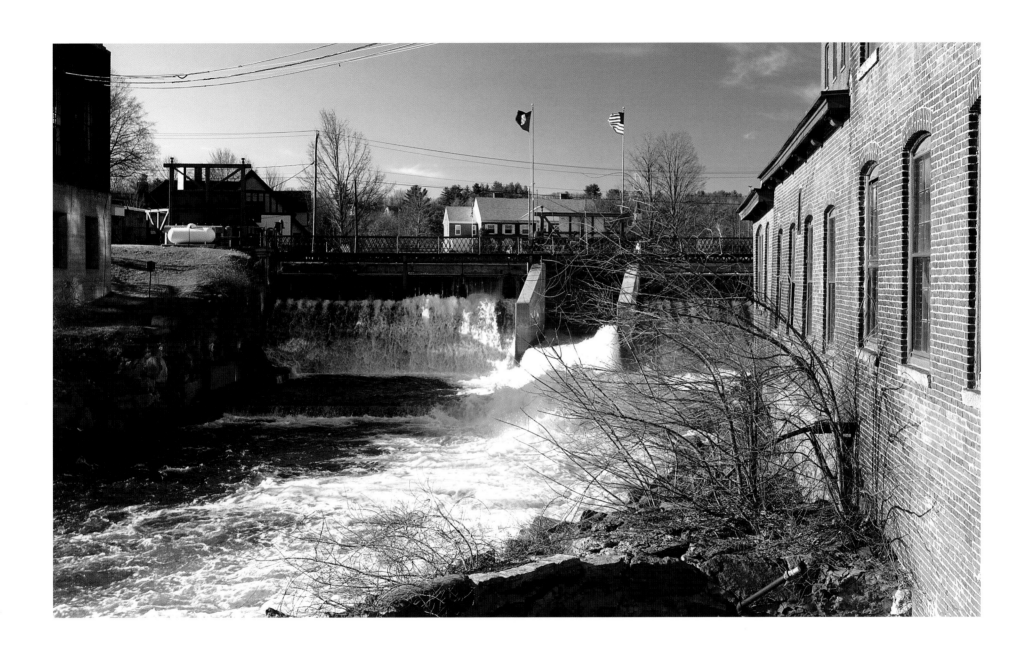

Franklin Falls Hydro Electric Power dam, Franklin, 2004. Although somewhat similar to the dam on the page opposite, this one, located about a mile down the Winnipesaukee River from the Cross Mill dam, was originally built to power the Sulloway Mills. The falls still generate electricity.

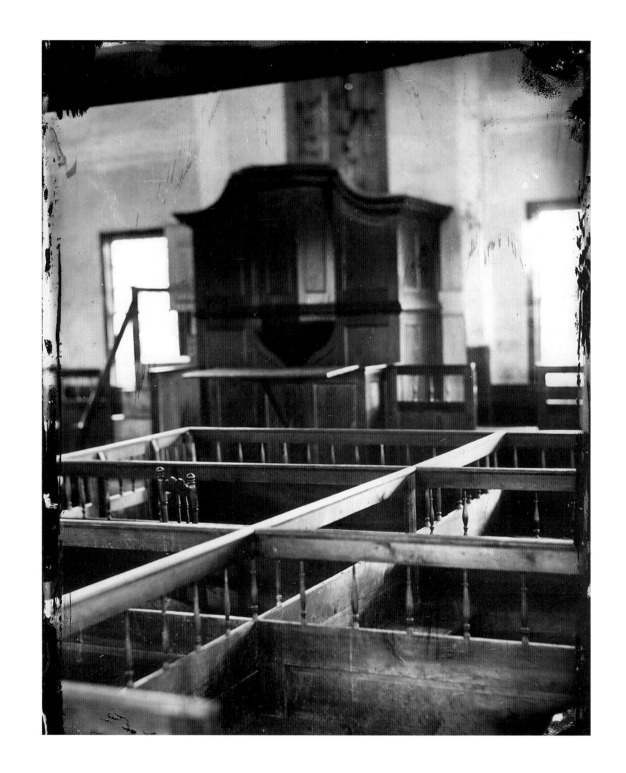

Fremont Meetinghouse, 1867. Built in 1800 when the town was known as Poplin (1764-1854), this building has remained town property ever since, and was the site of Town Meeting until 1911. Because the town did not have a settled minister, it was used by itinerant preachers. During muster days, tavern keepers were licensed to sell spirits here. Matthew Thomas collection.

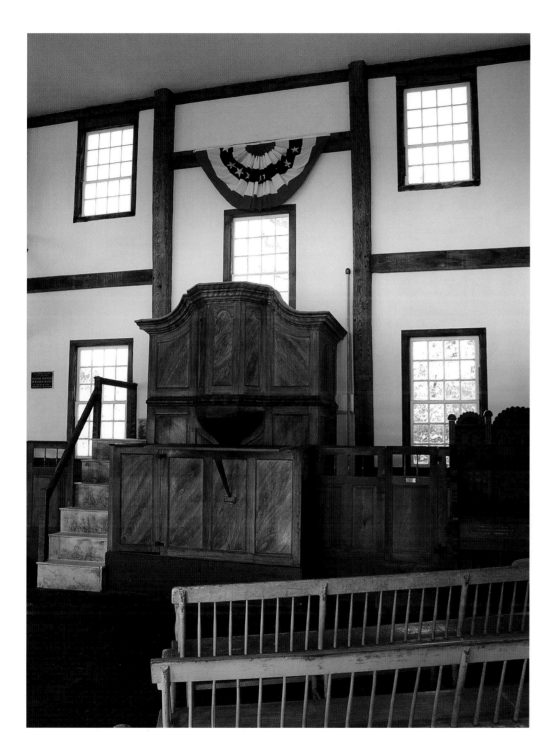

Fremont Meetinghouse, 2005. Although the box pews in the center of the building have been removed, several remain on the front wall, as well as the best preserved 18th-century choir stall in the state. The pulpit and its surroundings are original. Still owned by the town, the meetinghouse is now used for weddings, Old Home Day celebrations, and concerts.

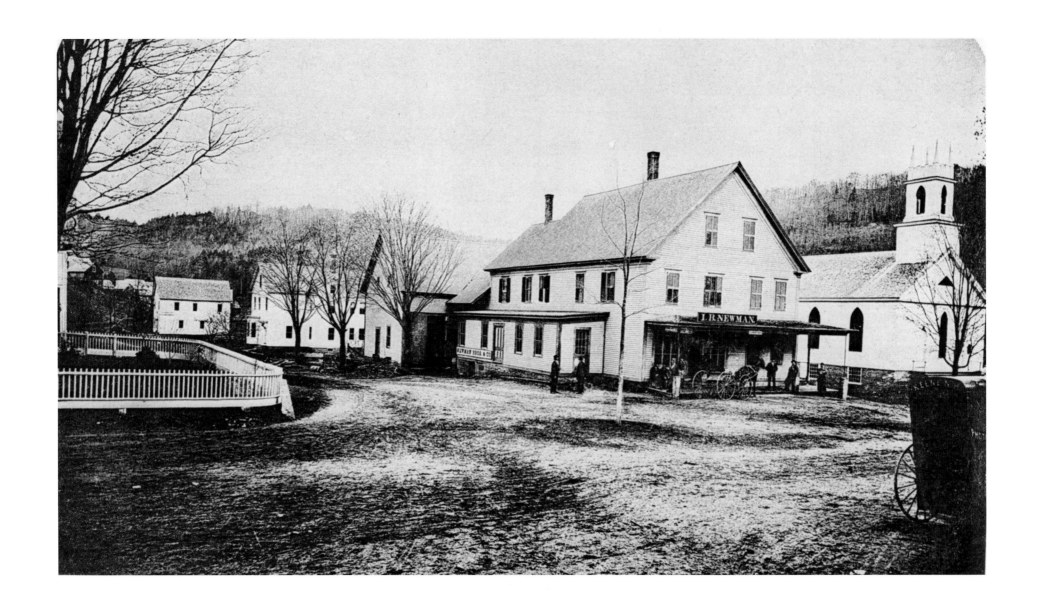

Gilsum Village, c. 1880. The store, c. 1870, and buildings of George W. Newman form the center of this small town, where the mining of feldspar and mica was a major industry for many years. At right is the First Congregational Church, built in 1834. New Hampshire Historical Society collection.

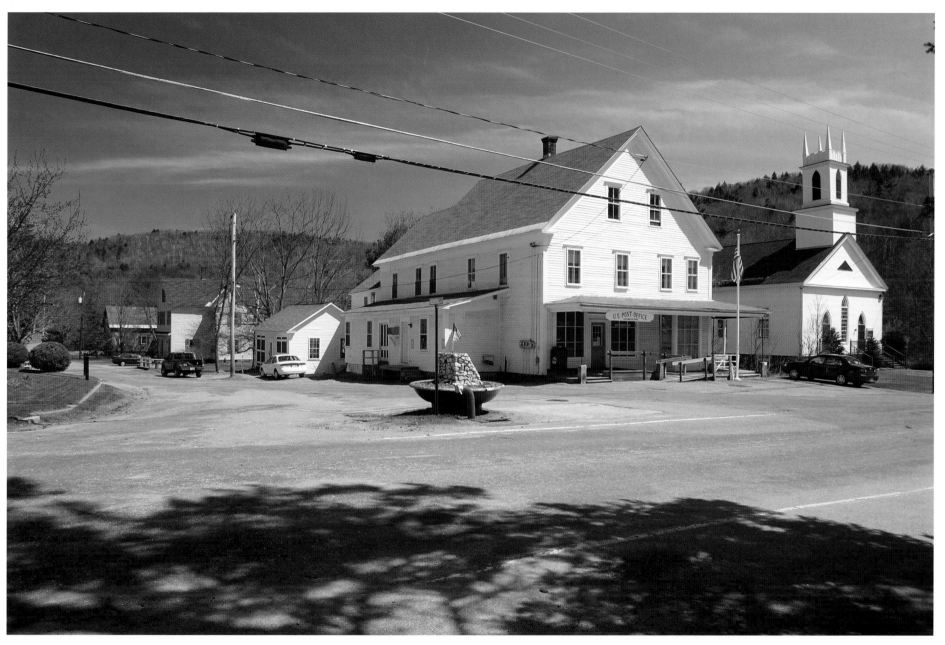

Gilsum, 2003. Newman's store is now the Gilsum post office, but the village shows few other changes in this view. Crystals of tourmaline and quartz of fine quality, as well as beryl, can be found in Gilsum. The annual Rock Swap is popular with mineral collectors who visit mine sites and geologic locations such as Vessel Rock, a huge boulder and the largest glacial erratic in the region, plus potholes, kames, and steep rock ledges.

Hampton Falls town common, photographed by Frank Batchelder Fogg (1875-1914), c. 1905. When this photograph was made, early in the 20th century Hampton Falls was largely a farming community. Into the 1960s, the buildings at right comprised Edgerly Farm, a popular truck garden selling fresh vegetables and fruits from its roadside stand. The author spent part of a summer there picking beans and carrots in the field behind the buildings. Once the site of Indian encampments, the field often yielded ancient artifacts as well as vegetables. The broad common in front of the monument was used as our baseball and football field. New Hampshire Historical Society collection.

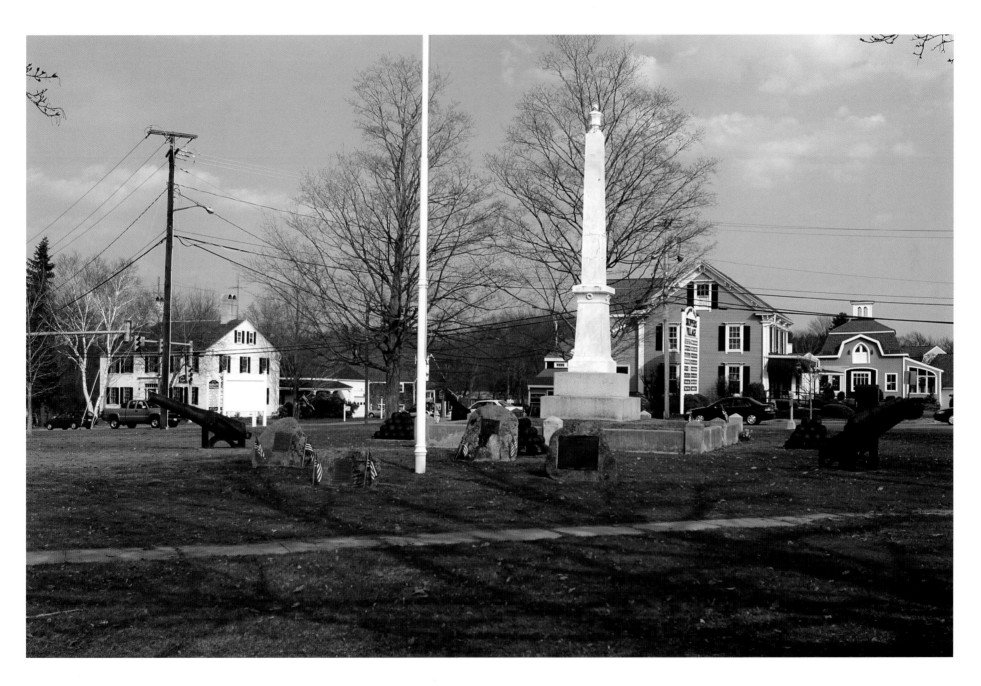

Hampton Falls common, 2003. While the cannons and monument remain the same, Edgerly Farm is now a mini-mall shopping center and the home at left is a retail shop. Children no longer play sports on the common, but Memorial Day services are still held here as well as craft and antiques shows, and musical events in a new bandstand.

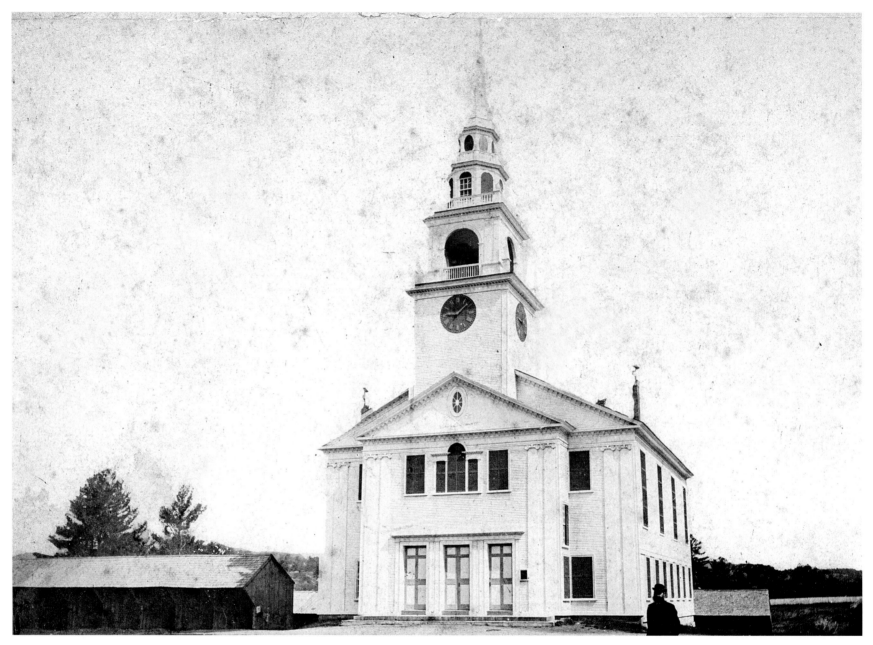

Town Hall, Hancock, c.1880. It was built in 1820, but without its lower level and on the other side of the street. The tower includes a fine bell made by Paul Revere and Sons. In 1851, the meetinghouse was moved to its current location and was raised a bit, allowing a lower level. This floor became the town hall which remained there until 1971. New Hampshire Historical Society collection.

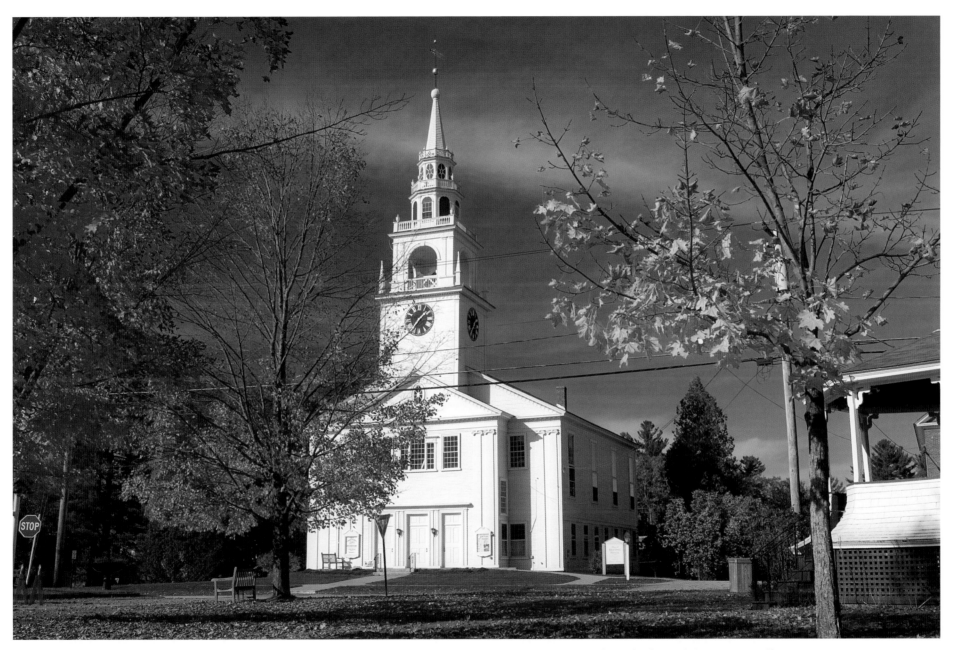

First Congregational Church, Hancock, 2004. In the 1980s, the church was beautifully restored to its original, simple, Federal-period design, an excellent example of New England church architecture and the frequent focus of artists from near and far. To this day, the meetinghouse is owned jointly by the town and the church and remains the only such historic example left in New Hampshire.

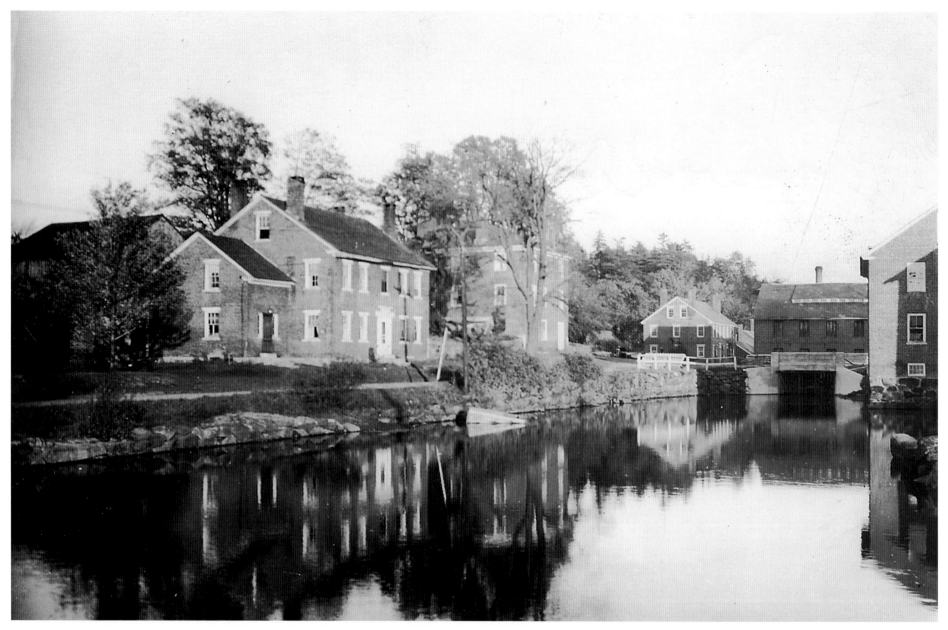

Harrisville, c. 1940. Cheshire County's youngest town was incorporated in 1870 from parts of Hancock, Dublin, Roxbury, Nelson, and Marlborough. First settled in 1760, the town became a mill center when the Harris family built one of the first woolen mills in New England. The town was known as Twitchellville, after Abel Twitchell, whose daughter had married into the Harris family. When the business name was changed to Cheshire Mills, the town incorporated as Harrisville. It was named in honor of Milan Harris, whose several stone and brick mills made use of the abundant waterpower of three nearby lakes until 1970. Historical Society of Cheshire County collection.

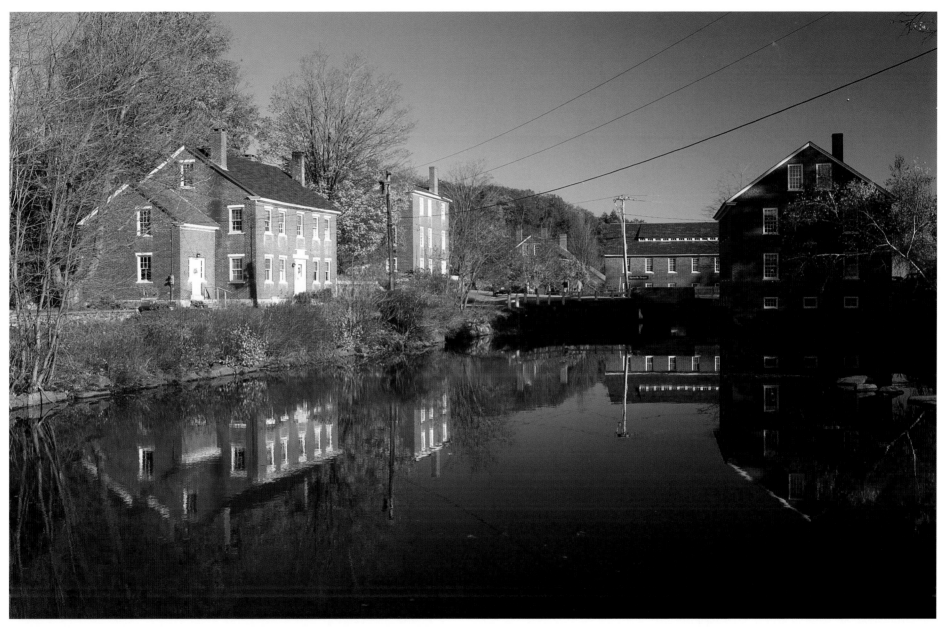

Harrisville, 2004. When wool production declined and mills closed in the 1970s, residents found a way to preserve the town's identity. Historic Harrisville, a public, nonprofit foundation, acquired many of the buildings with the mission of preserving Harrisville as a working village, not a museum. Harrisville Designs was started in 1971 as an effort to preserve and help reestablish the economic vitality of the historic 18th-century textile village. Harrisville is recognized as the only textile village of that era in America that survives in its original form.

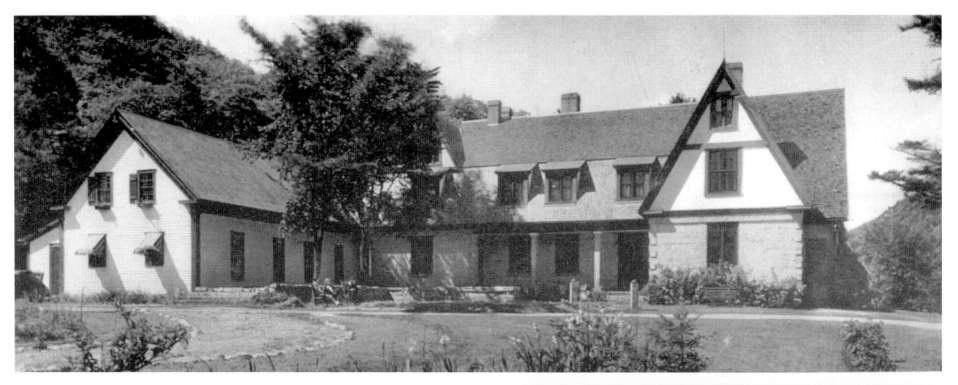

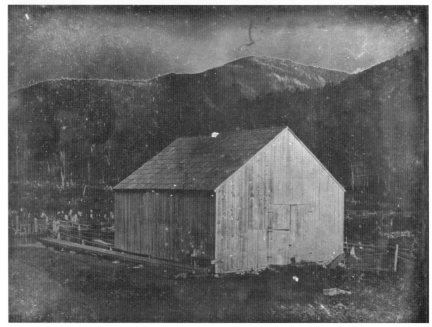

The Inn Unique, Hart's Location, c. 1950. Boston dentist Samuel A. Bemis was one of the early 19th-century visitors to Abel Crawford's inn at the lower end of Crawford Notch. Bemis loaned Crawford money on several occasions and when the old man died, Bemis foreclosed on the property and became the owner of some 6,000 acres, about 90 percent of the whole town. In 1859, Bemis completed this granite mansion (above) on a hill overlooking Crawford's old inn. Bemis also became one of America's first amateur photographers when he purchased camera equipment from an associate of Louis Daguerre for $51 in 1840. Bemis photographed only briefly in Boston and the White Mountains. At right is his photograph of what is thought to be Abel Crawford's barn, which was situated near his old Notch House. The mountain in the background appears to Mt. Tom with a shoulder of Mt. Willard. The image is reversed, which is inherent in the daguerreotype process. As an eccentric recluse, Bemis made the mansion his year-round home and as he aged and became blind, he hired George Morey and his wife, Mary, to care for him and his property. In return for their care, Bemis left the property to the Moreys when he died in 1881, at age 88. Morey's daughter-in-law, Florence, turned the mansion into the Notchland Inn in 1920, later changing the name to the Inn Unique. Above photograph from The Notchland Inn collection. Right photograph from the J. Paul Getty Museum.

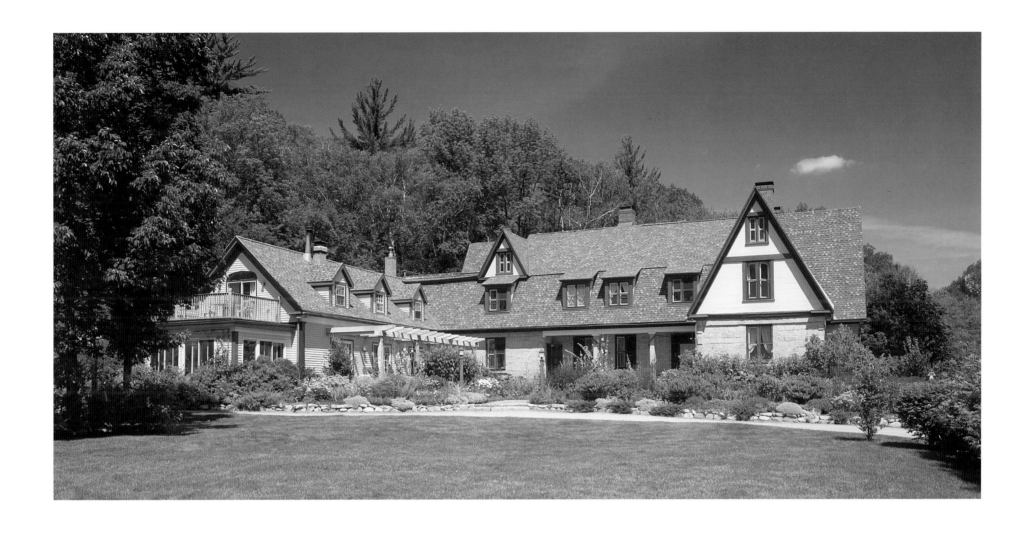

The Notchland Inn, Hart's Location, 2004. Florence Morey dominated public affairs in the tiny town for decades until her death in the 1970s. When the family auctioned off the inn's furnishings, 21 of Bemis's daguerreotypes were found in an attic bureau. Hidden away for more than 100 years, the photographs sold for $140,000. In 1984, John and Pat Bernardin bought and restored the building, and changed the name back to the Notchland Inn. The Bernardins sold the property in 1992 to the current owners, Ed Butler and Leslie Schoof, who carry on a White Mountain innkeeping tradition that first began just across the road from this inn.

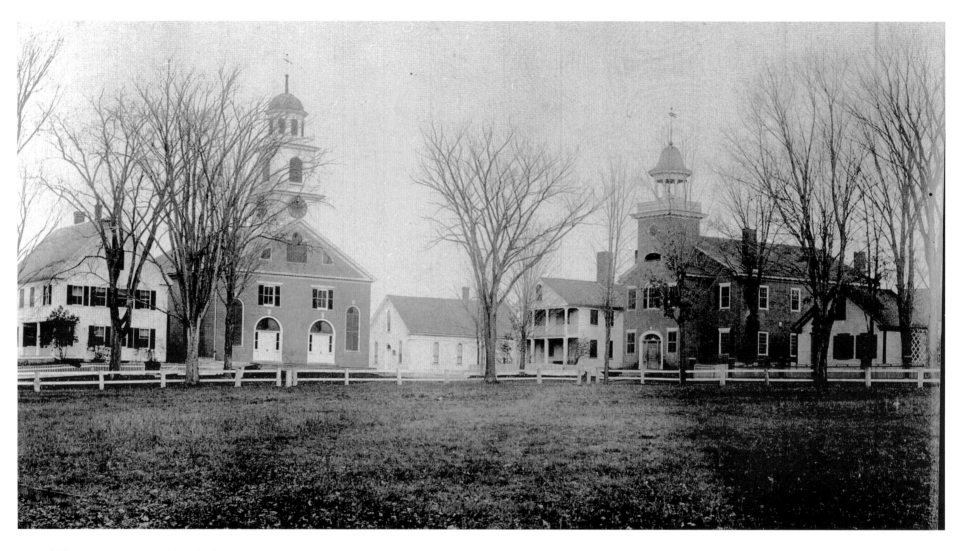

Haverhill Corner, c. 1890. Although the common was given for public benefit in the late 18th- and early 19th-centuries, the granite post-and-rail fence enclosing it was not installed until the mid-19th century. Originally the common was used for such activities as militia musters, and the grazing of animals. The buildings are, from left, the First Congregational Church Parsonage, built in 1840 as a residence in the Greek Revival style; First Congregational Church, built in 1827 by the Methodists, who sold it two years later as a result of financial distress, to the Congregationalists, who wanted a more prominent location "on the common"; the Italianate-style Parish House, originally used as a chapel, was built in 1890; and Pearson Hall, originally built in 1816 by Haverhill Academy and Grafton County to house both the academy and court functions, along with the common schools. The building takes its present name from James H. Pearson, an Academy alumnus and former resident who became a midwestern lumber baron. To the left of Pearson Hall is the Stephen Adams House and Shop, built by a Haverhill cabinetmaker as a combined dwelling, shop, and store, probably in the 1820s. In 1970 it was moved to the northwest corner of the common and restored. To the right of Pearson Hall is the shop of Noah Davis, later moved to another location following a fire which destroyed the Davis House. New Hampshire Historical Society collection.

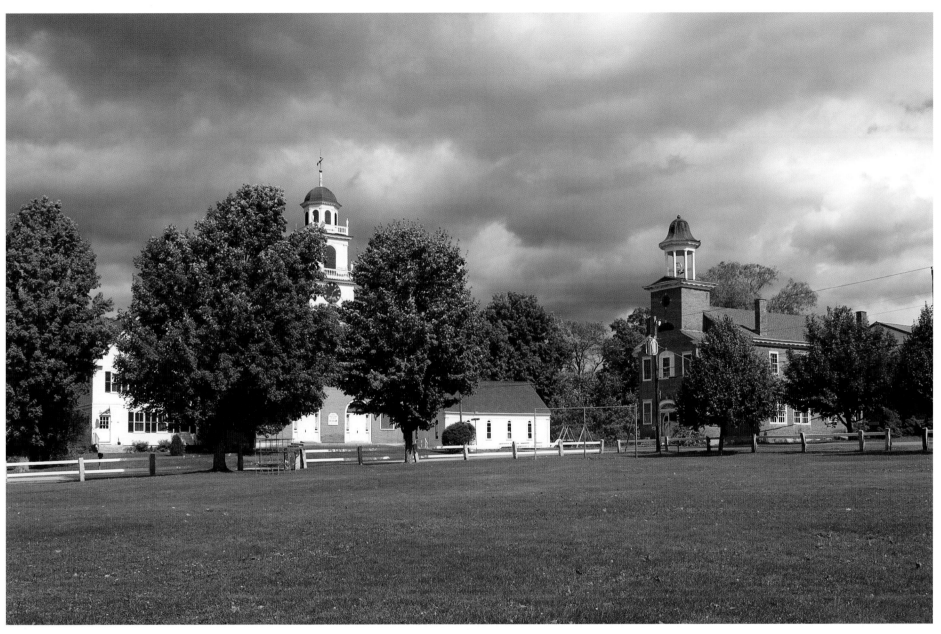

Haverhill Corner, 2004. In 1987 the common became the focal point of the Haverhill Corner National Register Historic District, which lists a total of 63 buildings. The common is now used for band concerts, flea markets, fairs, and, on the day of the photograph, softball. When Haverhill Academy built a new home next door in 1897, James H. Pearson renovated the building "for auld lang syne" for use as a library and village hall. Presently owned by Haverhill Heritage, Inc., a local preservation group, the building is slated to house the Haverhill Historical Society following extensive renovation.

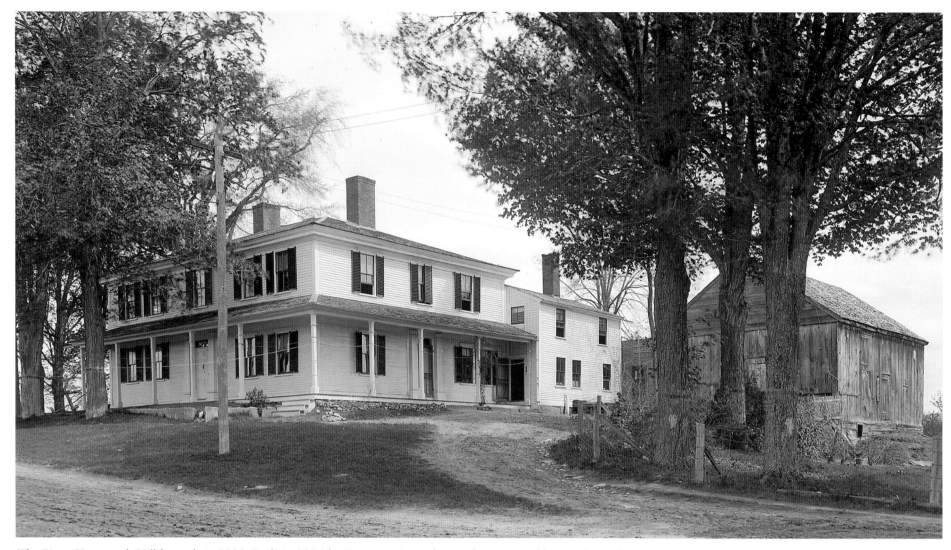

The Pierce Homestead, Hillsborough, c. 1900. Built in 1804 by Benjamin Pierce the year his son, Franklin, was born, the homestead's large spacious rooms, hand-stenciled walls, and imported wallpaper symbolize the elegance of the age. Benjamin Pierce came to Hillsborough in 1786, after he had served under George Washington in the War for Independence, but after the war's end he was nearly impoverished. The beauty of the land surrounding Hillsborough and the affordable prices of property attracted him to buy a log cabin with 50 acres. By the time the homestead was built, Benjamin Pierce was a prosperous and prominent man. His career in public service continued for 57 years, during which he was twice governor of New Hampshire. The homestead was a gathering place of great individuals. With friends such as Daniel Webster as visitors, Franklin Pierce (1804-1869) learned about politics, a skill that led him to Congress and U. S. Senate, then in 1852 to be elected as the 14th and youngest president of the United States. Although Franklin Pierce is far from forgotten, his life is often overlooked or misunderstood. Pierce was a compelling and sometimes contradictory man. He has been described as a powerful orator, a faithful friend, and a master politician. He is also remembered as a defender of slavery, a partisan politician, and an ineffective president. Manahan-Phelps-McCullough collection of the Hillsborough Historical Society.

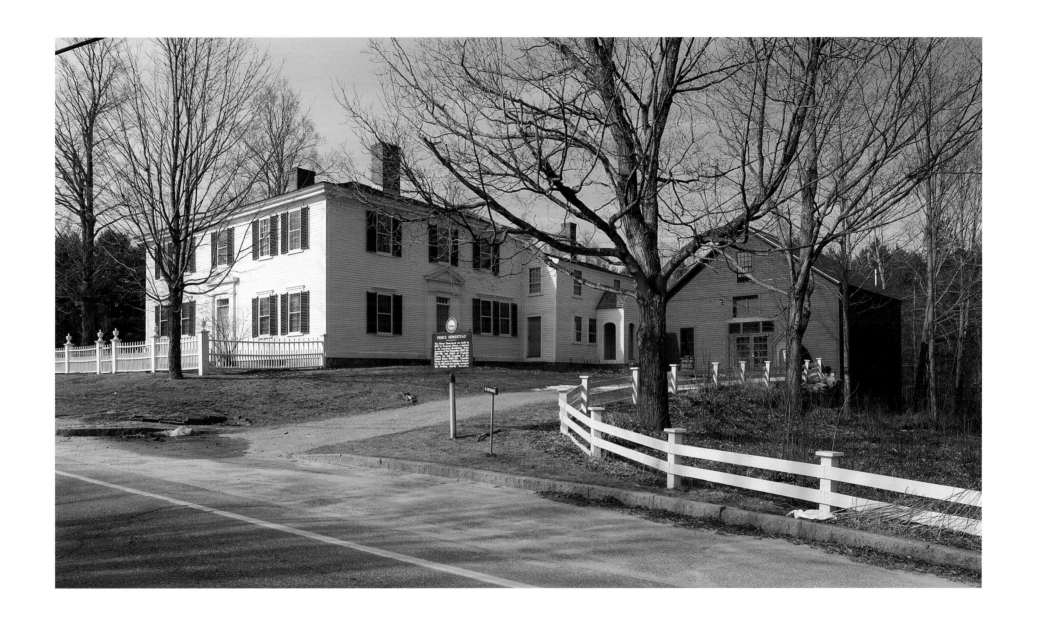

The Pierce Homestead, Hillsborough, 2005. Owned by the New Hampshire Division of Parks and Recreation and operated by the Hillsborough Historical Society, the boyhood home of Franklin Pierce, America's 14th president, has been restored as a spacious and beautiful, Federal-style country home. It reflects the gracious and affluent living of the 19th century. A ballroom, which extends the length of the second floor, was used for entertaining neighbors and distinguished families of the state and the nation.

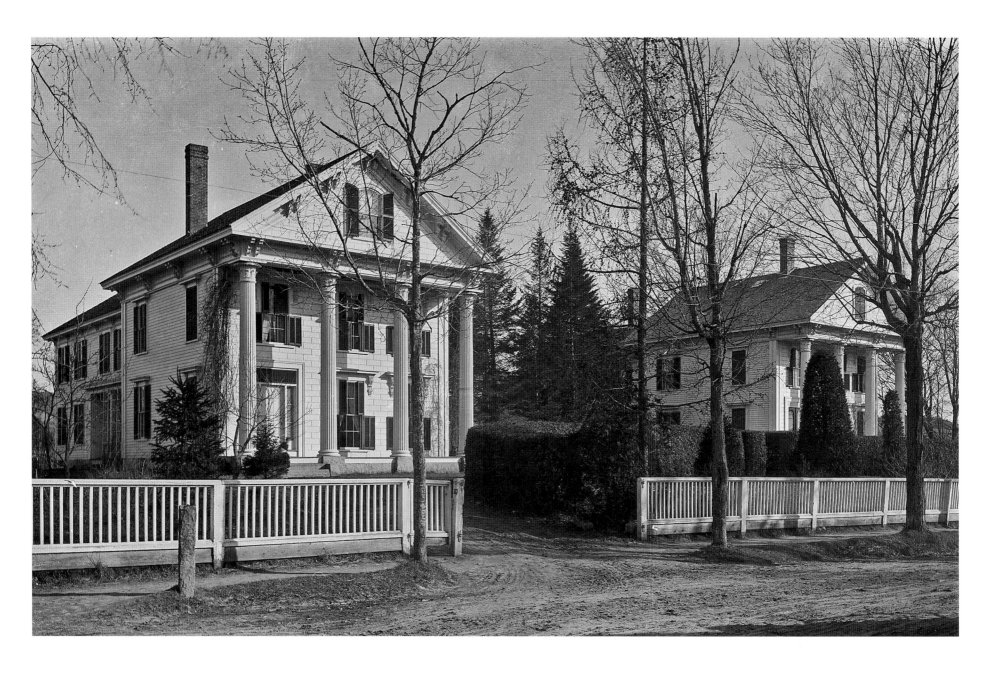

The so-called Dutton Twin Houses, Main Street, Hillsborough, photographed by William H. Manahan Jr., 1915. Originally built as separate houses in 1857 by Ephraim Dutton and his son, Benjamin Franklin Dutton, the buildings are outstanding examples of mid-19th-century Greek Revival/Italianate style architecture. Manahan-Phelps-McCullough collection of the Hillsborough Historical Society.

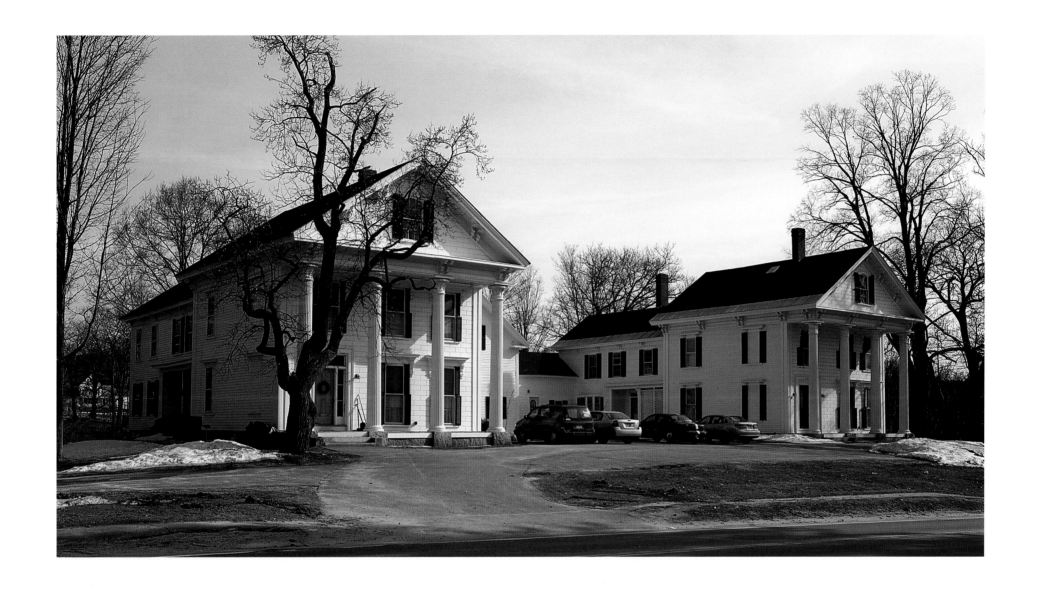

The Dutton Twin Houses, Main Street, Hillsborough, 2005. The houses were later joined by a connecting barn and have served over the years as private homes, a funeral parlor, a restaurant, and a private club. Note the twisted tree at the left by the front door in the older picture and how it has survived and grown into a mature tree, still recognizable in form as depicted in the recent picture.

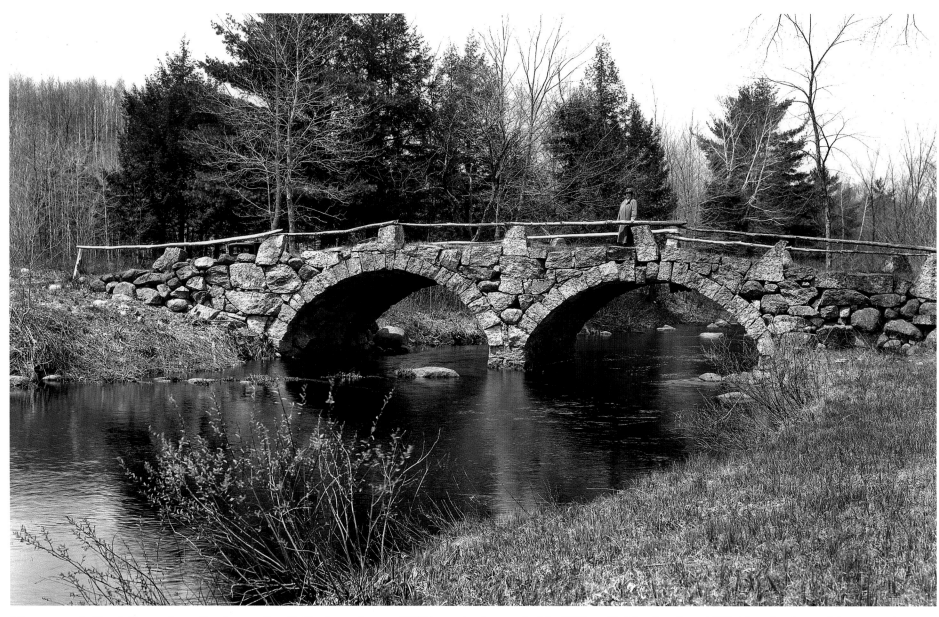

The stone-arch Carr bridge on Jones Road across Beard's Brook, southwest of Hillsborough, photographed by William H. Manahan Jr., c. 1920. Note the shape of the stones: they were fitted together without mortar or cement, and were intended to last much longer than bridges constructed with wooden timbers, which was the alternative at the time. This technique has proved to be effective. In all, there were 11 of these stone-arch bridges constructed near Hillsborough during the early part of the 19th century, eight of them still standing and six still in use. The American Society of Civil Engineers lists this and four other stone-arch bridges near Hillsborough as Designated Historic Civil Engineering Landmarks. Manahan-Phelps-McCullough collection of the Hillsborough Historical Society.

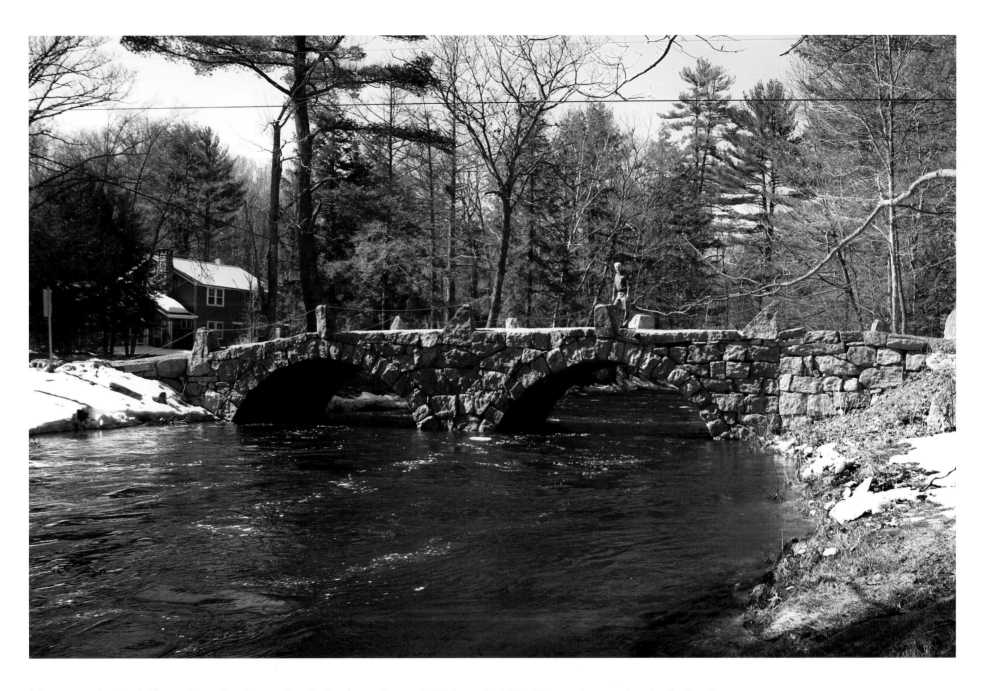

The stone-arch Carr bridge on Jones Road across Beard's Brook, southwest of Hillsborough, 2005. Heavy rains caused major flooding in October 2005 and closed the road, but the bridge remained intact.

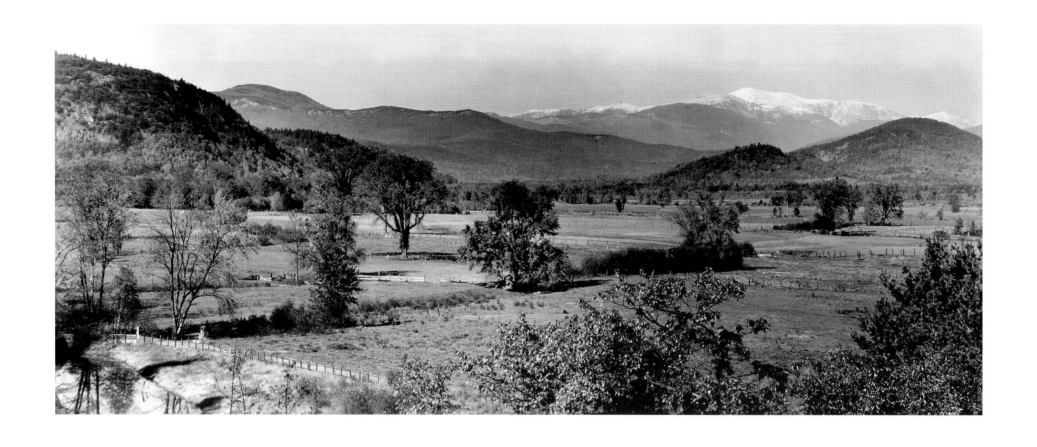

The Intervale Overlook, North Conway, photographed by Guy L. Shorey (1881-1961), c. 1920. With snowcapped Mount Washington and other Presidential Range peaks in the background, this view is one of New Hampshire's finest, and was often painted by artists of the so-called White Mountain School. The broad plain in the foreground, formed by the meandering Saco River, was first used by Native Americans for a summer encampment. Then for more than two centuries, the rich soil nurtured gardens and livestock raised by European settlers. Mount Washington Observatory collection.

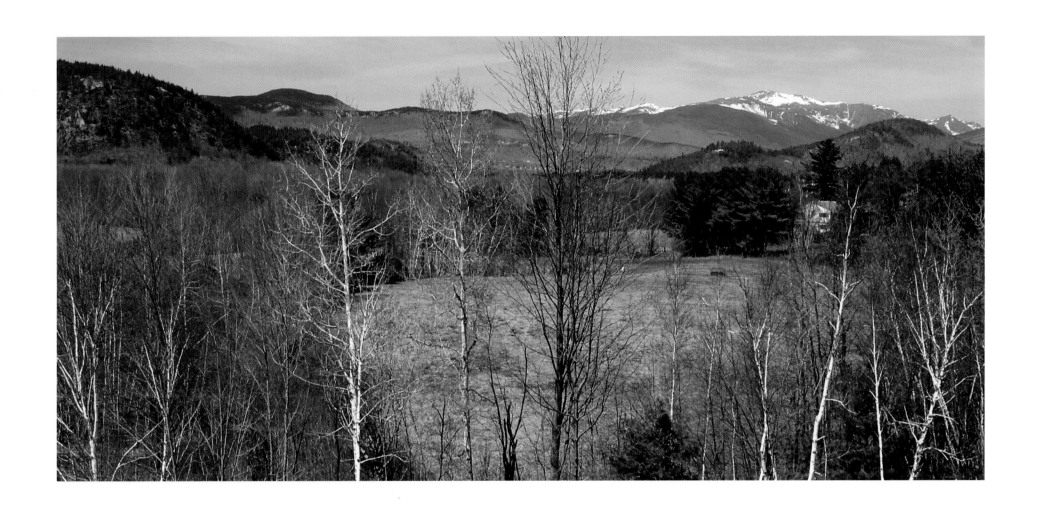

The Intervale Overlook, North Conway, 2003. Now the site of a State of New Hampshire information center and rest area, the overlook still features the same view of the mountains. The floodplain is no longer farmed and is growing back with trees and shrubs, and, at right, condominiums.

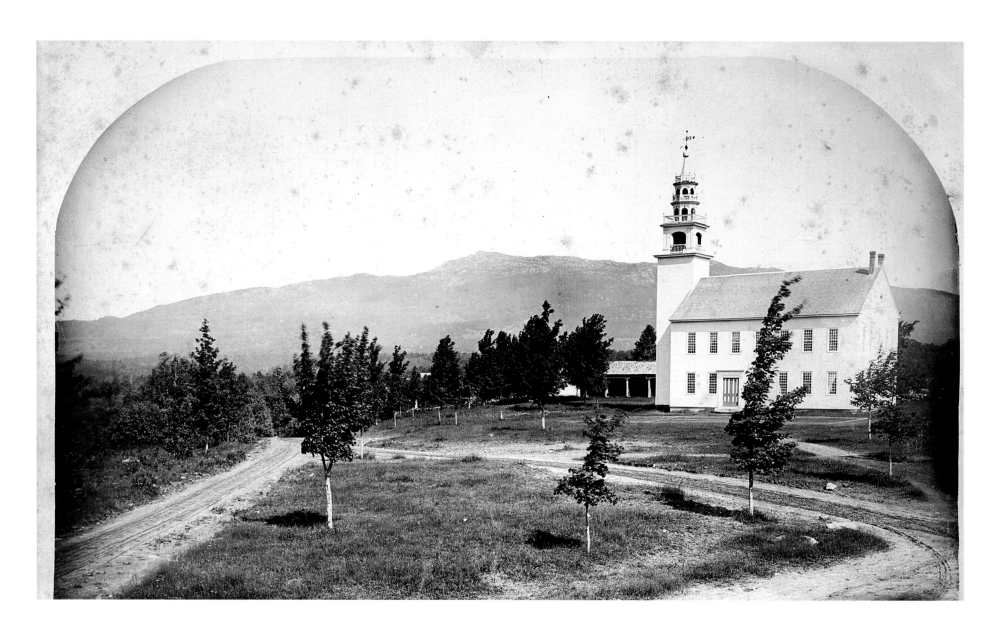

Jaffrey Center meetinghouse, c. 1773. When it was first constructed, the building remained unfinished for several years, until 1778, when Hessian mercenary Johan Buchler, who had escaped a prison camp after Burgoyne lost the Battle of Saratoga, came to Jaffrey. He was viewed with suspicion, but he made no trouble. Someone in town discovered that Buchler was a cabinetmaker. The Jaffrey meetinghouse had been sitting unfinished for three years and the Hessian was hired to complete the paneling and the inside of the building. He decided to stay in Jaffrey permanently. He soon changed his name to John Buckley, bought some land, built a house, and married a local girl by the name of Peg Dunlap. He eventually bought a 100-acre farm, continued his cabinet making business, and raised a family of seven children. New Hampshire Historical Society collection.

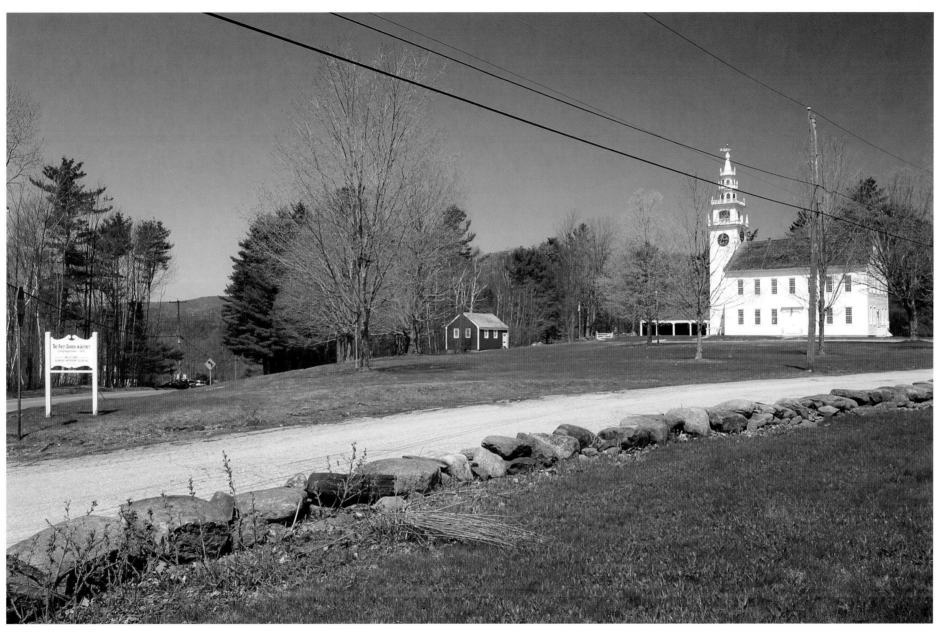

Jaffrey Center meetinghouse, 2004. This magnificent building is the home of the Amos Fortune Forum, a series of lectures on subjects of public interest, and a continuing tribute to Fortune, a freed slave and much esteemed intellectual gentleman in the Jaffrey of his day. Fortune and novelist Willa Cather are buried behind the building. The above photograph and the historic one on the page opposite were taken from the same place, but the relationship between the steeple and Mount Monadnock is different. The earlier photographer must have been standing higher, perhaps in a house no longer here.

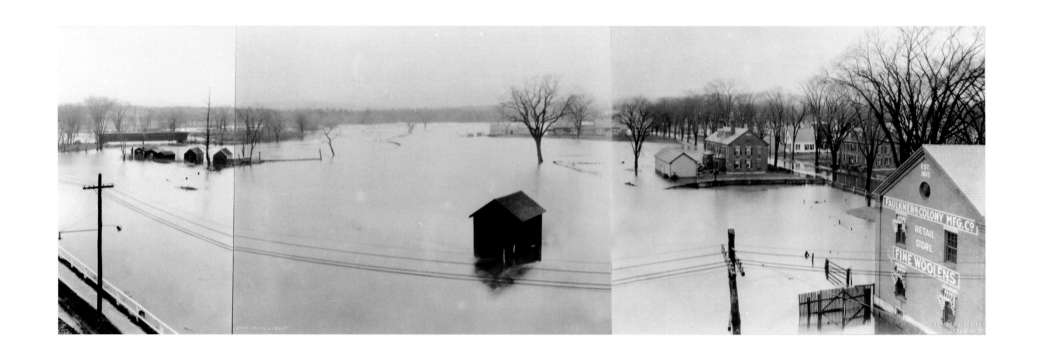

View from Mill No. 2, West Street, Keene. In 1927 floods created $100 million in damage along the Connecticut River Valley. Here water covers the area adjacent to West Street in Keene on November 4 at 1:30 P.M. This photograph was made from the roof of Mill No. 2, now the Colony Mill Marketplace. Note the two brick houses at right. Historical Society of Cheshire County collection.

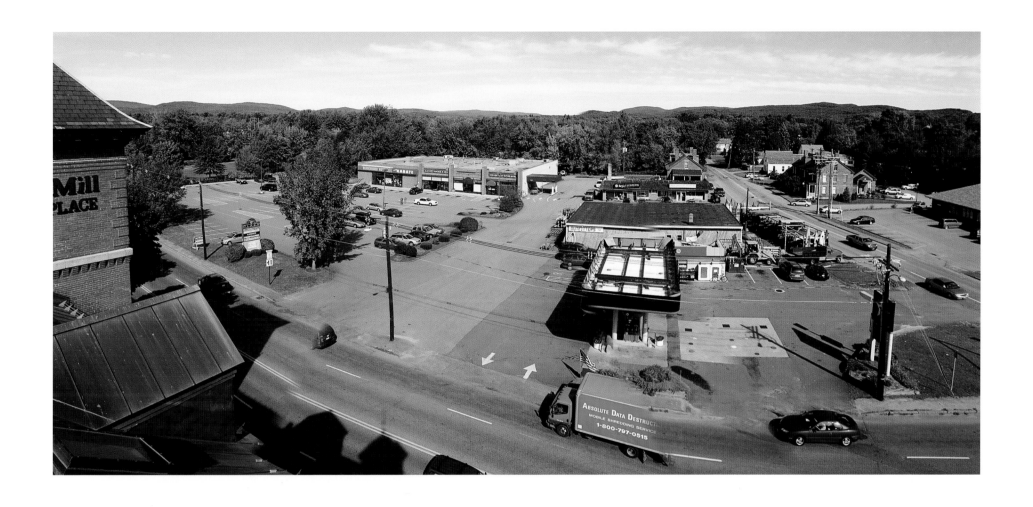

View from the bell tower of Colony Mill, 2005. This image is not quite as wide as the photograph on the page opposite, which was made from the roof on the other side of the bell tower. Note that the two brick houses at right are still standing. In order to prevent further floods, such as occurred in 1936 and 1938, the Army Corps of Engineers built Surry Mountain Dam at the confluence of the Ashuelot and Connecticut Rivers. In the October 2005 Cheshire County floods, this area remained dry, thanks to the dam.

Dr. Josiah Bartlett House, Kingston, The Halliday Historic Photograph Co., Boston, Mass./Hampstead, N.H., 1915. Dr. Bartlett (1729-1795) was a skilled physician who practiced medicine at Kingston from 1750 and was founder and first president of the New Hampshire Medical Society. He was called on frequently to fill state and national offices, and he often had to forgo his medical practice for long periods. Bartlett was a signer of the Declaration of Independence. He served as chief justice of the Court of Common Pleas (1779), was the president of New Hampshire in 1791, and served as governor in 1792, when the title of the state's chief executive was changed. New Hampshire Historical Society collection.

Dr. Josiah Bartlett House, Kingston, 2004. Situated on the picturesque, spacious town common, the house is a private residence. At right is a linden tree that Dr. Barlett planted in 1777.

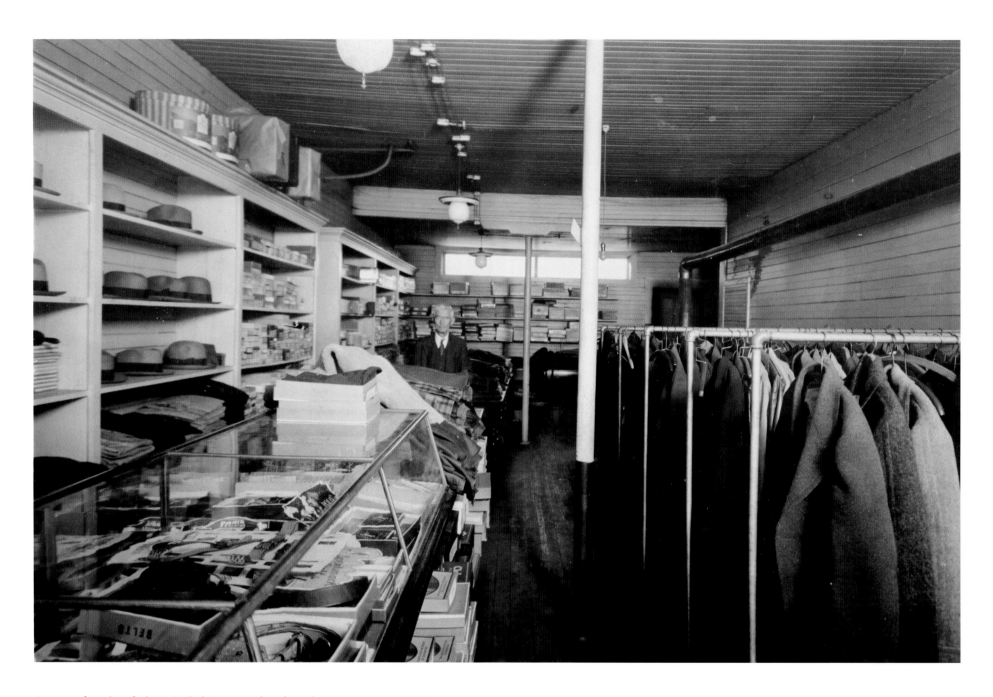

Interior of unidentified men's clothing store, thought to be in Lancaster, c.1930.
New Hampshire Historical Society collection.

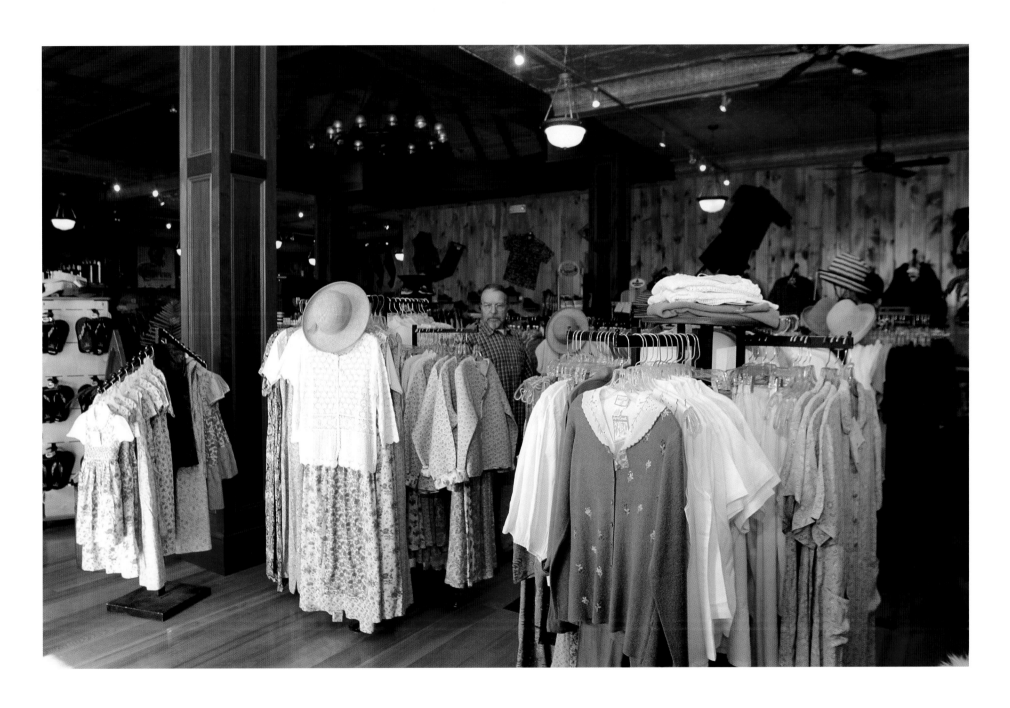

Jim Boyers adjusts clothing at Simon the Tanner, Main Street, Lancaster. 2003.

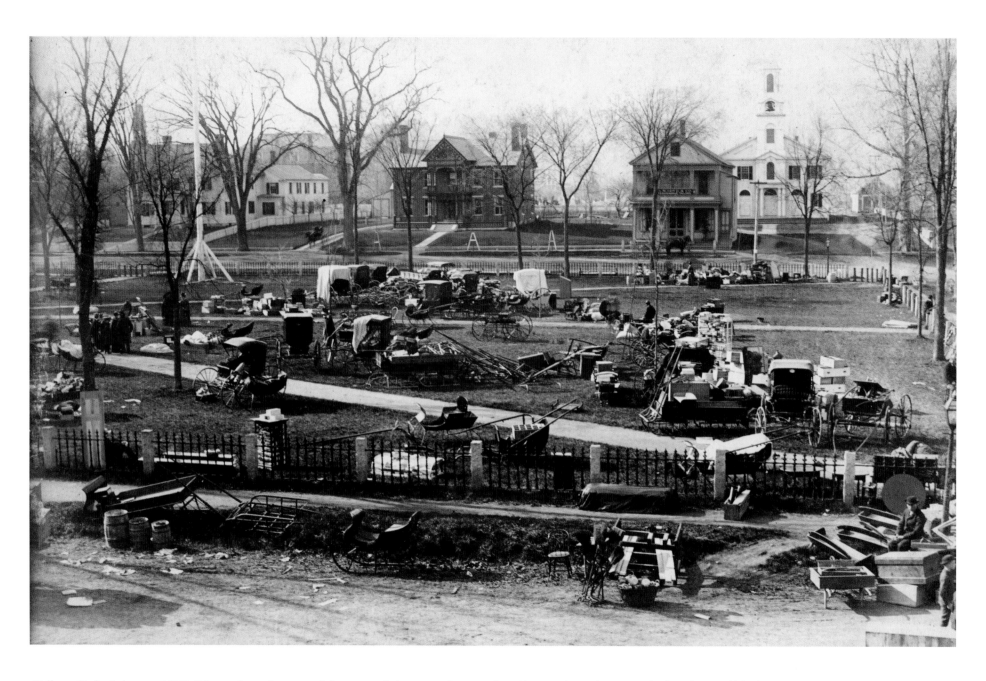

Colburn Park, Lebanon, 1887. When a huge fire ravaged downtown Lebanon on January 4, residents and merchants saved what they could by bringing items to the park. This photograph was taken on May 10, when most of the saved goods had been removed.

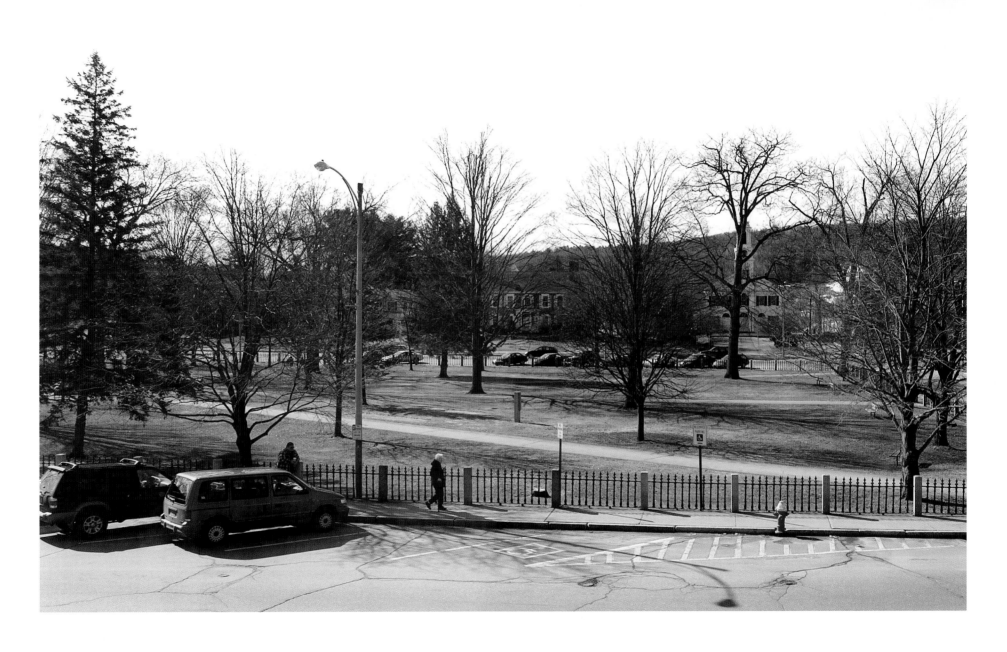

Colburn Park, Lebanon, 2004.

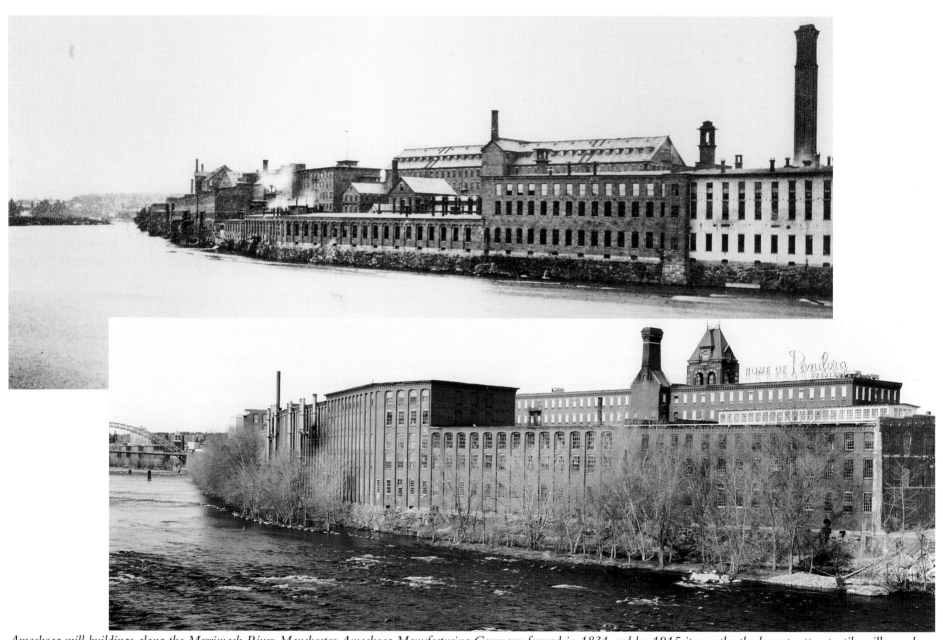

Amoskeag mill buildings along the Merrimack River, Manchester. Amoskeag Manufacturing Company formed in 1831 and by 1915 it was the the largest cotton textile mill complex in the world with over 17,000 employees. At this time, however, competition from southern mills forced Amoskeag into financial difficulties and the company cut wages which resulted in worker's strikes. The financial woes continued into the Depression and Amoskeag shut down permantly on Christmas Eve 1935. Top: The mills in 1880, Gary Samson collection. Below: The mills in 1980, photograph by Gary Samson.

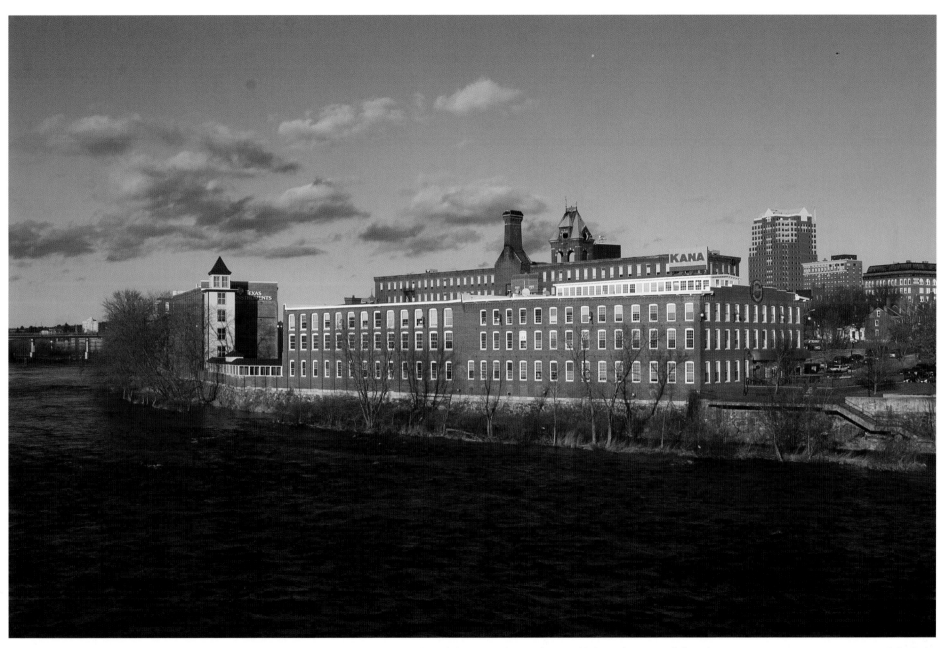

Amoskeag mill buildings beside the Merrimack River, Manchester, 2004. A number of the original Amoskeag mills have been razed, but the remaining structures are now used for light manufacturing, offices, artist's spaces, residences, and the Manchester campus of the University of New Hampshire. The large building at center has a restaurant that faces a small park. The old Queen City Bridge at left has been replaced with a new structure.

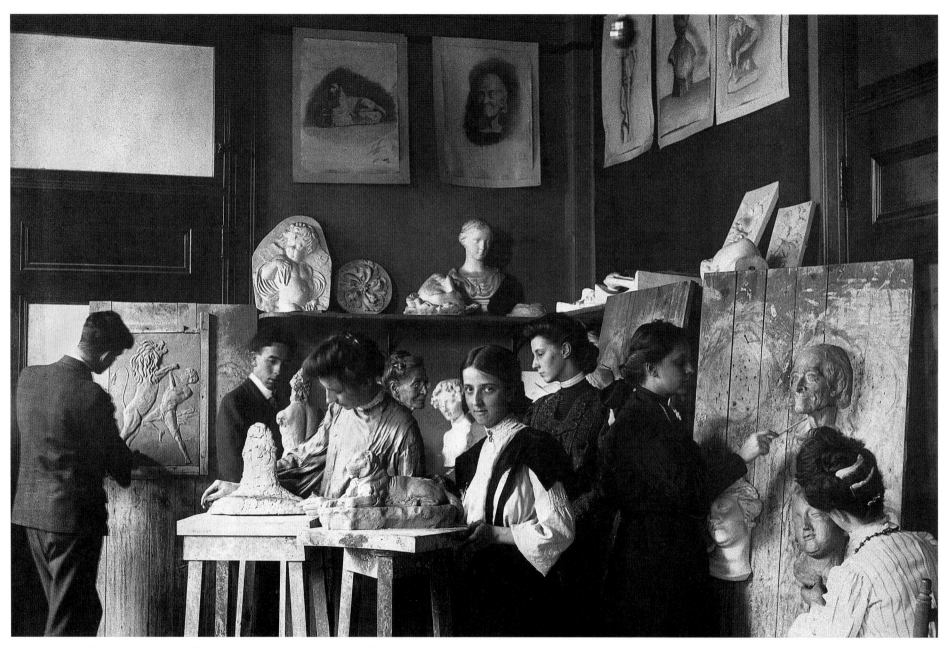

Art students, Manchester Institute of Arts and Sciences, Manchester, c. 1918. Founded in 1898, the institute's goal was to cultivate and stimulate the instruction and appreciation of art in a progressive environment. The institute functioned as an important cultural center for New Hampshire. In 1924, the State Board of Education certified the institute's four-year program to prepare high school graduates to teach art. Shortly thereafter, a four-year program in fine arts was approved. Manchester Institute of Arts and Sciences collection.

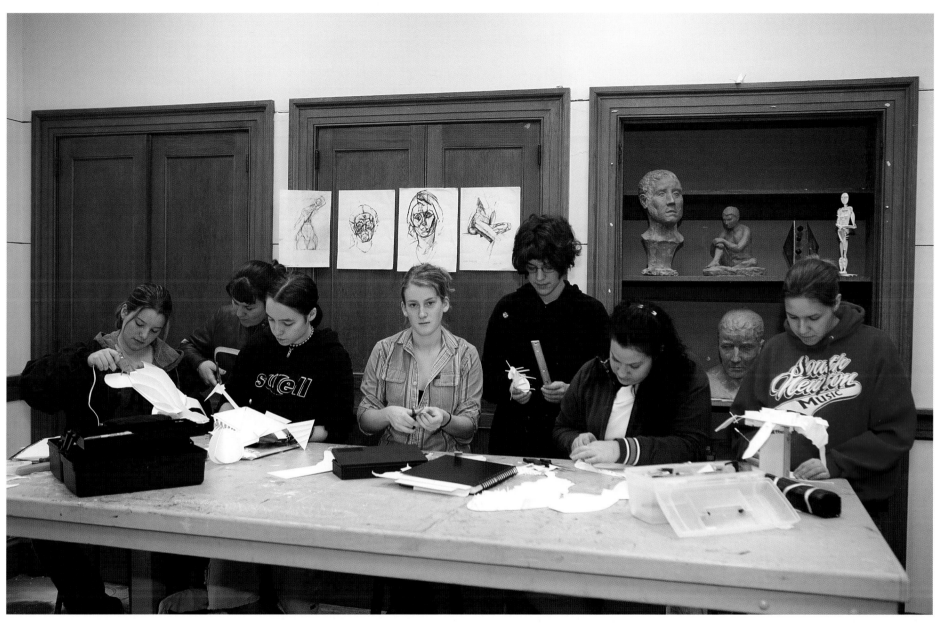

Art students, New Hampshire Institute of Art, Manchester, 2005. In 1996, the New Hampshire Postsecondary Commission authorized the institute to award the bachelor of fine arts degree. At that time, the institute became the New Hampshire Institute of Art. With the opening of Fuller Hall in 2000, the institute doubled the size of its urban campus, adding to the quantity and quality of classes offered. Students in a 3-D modeling class, left to right, are Ashley Haywood, Rachael Ouaska, Molly DeFrees, Molly Williams, Rebecca Parent, Christina Carignan, and Rebecca Sherfrey.

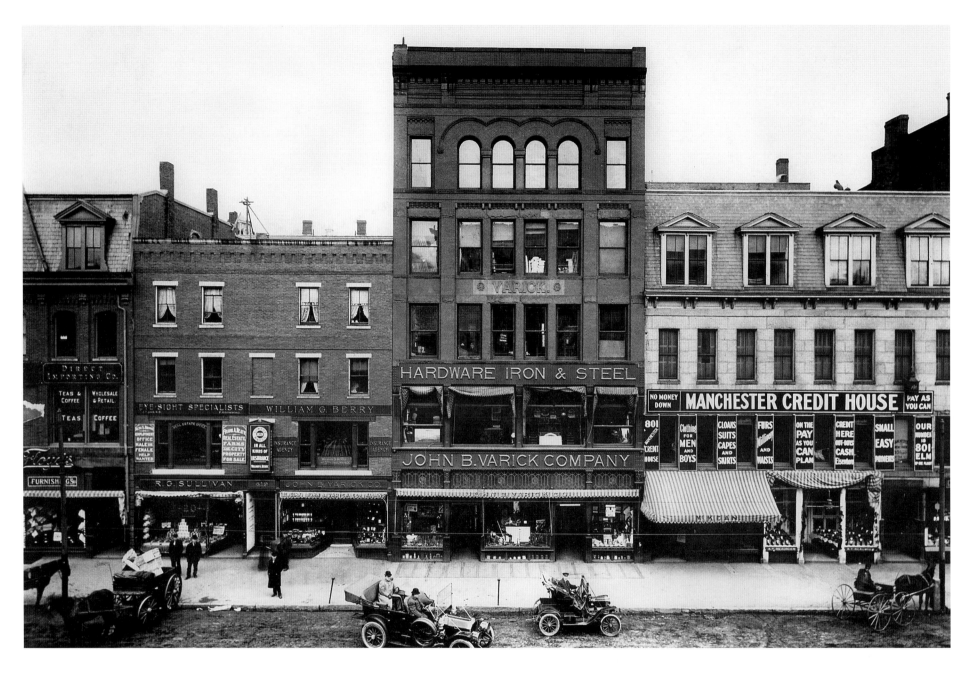

Varick's Department Store, Manchester, c. 1920s. Varick's was a renowned hardware/department store in its day that boasted the largest photography department north of Boston. Longtime Manchester photographer Ulric Bourgeois's studio was in Varick's for almost three decades. Bourgeois may have taken this image. Gary Samson collection.

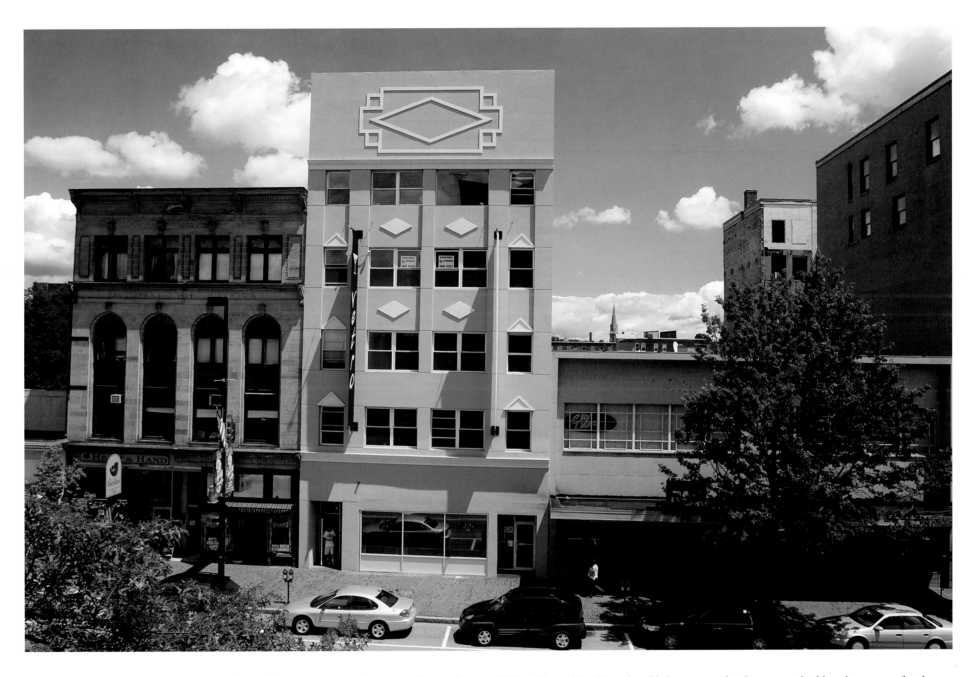

Varick's remodeled, Manchester, 2004. Change has come to Manchester as it has to the rest of New Hampshire. Here the old department/hardware store building has a new facade and there are new buildings on either side.

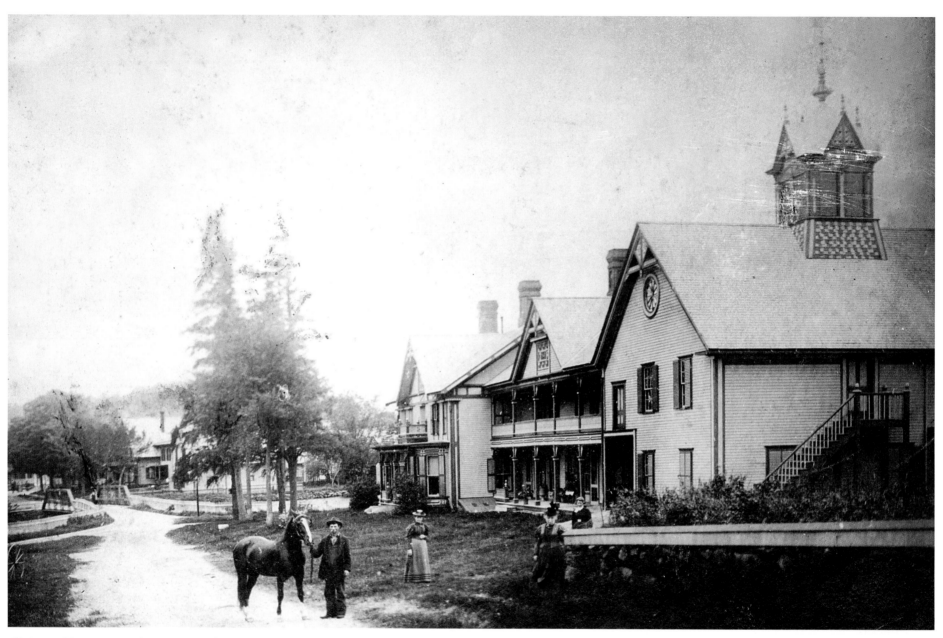

Christmas Trees Inn, Marlow, c. 1900. The inn was built in 1833 by Col. Bethuel Farley. Here, he and his family manufactured inks and extracts in a barn located on the property, and sold them through mail order. Throughout its colorful history, the Christmas Trees Inn has served as a private residence, mill housing, and a summer retreat for Hollywood stars. The inn was named by actress Virginia Sale and her husband, director Sam Wren, who purchased the property in 1955, and converted the building into a country inn where they entertained friends including cowboy sidekick Lester "Smiley" Burnette. New Hampshire Historical Society collection.

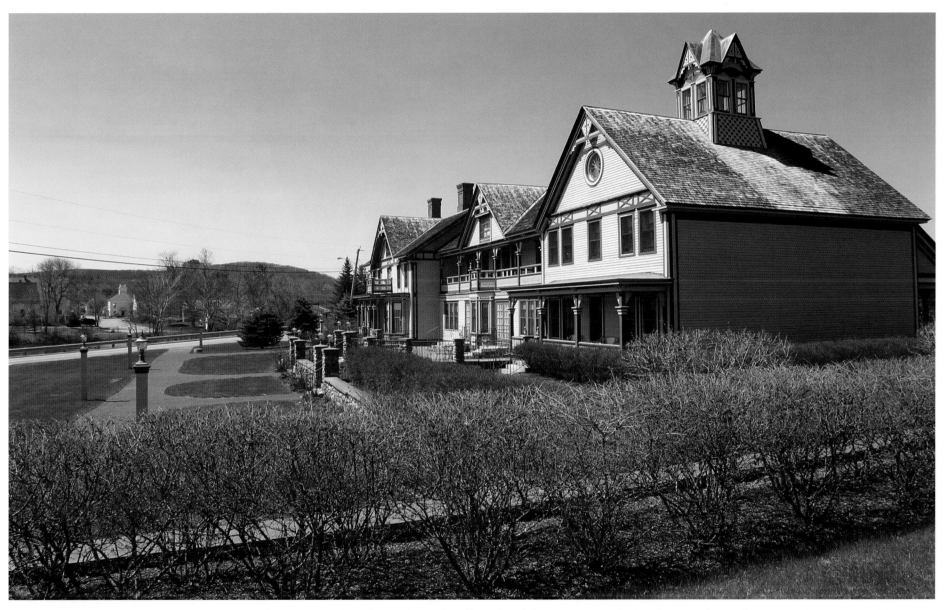

PC Connection, 2004. PC Connection, Inc.'s co-founders Patricia Gallup and David Hall purchased the property in 1984 and renovated it as the company's corporate training center. Since then, the direct marketer of personal computer products has grown from a mail-order supplier of computer peripherals and accessories to a $1.5 billion Fortune 1000 provider of complete information technology solutions with offices in Keene, Portsmouth, and Merrimack, as well as in many other locations across the country. In 1990, New Hampshire Governor Judd Gregg honored PC Connection with the Inherit New Hampshire preservation award for restoration of important village landmarks, most notably the Christmas Trees Inn. The company continues to utilize the building for company meetings and functions, private parties, and community benefit events.

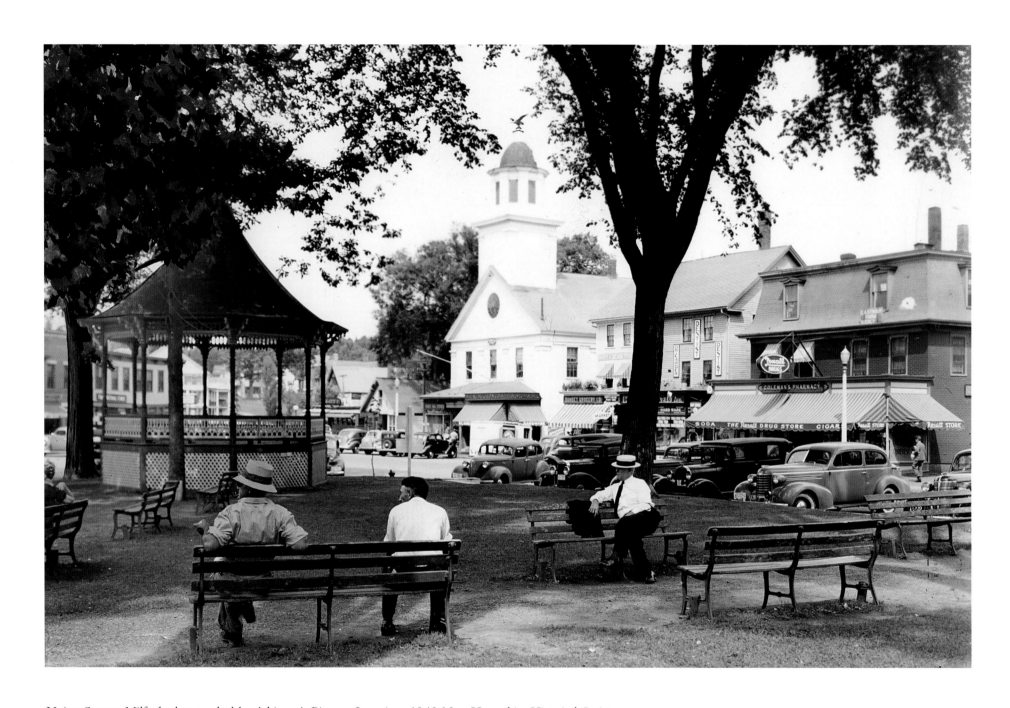

Union Square, Milford, photographed by Atkinson's Pictures, Laconia, c.1940 New Hampshire Historical Society.

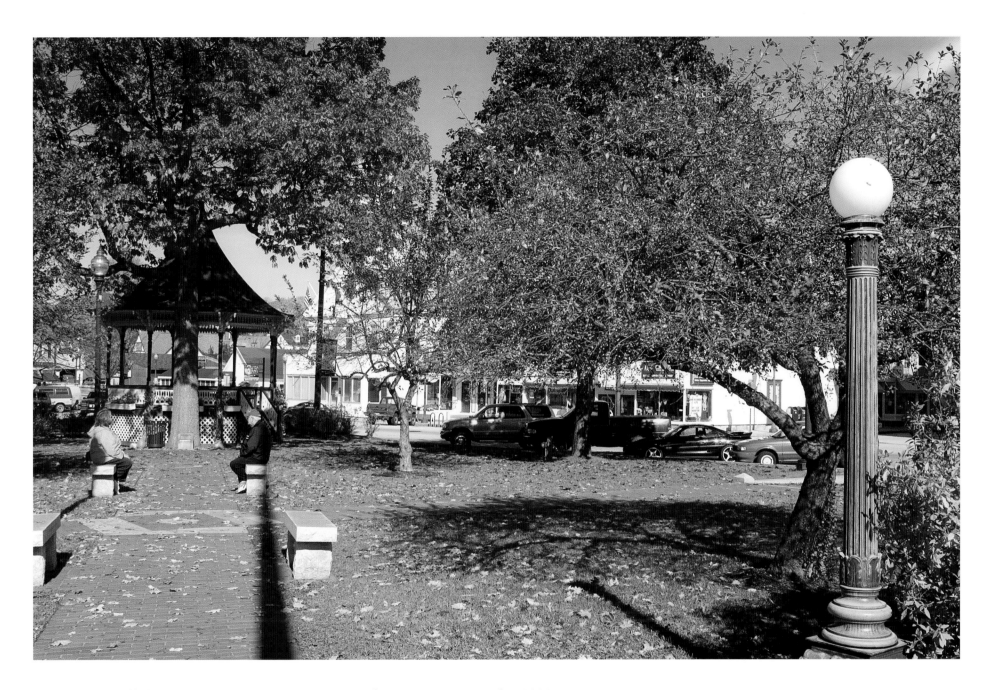

Union Square, Milford, 2004. As an ongoing community project, the common was renovated in 1996, complete with a sidewalk composed of bricks with the names of the buyers stamped on them.

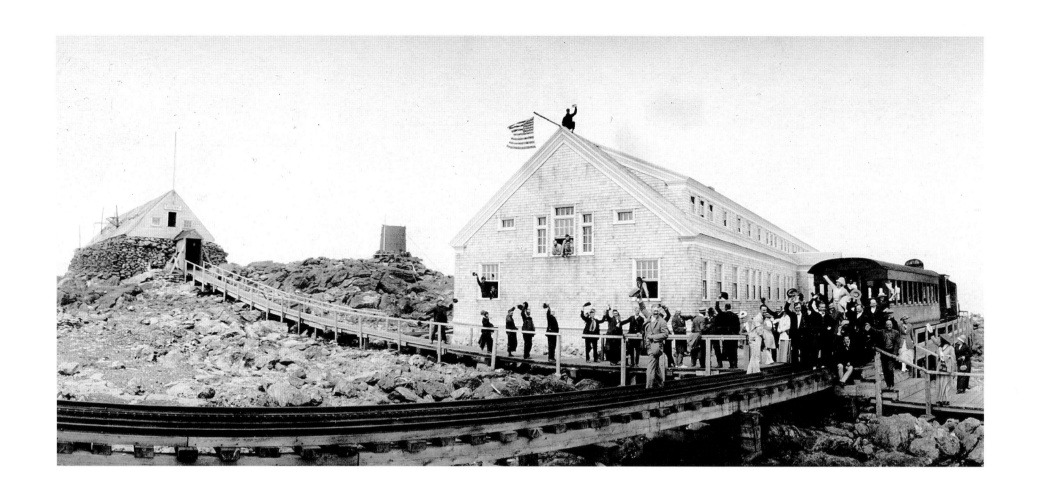

Summit House, Mount Washington, photograph by Guy L. Shorey, August 21, 1915. This image was made the day the third and last Summit House opened. It served overnight guests until 1968, then was torn down in the late 1970s. It replaced the previous Summit House, which burned in 1908. At left is the Tip Top House, built in 1853, originally with a flat roof. The building was expanded, and the peaked roof was added in 1861, and it remained as a hotel until 1873. The Mount Washington Cog Railway began trips to the summit in 1869. Mount Washington Observatory collection.

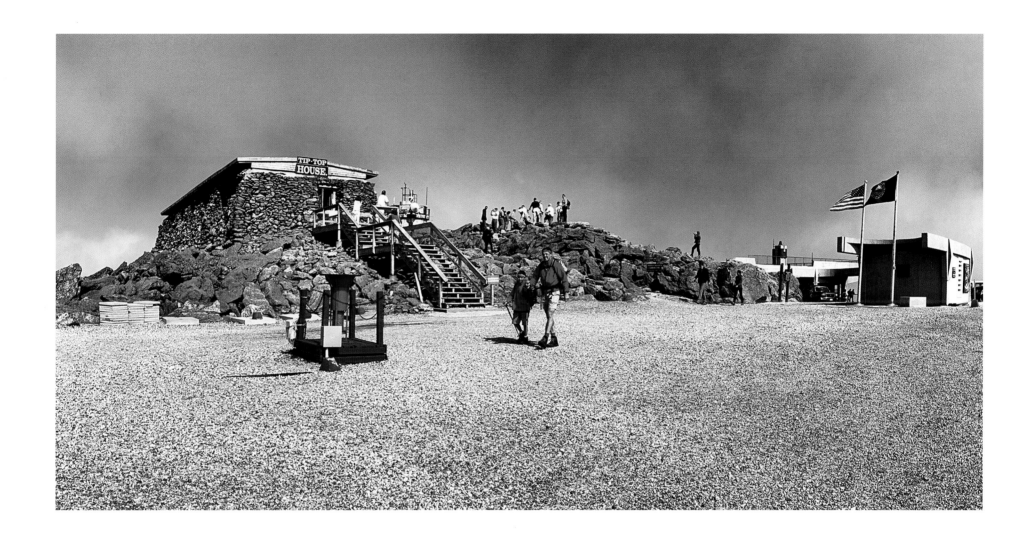

Summit buildings, Mount Washington, 2004. Since 1971, New Hampshire has operated the summit of the highest mountain in the Northeast as a state park. The badly deteriorated third Summit House was torn down to make way for the 1980 Sherman Adams building, at right, which houses the state park facilities and the Mount Washington Observatory, which began in 1932 in a separate building. In 1934, the observers reported a 231-mile-per-hour gust of wind, the highest ever recorded. The nonprofit observatory still records the mountain's weather, conducts research on a variety of projects, issues daily weather reports, and hosts overnight eco-trips in all seasons. The old Tip Top House was restored and is open to the public during the summer. The cog railway tracks are behind the photographer. The group of people at center are standing on top of the mountain at an elevation of 6,288 feet.

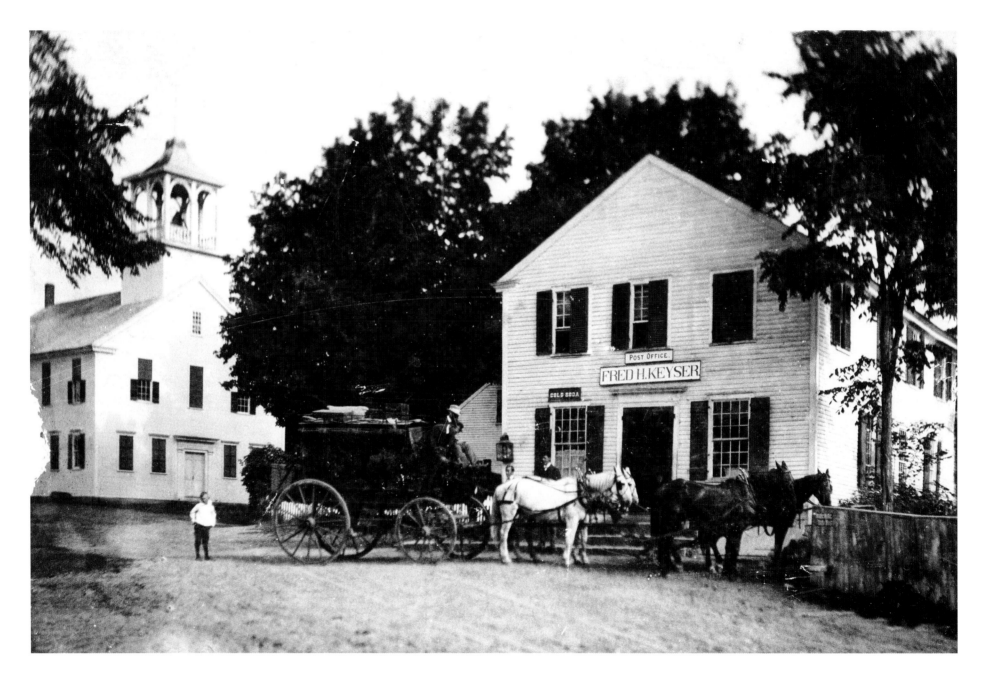

Post Office Square, North Sutton, 1900. In front of Fred Keyser's store is the Bradford and New London stagecoach that served the local towns into the early years of the 20th century. The North Sutton meetinghouse was built in 1797, about the same time the store was opened. New Hampshire Historical Society.

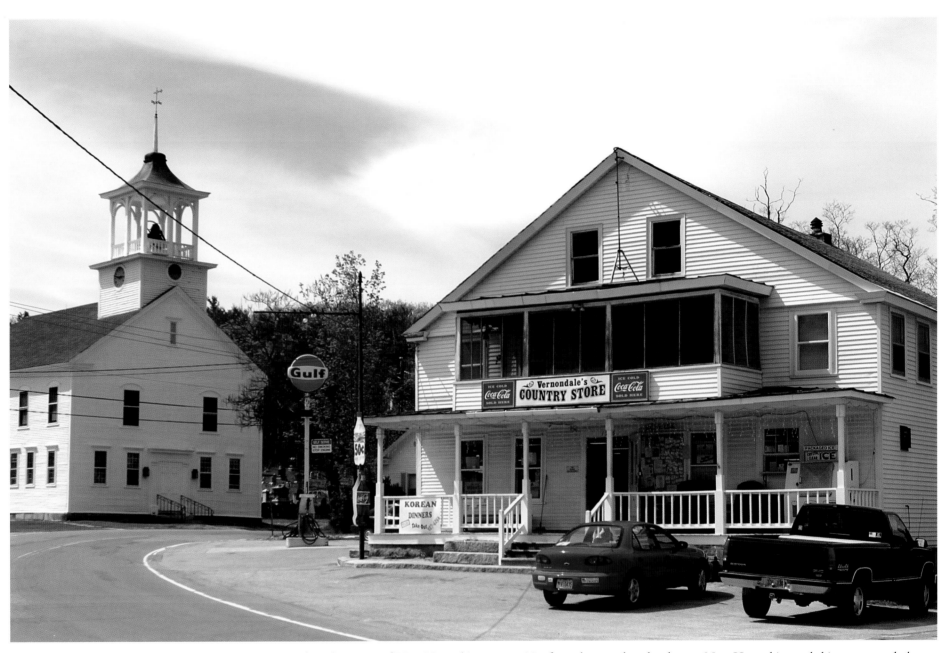

Post Office Square, North Sutton, 2003. Country stores have been part of New Hampshire communities for as long as there has been a New Hampshire, and this one, opened about 1800 may be the oldest continuously operating general store in the state. Vernon West and Dale McDonald purchased the store in 1934, built an addition on the front, and named it for themselves. Autos and gas pumps have replaced horses and watering troughs.

Nelson Village, 1920. Small-town Nelson is another of New Hampshire's communities that appear to have changed little in decades. At center, in this view from Cemetery Road, is the Congregational church. The three buildings at right are the 1846 brick schoolhouse #1; the town hall, which was part of the original 1780s meetinghouse and was moved to this location in the 1840s; and a residence that in the 20th century was the home of artist Albert Quigley. Historical Society of Cheshire collection.

Nelson Village, 2004. Nelson has undergone small changes when compared to the image on the page opposite. There's now a church addition, as well as the town library on the corner. The brick schoolhouse is now used for town offices, as is the small town hall next door. The latter is connected to the new library. In the 19th century, the little green at left was the site of several buildings. Now it holds a large collection of mailboxes.

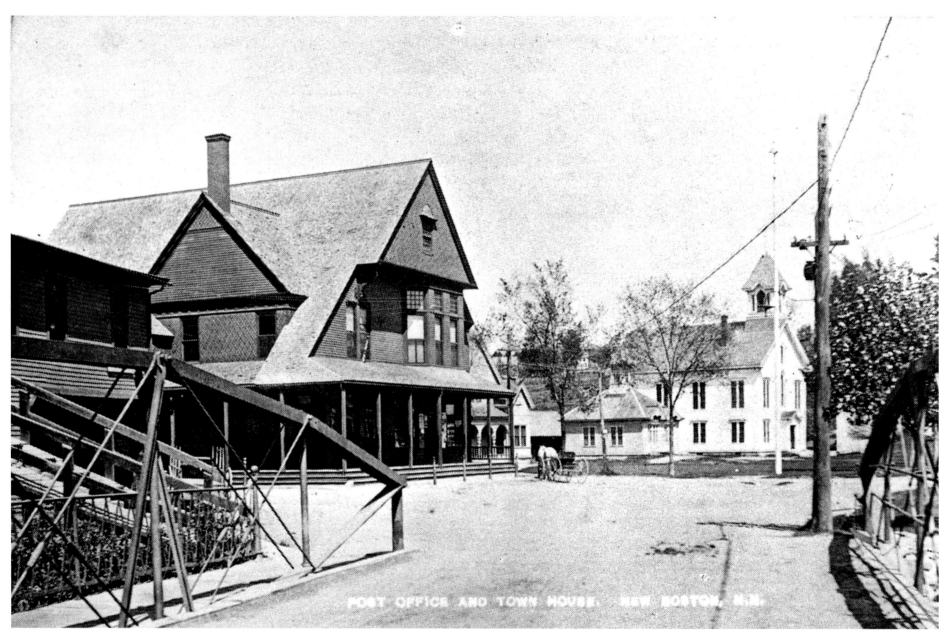

POST OFFICE AND TOWN HOUSE, NEW BOSTON, N.H.

New Boston Village, c. 1890. The building at left once held a blacksmith shop and a steam-powered cooper's shop. Sparks from this building caused the fire that destroyed the village in 1887. After the fire, town benefactor J. R. Whipple rebuilt the other structures shown here. At center is Valley Hall, which housed the post office and an 1,800-book library purchased and made available free to residents by Whipple. S. D. Atwood operated his general store on the first floor. To the right of the store can be seen the New Boston Baptist Church, the small firehouse, and the town house. New Hampshire Historical Society collection.

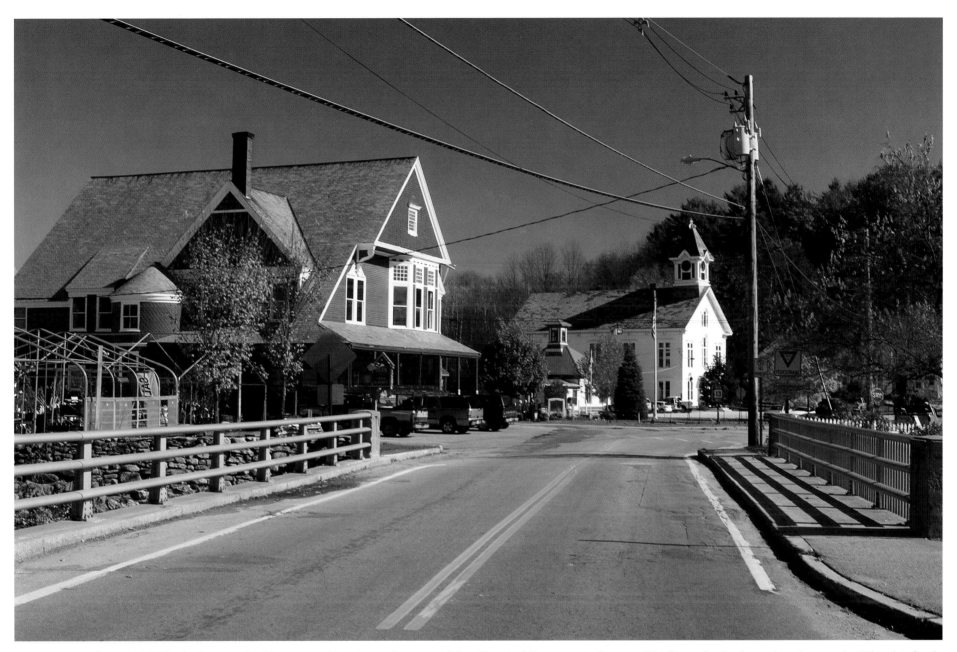

New Boston Village, 2004. The bridge over the Piscataquog River is new but most of the village buildings remain the same. The library books, donated to the town by Whipple's family after his death in 1912, formed the basis for the new Whipple Free Library, now located across the street from what is now Dodge's Store. The Baptist church is gone, but the firehouse is now the New Boston Historical Society.

Above: Fort Constitution and the lighthouse keeper's cottage, New Castle, c. 1945, photographed from the lighthouse apparently during World War II, when barracks and other military buildings were on the site. New Castle Town Archives.

Right: Fort Constitution and lighthouse keeper's cottage, 2005. The U. S. Coast Guard uses the house, but the fort is now a State of New Hampshire Historic Site and open to the public. The lighthouse is also open one day a month for visitors.

Hotel Wentworth, New Castle, c. 1880. Built in 1874, the hotel was expanded substantially when purchased in 1879 by Portsmouth ale-maker Frank Jones. He served as Portsmouth mayor, New Hampshire congressman, and president of the Boston and Maine Railroad. A local tycoon, Jones owned a newspaper, electric and power utilities, an insurance company, racing stables, and the Rockingham Hotel in downtown Portsmouth in addition to his large brewery. Under the terms of Jones's will, the hotel hosted at no cost the Russian and Japanese envoys who came to the region in 1905 to negotiate the Treaty of Portsmouth. Although painted green in this picture, the hotel was eventually painted white and featured two large wings attached to the right side of the building. A century after it was built, the hotel closed in 1982 and demolition was expected. Portsmouth Athenaeum collection.

Wentworth by the Sea Marriott Hotel and Spa, New Castle, 2005. Closed for 20 years and under the threat of demolition, the hotel was saved through the promotional efforts of the nonprofit Friends of the Wentworth and the expertise of the local Walsh family, hotel owners of Ocean Properties. Restored and enlarged by Ocean Properties at a cost of more than $20 million, the new hotel opened in May 2003. Throughout the 20th century, the hotel was a center of social activities on the seacoast. The new hotel has continued where the old one ended: It hosts wedding receptions, family reunions, and conferences, and in 2005 several events in celebration of the 100th anniversary of the Treaty of Portsmouth.

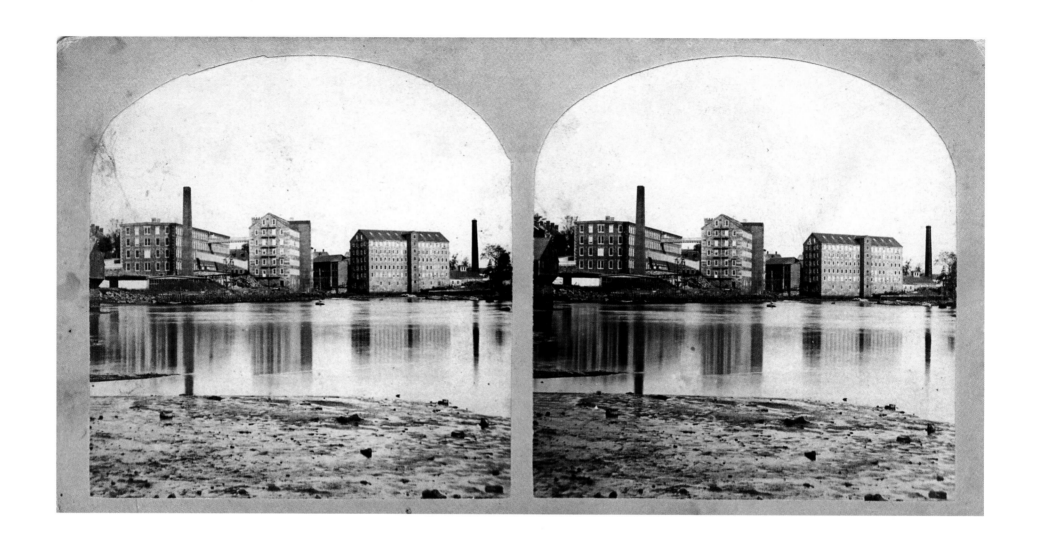

Newmarket Mills from the flats. Photographed by F. L. Hutchins of Newmarket, c. 1877. Before the Newmarket Manufacturing Company arrived in town in 1823, there had been mills at the Lamprey First Falls for more than 150 years. Salem, Massachusetts, merchants who had made their fortunes in the China trade, and looking for an opportunity to invest, came to Newmarket in 1823, bought up most of the properties around the First Falls of the Lamprey and began construction of a mill complex for the production of cotton thread and its weaving into cloth. Mill No. 3, north of the river, at right, was, built in 1827. Its machinery, 1,034 spindles, was installed in 1829. Mill No. 1, completed in 1824 with 2,500 spindles, is obscured behind Mill No. 2, at center, that was built in 1825. Mill No. 4, at left, was built in 1869, of "trap rock." The other mills were built of locally quarried granite blocks. For many years the textile company produced cotton, but by 1900 it was also weaving silk fabric. The complex eventually totalled eight mills. The falls of the Lamprey River originally provided the energy for the thriving textile mill complex, but later coal was used to provide power and heat. The mills were used for textile production until a labor strike and the Depression caused the company to move to Lowell, Massachusetts. The first shoe factories came in 1933. Matthew Thomas collection.

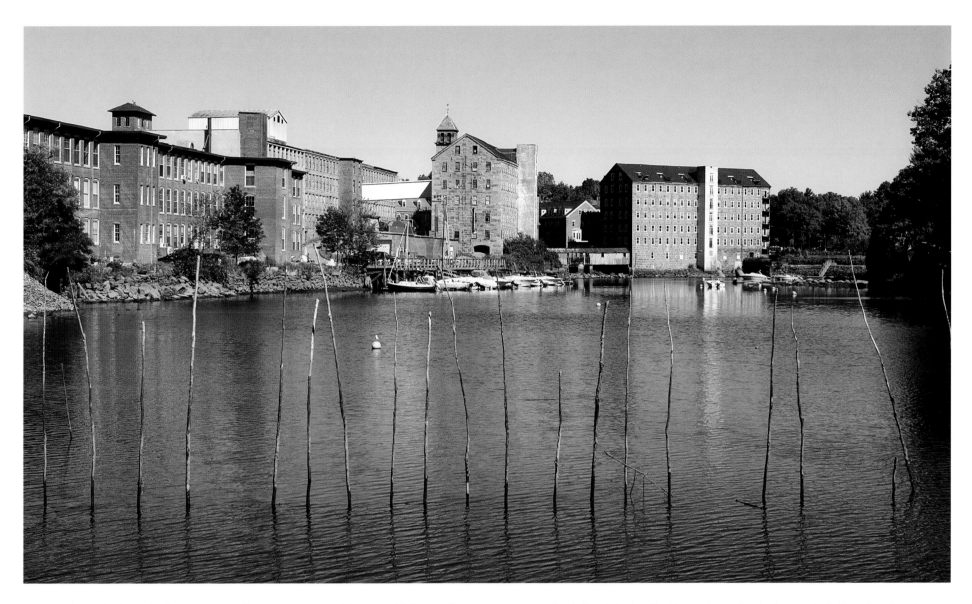

Newmarket Mills from the flats, 2005. Mills No. 5 and 6 at left were added to Mill No. 4, but as textiles declined during the Depression, other industries, including shoe factories such as internationally known Little Yankee (in Mill No. 4), where the author's father once worked, and Timberland, soon moved into the large spaces. Now the shoe businesses are gone as well. The Macallen Company, which produced mica products for the electrical industry, used to be principally in Mill No. 3, and Kingston Warren Company was started in Mills Nos. 5 and 6 and remained there until recent years when they moved to nearby Newfields. While some of the buildings remain industrial, others have been converted into residential condominiums. Mill No. 2, center, in later years had an upper tower section added to its west tower to house a bell and the weathervane. The poles in the foreground are part of a Lamprey River fish weir, recalling the past centuries when Native Americans lived and fished here.

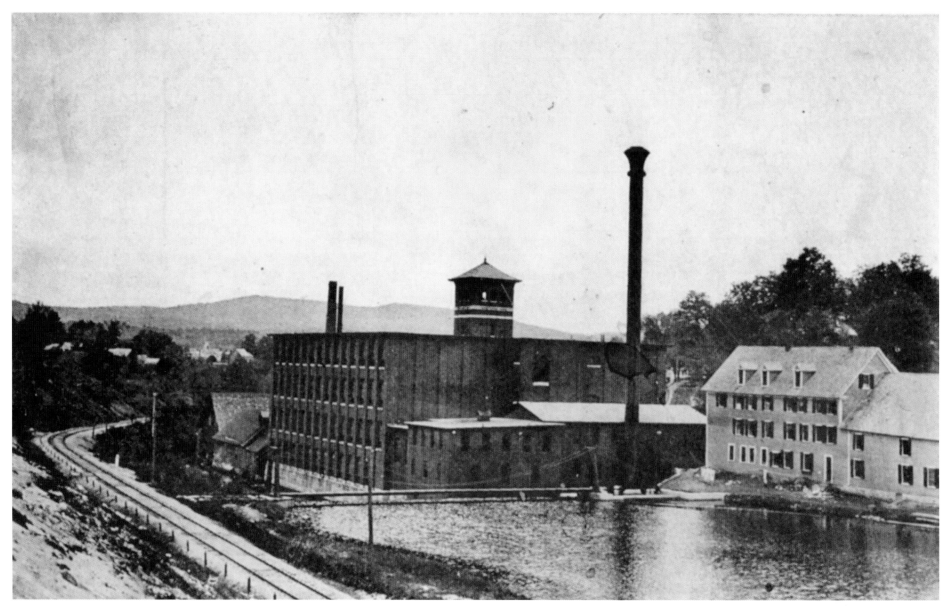

Dexter Richard & Sons Co. Woolen Mills, Newport, Frank W. Swallow Post Card Co., Inc., Exeter, c. 1910. Richards first constructed a wooden mill building on the Sugar River in 1848. In 1905, he built this brick mill around the wooden one, then tore down the old mill. In the 1930s the Brown family bought the mill and continued to make woolen fabrics through World War II. Newport, like many other New Hampshire communities situated on rivers, was once a thriving textile mill town. The railroad brought raw materials and hauled away the finished cloth. Eventually, competition from southern mills ended the New Hampshire textile industry leaving millions of square feet of empty mill space.

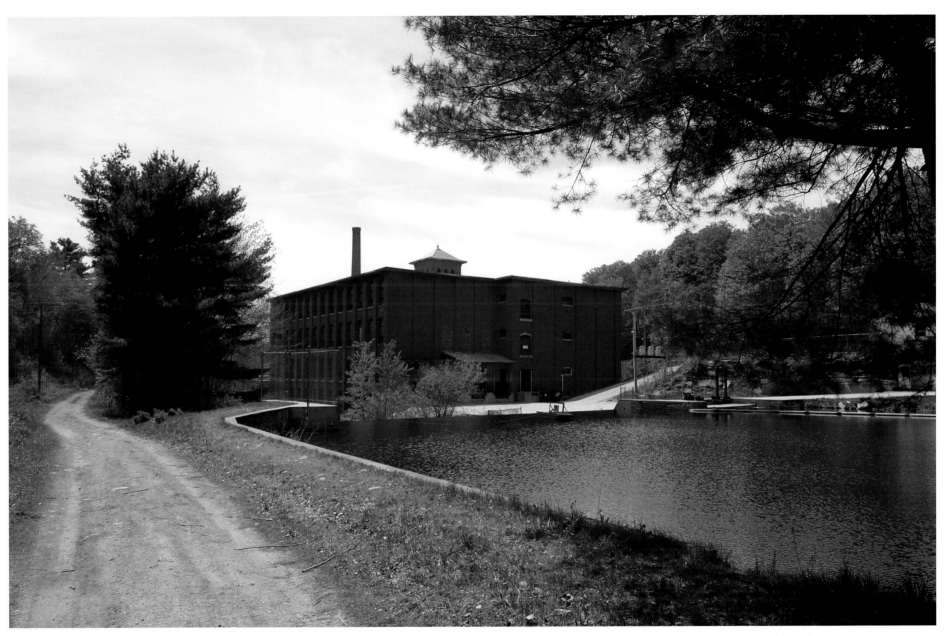

Textile Mill, Newport, 2005. The textile industry has left New Hampshire and indeed most of the United States as well, leaving the old mills to be used for other purposes. In the 1960s, this mill was used by the Sportwelt Shoe Company to make army boots, but the shoe industry also has left New Hampshire. The availability of dozens of abandoned mills eventually worked to the state's advantage as light manufacturing and then the high-tech industry were able to use the inexpensive mill space to begin or expand businesses. Since 1980, this mill has been owned by William Ruger, who has renovated the building, and it has been used by a variety of small companies. A hydro plant on the dam still generates electricity.

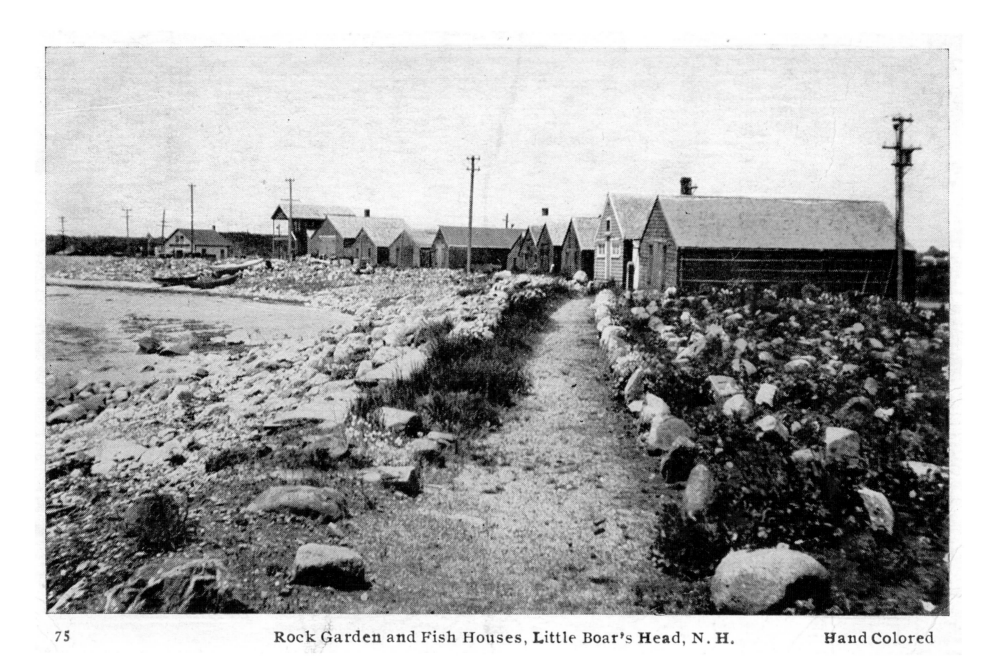

75 **Rock Garden and Fish Houses, Little Boar's Head, N. H.** **Hand Colored**

Rock garden at Little Boar's Head, North Hampton, c. 1940. The garden was created in 1937 by Molly Frost, who lived across the street. The fish houses are approximately 200 years old and were used to store bait and equipment. The fishermen worked from dories that were launched from the shore. With the development of powered boats, most of the fishermen moved to Hampton or Rye harbors and the houses became summer cottages. The last working fish house was sold about fifty years ago. Matthew Thomas collection.

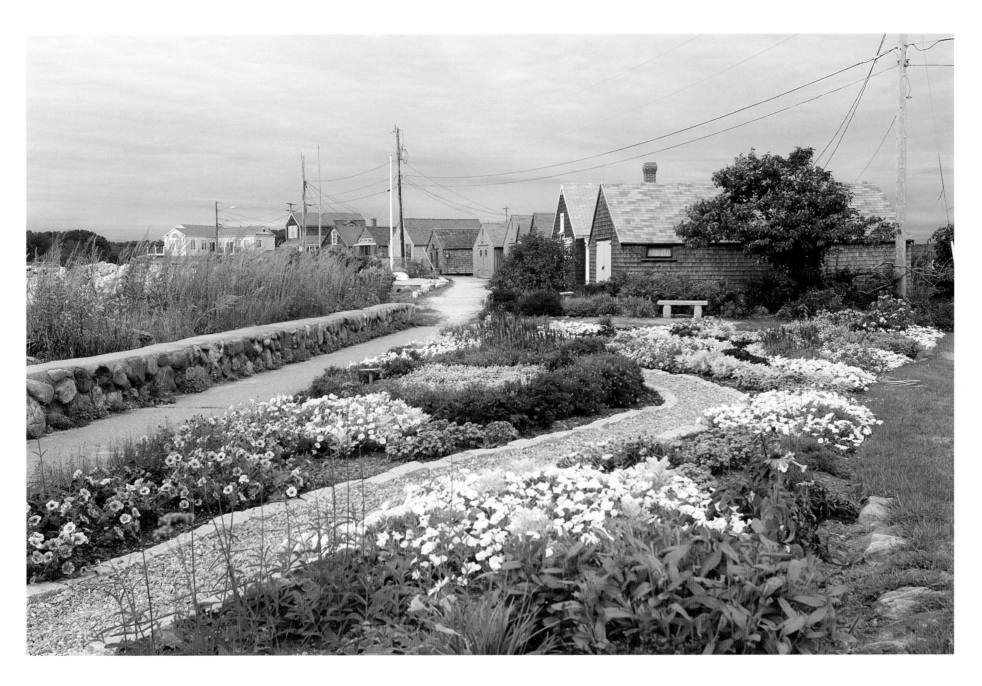

Rock garden at Little Boar's Head, North Hampton, 2005. For many years the garden has been maintained by the Rye Beach-Little Boar's Head Garden Club.

Grafton County Courthouse, Plymouth, photographed by W. A. Wright, Ayer, Massachusetts, c. 1895. The courthouse, built in 1890, was the county's third, and it served the superior and probate courts as well as the registers of deeds and probate. At right is Rounds Hall, built by the state in 1892 for Plymouth College, which began as a normal school in 1871. New Hampshire Historical Society collection.

Plymouth Town Hall, 2004. When the county constructed new facilities in 1969, the old courthouse became available to the town. It was remodeled in 1996. Rounds Hall is now part of the newly created Plymouth State University.

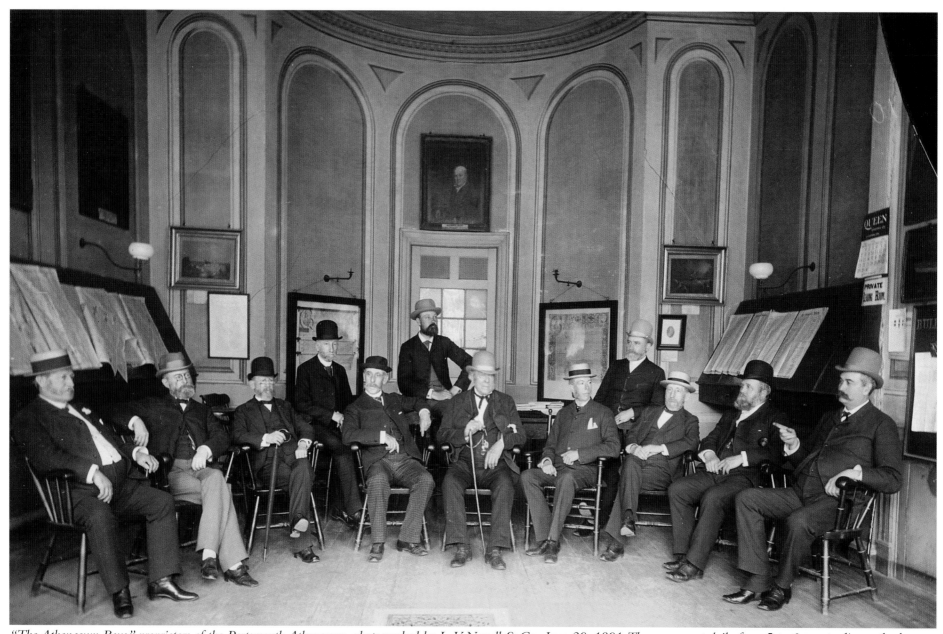

"The Athenaeum Boys," proprietors of the Portsmouth Athenaeum, photographed by L. V. Newell & Co., June 29, 1891. These men met daily from 5 to 6 P.M. to discuss theology, politics, and other topics. Left to right are Col. William Sise, Robert C. Peirce, Joseph Sise, Joseph W. Peirce, Thomas Neal, Frank J. Philbrick, Capt. John G. Moses, T. Salter Tredick, Cdr. Edwin White, John Sise, Capt. C. C. Carpenter, and Capt. F. E. Potter. In this era, the Athenaeum, which was founded in 1817 as a private library, had 100 male proprietors. Portsmouth Athenaeum collection.

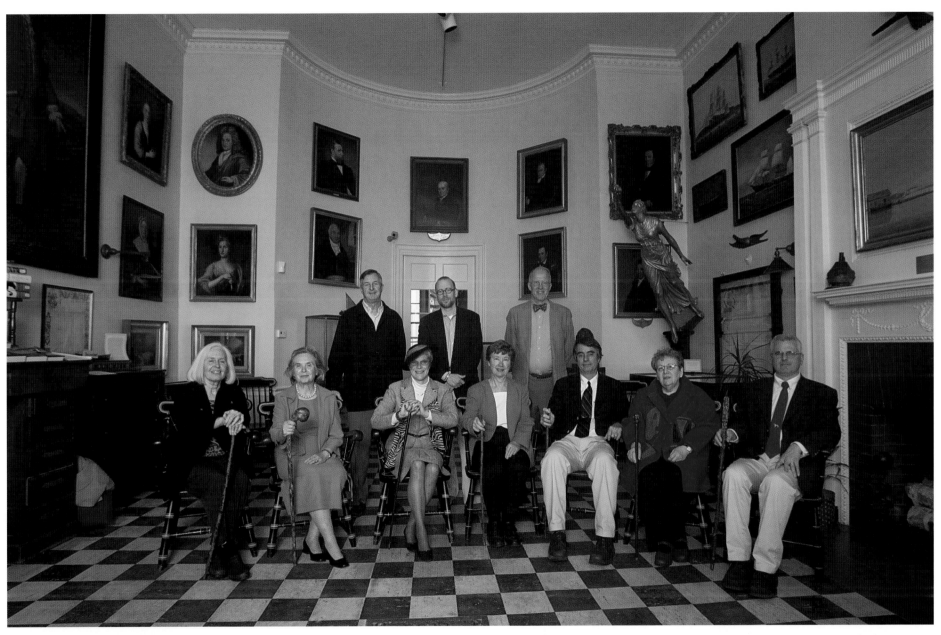

Members of the Board of Directors of the Portsmouth Athenaeum, 2005. Left to right, are Patricia deGrandpre, Eléonore Sanderson, Robert Thoreson, Wendy Lull, Michael Baenan, Gail Drobnyk, William Purington, President Michael Chubrich, Rose Eppard, and Keeper Thomas Hardiman. Women are now welcomed as valued proprietors of which the Athenaeum currently has 375. The Athenaeum has used the Sawtelle Reading Room since 1823. The center painting over the door in both photographs is the Athenaeum's first president, Nathaniel Haven.

The Wentworth-Coolidge Mansion, Portsmouth, photograph by Davis Bros., Portsmouth, ca. 1880s. The mansion is the former home of New Hampshire's first royal governor, Benning Wentworth, who served from 1741 to 1767. The rambling, 40-room building, which overlooks Little Harbor, is one of the most outstanding homes remaining of the colonial era. The property was purchased in 1886 as a summer place by J. Templeton Coolidge, a Boston Brahmin and amateur artist. Historic New England collection.

The Wentworth-Coolidge Mansion, 2004. Now owned by the State of New Hampshire, the mansion is open to the public in season. The grounds are also used for wedding receptions and other events. New Hampshire's governor and council occassionaly meet in the building's colonial council chambers. The adjacent garage has been remodeled and is now an art center with changing exhibits during the summer and fall. The property is known for its lilacs, supposedly descendants of the first ones planted in America.

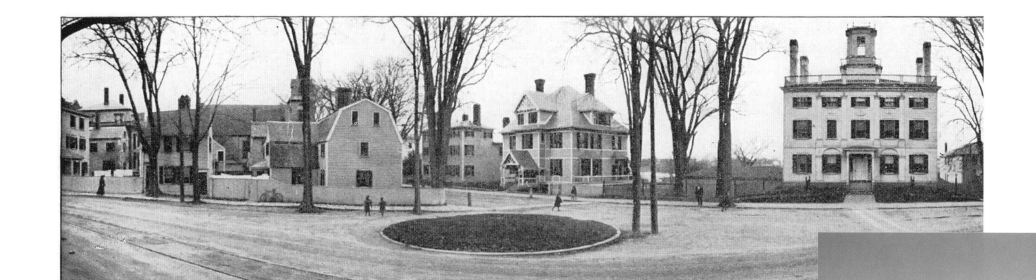

Haymarket Square, Portsmouth, photographed by C. S. Gurney, c. 1900. Situated at the intersection of Middle and Court Streets, the square was the entrance to the city's downtown area and the location of some of Portsmouth's finest homes. At right is the Federal-style John Peirce mansion, built in 1799, when this was considered the outskirts of town and the hay scales were located here. At center is the c. 1880 Queen Anne-style home of John Sise, a prominent 19th-century businessman. At left center is the smaller, gambrel-roofed Oracle House, where the Oracle of the Day *newspaper was printed when the house stood on Congress Street, next to North Church. The house was moved to the site shown above, then moved again to the foot of Court Street, opposite Prescott Park.*

Haymarket Square, Portsmouth, 2004. The most obvious change to the square is the Middle Street Baptist Church, built in 1954. The Peirce Mansion was moved back from the street and is now the church's parish house. The Sise house to the left of the church is now the elegant Sise Inn, and on the site of the Oracle House is a commercial building.

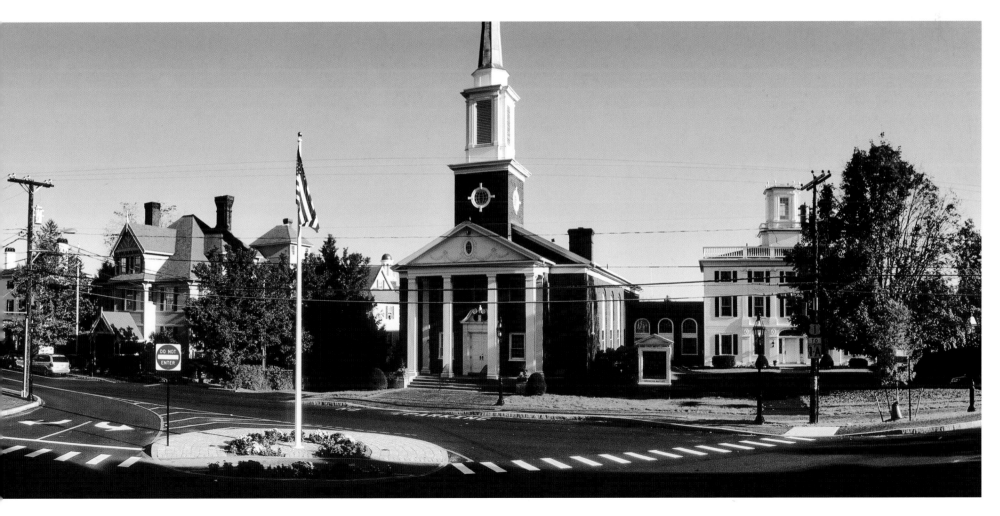

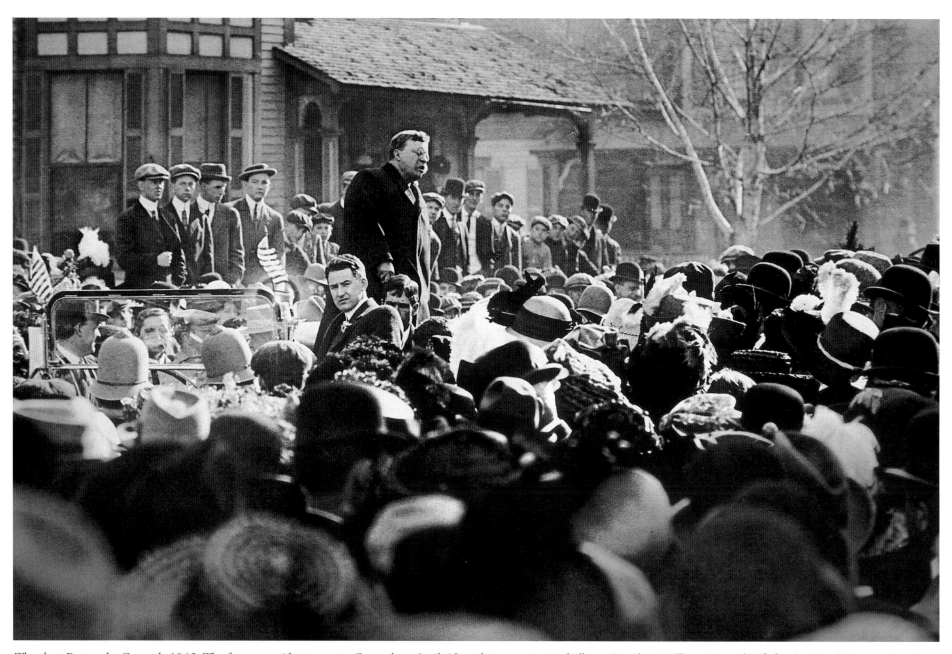

Theodore Roosevelt, Concord, 1912. The former president came to Concord on April 12 on his campaign to challenge President William Howard Taft for the Republican nomination. TR spoke at Phenix Hall, then moved to Green Street, where this photograph was taken. TR lost the nomination and ran on the Bull Moose ticket, but finished second behind Woodrow Wilson. Taft was third. New Hampshire Historical Society collection.

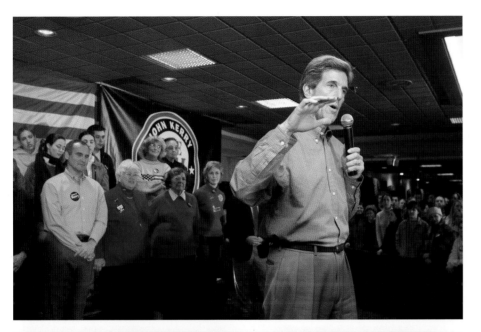

Presidential Primary, Portsmouth, 2004. Clockwise from top left: Senator John Kerry at Yoken's Restaurant, Senator Joe Lieberman in Market Square, retired general Wesley Clark at the Music Hall, and Senator John Edwards outside South Church. Although election rhetoric in the early part of the 20th century was equally as strident as it is now, today's campaigns are much more colorful.

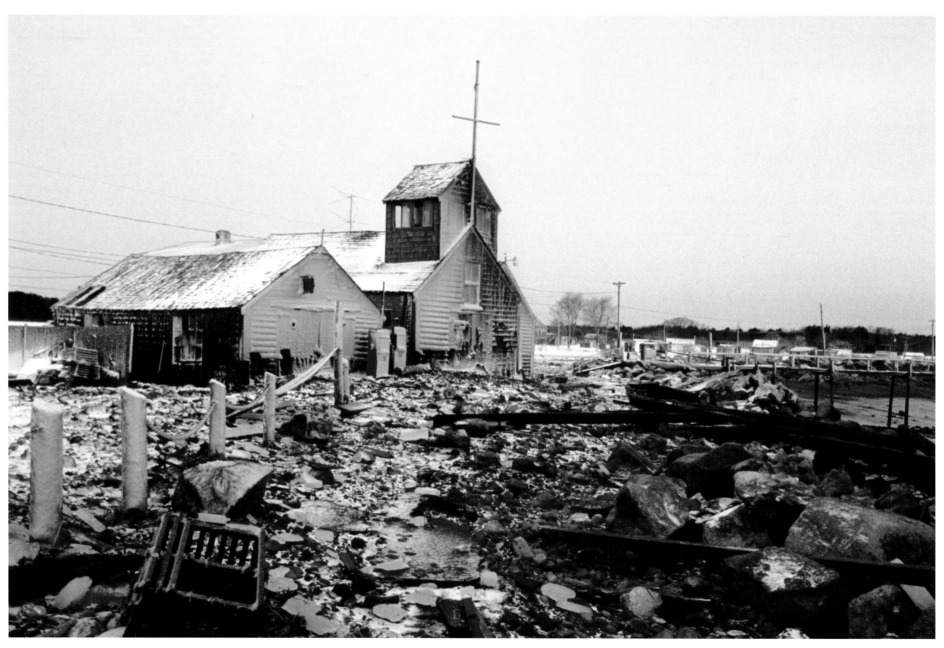

The Port of Missing Men, Rye Harbor, photograph by Peter E. Randall, 1972. This collection of fish houses dates from the mid-1800s, but in 1930s the center building became an informal clubhouse and yacht club for local people and summer residents. In 1972, a February northeaster swept along the coast, destroying Harbor Road but doing little damage to the old houses.

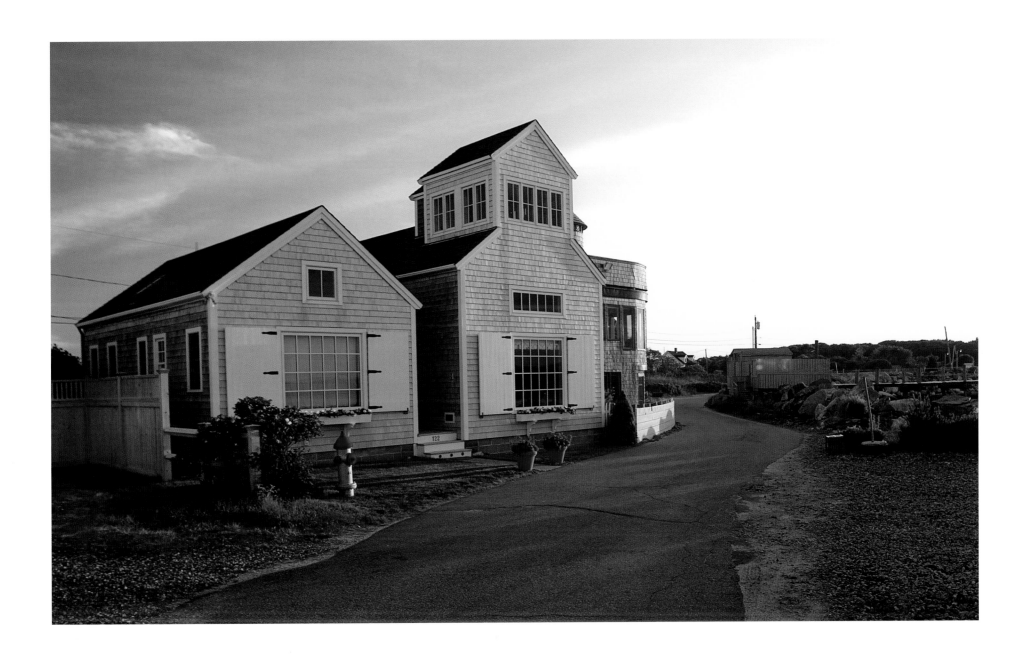

Foss cottage, 2004. The old Port of Missing Men was eventually torn down and replaced with a similar-looking building. Next to the Foss cottage is a tiny, contemporary summer home converted from another old fish house.

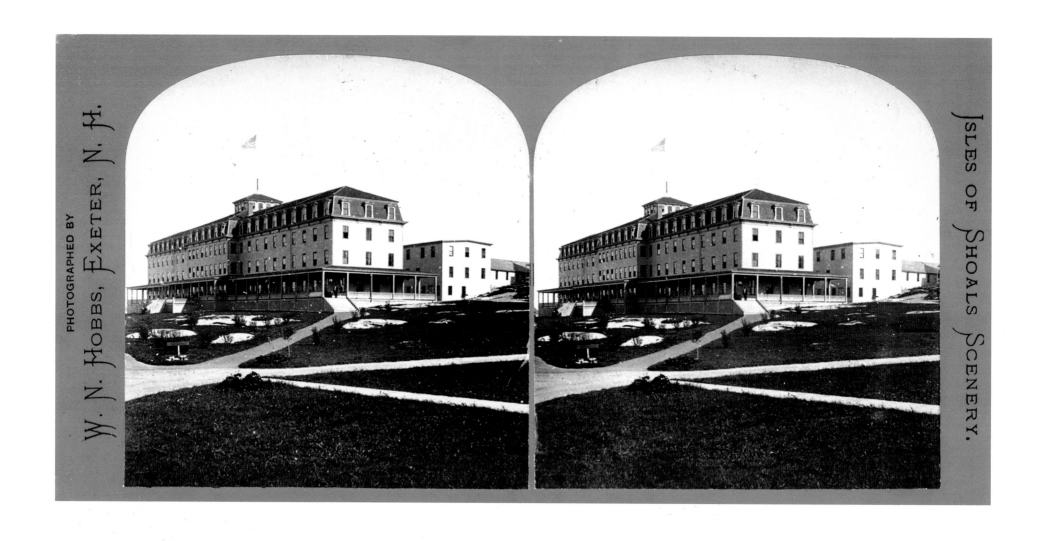

Oceanic Hotel, Star Island, Isles of Shoals, Rye, photographed by W. N. Hobbs, c. 1873. With the success of the Appledore House on nearby Appledore Island as a guide, John Poor built the spacious Oceanic Hotel in 1873. Reportedly it had the first hotel elevator in New England. In 1875, the hotel burned to the ground, succumbing to the fate of most of the other Victorian hotels of New England. The Laighton family bought the property in 1876 and in 1916 the Star Island Corporation purchased the Laighton property, which included Star Island as well as Appledore and Duck Islands. Author's collection.

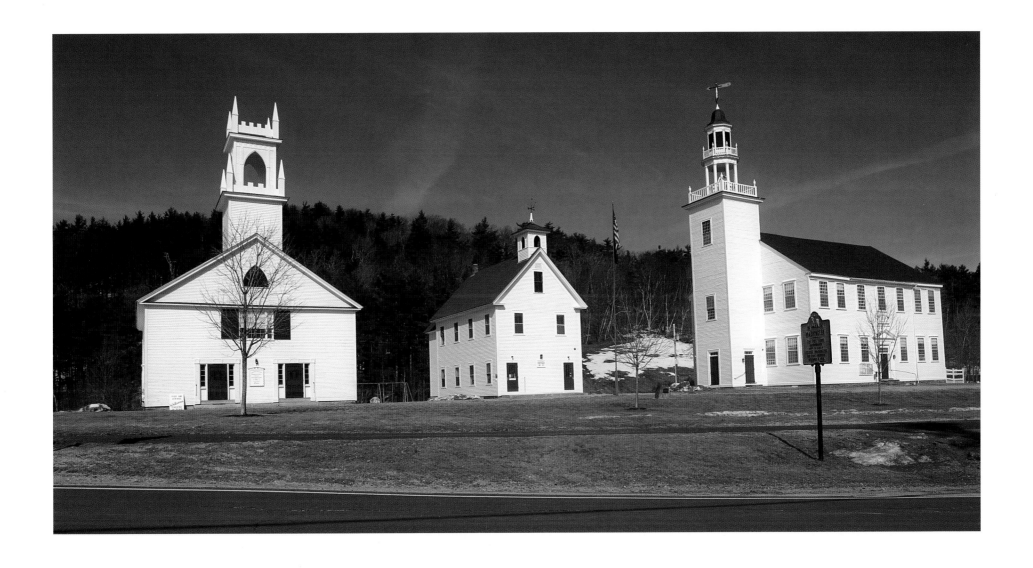

The town center of Washington, 2005. This much photographed view is on the cover of my first book of New Hampshire photographs. The building on the right was started in 1787 and completed in 1790 as the town meetinghouse and is now the town hall. The building on the left was erected during the years 1839 to 1840 as the meetinghouse of the Washington Congregational Society. It has been in continuous service since that time, and is now the Washington Congregational Church. The building in the center was built in 1883, after many heated discussions at town meetings. The old brick school was removed and replaced by this two-story wooden building. It served as a two-room schoolhouse (one room downstairs and one upstairs) until 1992, when, again after many heated discussions at town meetings, a new elementary school was built half a mile south of the center of town. The former schoolhouse is currently the Washington Police Station. The entire Washington Town Common, including the three buildings pictured, was put on the National Register of Historic Places in 1986.

Algonquin Club, Wentworth Location, photographed by J. P. Haseltine, Lancaster, c. 1890. The hunting and fishing club, at this date a collection of tents, was started by Scott Davis in the 1880s. He was soon joined by family members and friends from Hopkinton, Contoocook, and Concord. In these early years and into the 20th century, the journey from Concord required two days: First a train ride to Colebrook, then a horse and wagon trip through Dixville Notch to Errol, then north beside the Androscoggin and Magalloway Rivers to the camp. New Hampshire Historical Society collection.

Algonquin Club, Wentworth Location, 2004. In 1902 for $400, the club purchased a lot beside the Magalloway River and built this camp. Members turned down an opportunity to buy six miles of riverfront down to Errol for an additional $400. Most of today's members are descendants of the original families who began the club. The camp is still used for hunting and fishing, and family outings.

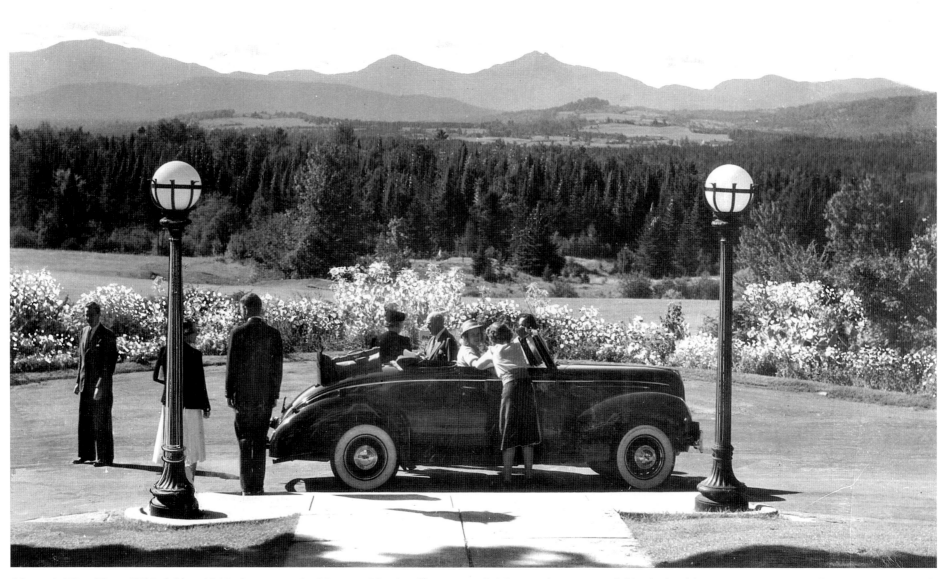

Mountain View House, Whitefield, c. 1940. Seen across the Mountain View's golf course are the Twins and Mount Garfield. The hotel began in 1866 as a small country inn operated by William Dodge. Then in 1872 and many times thereafter, it was expanded by the Dodge family, who operated it for 122 years, the oldest American resort to be owned and operated continuously by the same family living on the same property. New Hampshire Historical Society collection.

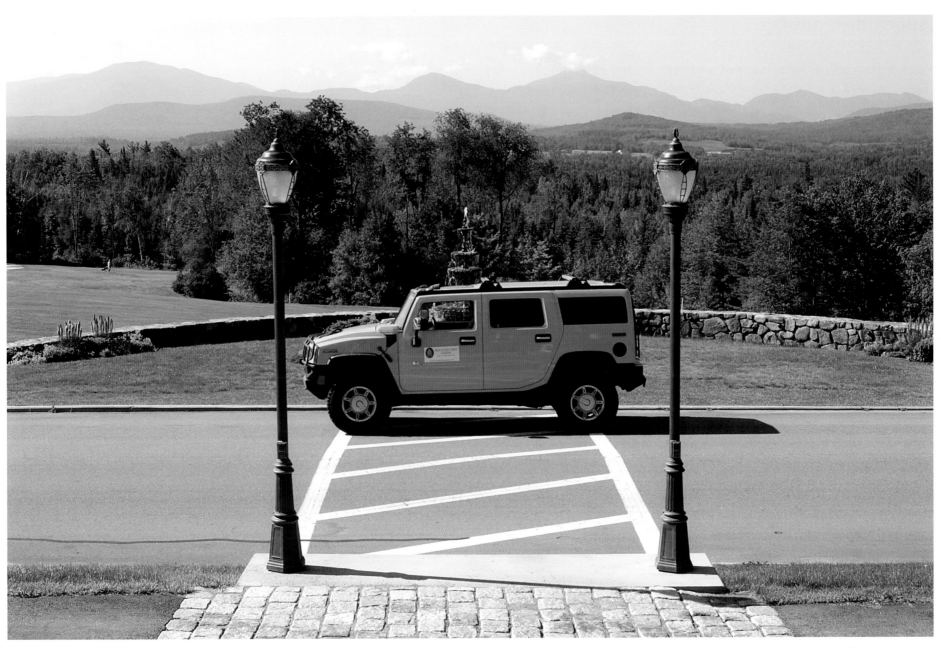

Mountain View Grand Resort and Spa, 2005. Unlike most other White Mountain hotels, which burned, the Mountain View continued in operation until the Dodge family sold it in 1979. New owners kept it going until 1986, when it closed, leaving only the golf course in operation. In 1998, Kevin Craffey, of Hanover, Massachusetts, bought the rundown hotel and, $20 million later, reopened the restored property in 2002.

About the Author

Peter E. Randall has been involved with writing and publishing since his high school days as a high school correspondent for the local newspaper. A native of the New Hampshire seacoast, he is a graduate of the University of New Hampshire with a major in history. At UNH he began to photograph under the instruction of Richard Merritt. He has been a daily and weekly newspaper reporter, editor, and photographer, editor of *New Hampshire Profiles* magazine, and, since 1976, owner of Peter E. Randall Publisher. The company has produced some 400 titles, most of them related to local history and biography. He is the author of fourteen books, of which this is his third volume of New Hampshire photographs. He and his wife, Judith, now reside in Eliot, Maine.

Website addresses for selected places photographed in the book.

Moosilauke Ravine Lodge, Benton
www.dartmouth.edu/~doc/moosilauke/ravinelodge/

Maplewood Casino, Bethleham
www.maplewoodgolfresort.com/

Segway Human Transporter, Bedford
www.segway.com

Conway Scenic Railroad, North Conway
www.conwayscenic.com

Saint Gaudens National Historic Site, Cornish
www.sgnhs.org/saga.html

Appalachian Mt. Club Highland Center, Carroll
www.outdoors.org/lodging/lodges/highland/index.cfm

The Cordwainer Shop, Deerfield and Bedford
www.cordwainercraftgallery.com/store_shoes.php

Enfield Shaker Museum, Enfield
www.shakermuseum.org/

American Independence Museum, Exeter
www.independencemuseum.org/

The Frost Place, Franconia
www.frostplace.org

Notchland Inn, Hart's Location
www.notchland.com/

Simon the Tanner, Lancaster
tanner.islandpond.com/

New Hampshire Institute of Art, Manchester
www.nhia.edu/

PC Connection, Marlow
www.pcconnection.com

New Hampshire Division of Parks
www.nhparks.state.nh.us/

Mount Washington Observatory, North Conway
www.mountwashington.org/

Friends of the Portsmouth Harbor Lighthouse
www.lighthouse.cc/portsmouth/

Wentworth by the Sea Marriott Hotel and Spa, New Castle
www.wentworth.com/

Portsmouth Athenaeum, Potsmouth
portsmouthathenaeum.org/

Star Island Corporation, Rye
www.starisland.org/

The Homestead, Sugar Hill
www.thehomestead1802.com/

Mountain View Grand Resort and Spa, Whitefield
www.mountainviewgrand.com/

Many New Hampshire historical Societies have websites and can be found by searching the internet. The New Hampshire Division of Parks is the source for information about the Flume, Franconia Notch, Franklin Pierce Homestead, and the Wentworth-Coolidge Mansion.